Collins

ROYAL
OBSERVATORY
GREENWICH

TOM
KERSS **DIAMONDS**
EVERYWHERE
AWE-INSPIRING ASTRONOMY DISCOVERIES

Published by Collins
An imprint of HarperCollins Publishers
Westerhill Road, Bishopbriggs, Glasgow G64 2QT
www.harpercollins.co.uk

HarperCollins Publishers
Macken House, 39/40 Mayor Street Upper,
Dublin 1, D01 C9W8, Ireland

In association with
Royal Museums Greenwich, the group name for the National Maritime Museum,
Royal Observatory Greenwich, the Queen's House and *Cutty Sark*
www.rmg.co.uk

© HarperCollins Publishers 2023
Text © Tom Kerss
Cover photograph © Erich Kolmhofer (Johannes-Kepler Observatory),
Herbert Raab (Johannes-Kepler Observatory)
Images and illustrations: See Acknowledgements page 236

Collins® is a registered trademark of HarperCollins Publishers Ltd

The contents of this publication are believed correct at the time of printing.
Nevertheless the Publisher can accept no responsibility for errors or omissions,
changes in the detail given or for any expense or loss thereby caused.

HarperCollins does not warrant that any website mentioned in this title will be provided
uninterrupted, that any website will be error free, that defects will be corrected, or that the
website or the server that makes it available are free of viruses or bugs. For full terms and
conditions please refer to the site terms provided on the website.

A catalogue record for this book is available from the British Library

ISBN 978-0-00-863696-8

10 9 8 7 6 5 4 3 2 1

Printed in India by Replika Press Pvt. Ltd.

If you would like to comment on any aspect of this book, please contact us at the
above address or online.
e-mail: collinsmaps@harpercollins.co.uk

facebook.com/CollinsAstronomy
@CollinsAstro

This book is produced from independently certified FSC™ paper
to ensure responsible forest management.

For more information visit: www.harpercollins.co.uk/green

Collins

ROYAL
OBSERVATORY
GREENWICH

For Mum and Dad,
who brought me into this Universe
and brought me up to explore it.

TOM
KERSS **DIAMONDS
EVERYWHERE**

AWE-INSPIRING ASTRONOMY DISCOVERIES

CONTENTS

A NOTE FROM THE AUTHOR

When I look at the current state of the science of astronomy, it is at times almost impossible to believe how far we have come since the advent of the telescope just over four centuries ago. Even in my own lifetime, enormous strides and groundbreaking discoveries have been made. New, cutting-edge observatories and techniques have pushed the boundary of the known Universe further out, whilst nearer to home, a fleet of space probes – robotic emissaries sailing the Solar System on behalf of humankind – has brought our neighbouring worlds into sharp relief, well beyond the degree to which any telescope could. A few months after I was born in 1986, NASA's *Voyager 2* spacecraft made an historic first (and to date only) flyby of Uranus. As of today, we've visited every planet, Pluto and the Kuiper Belt, and even numerous comets and asteroids. Spacecraft have even touched down on some of these miniature worlds, as well as Saturn's utterly compelling moon Titan.

Meanwhile, the very way we think about the Milky Way has been transformed by research. New kinds of stars and other non-stellar objects were hiding in the night sky all along; countless unseen systems of worlds exist, some not dissimilar from our own; vast spiral arms sweep out into a diffuse halo of stars and clusters; and a mysterious, influential substance called dark matter permeates it all. Looking to horizons beyond our galaxy, astronomers have determined that the Milky Way is but one 'island universe' among hundreds of billions of other galaxies, and most

of them are racing apart, carried by the expansion of space itself.

It would be something special to show these discoveries, images and findings from the age of modern astronomy to those who pioneered the use of the telescope in the early 17th century: Thomas Harriot, Galileo Galilei, Johannes Kepler – what would they think? If we are being honest with ourselves, we must admit that one day future generations will ask the same of us. For all we have learnt, we now know there is yet more – considerably more – work to be done. Every question answered, and every problem solved, opens up more possibilities for study. Any one of the 101 topics explored in the following pages could provide a lifetime of research for a budding astronomer, but you needn't become a professional researcher to engage with the cosmos: astronomy is for all of us, and we can all benefit from sharing in the collective effort for knowledge.

Such is the calling of the science communicator, and the reason for creating this book. My hope is that it may inspire you to start your own relationship with astronomy, and that it will leave you more intimately familiar with the things happening outside your everyday experience. We tend to think that we are beings within the Universe, but from another perspective we are a part of the Universe, and by understanding it we also stand to learn about ourselves. May this book introduce you to new ideas, new questions and a deeper desire to understand!

SPACESHIP EARTH:
A HABITABLE HAVEN OF
ASTRONOMICAL CHALLENGES

Our planet is a spaceship. Although not built artificially, Earth travels through space and provides protection for us, but it's out of our control. Its motion is complex, as it orbits the Sun, which itself moves through the Galaxy. The Earth also rotates and its axis of rotation wobbles. Altogether, this creates challenges for astronomers trying to study the stars, and they have sought creative solutions to counter them throughout history.

On the largest scale, the Earth is bound to the Sun moving through the Milky Way. The effect of this motion is difficult to detect and therefore doesn't interfere with most astronomical observations. The Earth's orbit around the Sun, however, does place limits on what we can see. As the Sun traces its annual path through the constellations of the zodiac, it effectively **covers up certain regions of the sky**. Even space-based observatories, which are not affected by daylit sky, are seldom pointed anywhere near the Sun unless they are purpose-built to study it. Each part of the sky has an optimum window for observation, centred around the period when it appears opposite the Sun, and is thus well-placed at solar midnight.

Earth's rotation is the largest factor affecting astronomical observations. As our planet spins on its axis, telescopes must be **moved at the same rate in order to counteract the rotation** and continue pointing at the same target. This is essential for continuous study, long-exposure imaging or other forms of instrument-based measurement. **Astronomers have used tracking systems for centuries**, with new generations of technology enabling improved accuracy. Today's telescopes can point to a star with astonishing precision, by calculating and correcting tracking errors in real time.

The rotation axis of the Earth is itself rotating, or wobbling. The effect is called precession and a full circle takes about 26,000 years. This doesn't affect observations but it does cause maps of the positions of stars to become out of date after a period of some years. Our astronomical coordinate system drifts relative to the sky on a given date, and so coordinates are defined for a specific astronomical epoch. When the error becomes significant, it is imperative to update the coordinates to a new epoch, or use an equation of transformation to account for it.

This compound motion is of course not a bad thing. The rotation of the Earth is essential for distributing heat in its atmosphere, and its orbit (in concert with its axial tilt) results in seasonal changes that contribute to habitability. **It is only the desire for precision that makes spaceship Earth's quirks a challenge for astronomers**. Fortunately, the pace of technology hasn't slowed down and tomorrow's observatories will be even more capable than the ones in use today.

THE SUN IS THE ALPHA & THE OMEGA

100 TIMES LARGER

The Sun, like every other star in the Universe, is not immortal. Eventually, it will exhaust its fuel and reach the end of its life. But what will happen to Earth when the Sun dies? The answer is not pretty.

When relatively lightweight stars like the Sun run out of hydrogen in their cores, they begin to fuse helium into heavier elements. This process causes the star to expand, becoming a red giant. The Sun, in particular, is expected to grow about 100 times larger than it is now, swallowing Mercury, Venus and possibly Earth in the process.

the resulting drag would draw Earth deeper into the red-giant Sun, where it would ultimately be vaporised

This is not due to happen anytime soon, however. The Sun is only about halfway through its normal life, and it will be several billion years before it begins to run out of hydrogen. When the Sun does expand, its outer layers will become less dense as they reach outwards towards the inner, rocky planets. Earth, being the third planet from the Sun, could be engulfed by these growing shells of gas, and the resulting drag would draw Earth deeper into the red-giant Sun, where it would ultimately be vaporised.

But the actual fate of the Earth depends on the specifics of the Sun's evolution in later life, which are not known with certainty. Some scientists think that our planet may actually survive the red giant phase, moving into a higher orbit as the Sun loses mass. But even if the Earth does survive, it will be a very different place than it is today. The increased heat and radiation from the Sun will make the Earth's surface thoroughly uninhabitable, and any of our remaining descendants will be forced to find a new home to survive.

The end of the Sun's life is not something we need to fear, and indeed it is a natural part of the life cycle of all stars. Countless stars have already lived and died, likely consuming their own habitable worlds, and it is this cycle that has enriched the Galaxy with the elements that planets and people are made of. When the Sun dies, it will cast out its fusion products into the Milky Way, where they will eventually become part of new stars and planets.

It's fitting that the Sun's demise should be shared by its planets. After all, the Sun also created the Solar System with all its worlds billions of years ago. It drew in the material from which the Earth was born, made this beautiful world into a habitat for life, and will ultimately take it back before seeding a new generation of planets elsewhere.

REVEALING THE MOON'S
TRUE COLOURS

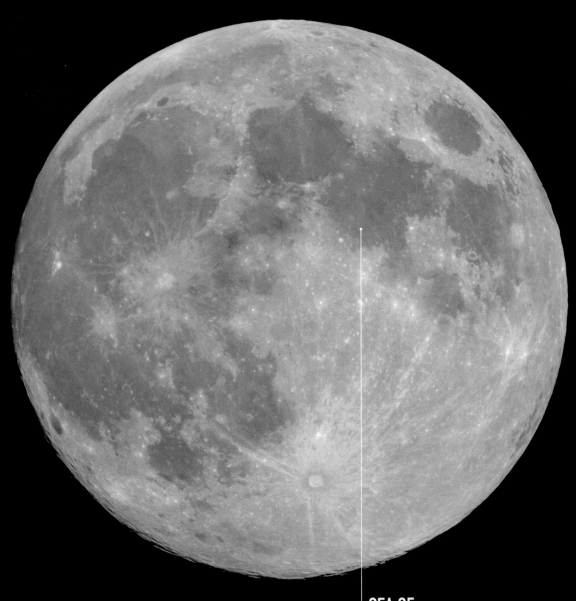

SEA OF
TRANQUILITY

We often describe the Moon in colourful terms, though little is said of its true colour. The rising or setting Moon takes on a golden shade, as sunlight reflected from its surface is filtered through the Earth's atmosphere. The so-called 'Blood Moon' takes on its eponymous deep red hue during a lunar eclipse, since the Earth's shadow is flooded with the light of every sunset and sunrise simultaneously. A 'Blue Moon', on the other hand, shows no unusual colour at all – its curious name is a traditional title from the North American farming community. But some parts of the Moon really are blue, and others appear somewhat rusty orange or brown.

Invisible to our eye, the Moon **exhibits subtle shades of colour across its surface**, which can be teased out by processing photographs, and using sophisticated cameras and software, so we can see a picture of the Moon awash with striking hues. Of course, the colours are unnaturally enhanced to be obvious to us, but they are no less real than the other details we naturally perceive.

Astronomers have for centuries described very faint hints of colours visible on the lunar surface through telescopes. Mare Tranquillitatis (the Sea of Tranquility) was known for its blueish tint. Palus Somni (the Marsh of Sleep) has a reputation for being slightly sandy in colour. Of all the colourful regions to hunt down, the Aristarchus Plateau is widely considered the most conspicuous. This enormous block of highland terrain rises above the volcanic plains of Oceanus Procellarum (the Ocean of Storms) on the western reaches of the Moon. Peppered with a layer of dark pyroclastic glass, the plateau nevertheless presents a strong yellow colour, sometimes described as 'mustard'.

These colours actually hold great scientific value, **offering clues as to the mineral composition of the lunar surface**. The obvious blue tones are produced when sunlight is reflected off basalts containing relatively high concentrations (7 per cent by weight) of titanium dioxide (TiO_2). Meanwhile, the yellow or orange hues are a combination of terrestrial-type basalts (where the titanium dioxide concentration is less than 2 per cent by weight) and a relatively high abundance of a more familiar oxide, iron oxide (FeO), also known as rust. High concentrations of iron oxide and titanium dioxide render the *maria* ('seas') darker than the highlands, due to their relatively low reflectivity. The rugged older highlands, with their numerous impact craters, contain iron oxide, giving them a rusty appearance. They have brighter, near-white streaks where relatively fresh material from more recent impacts has settled on top of the darker rock below. **Colour has been used to selenologically evaluate the lunar surface and piece together its entire history**. Why not take your own photo of the Moon and tease out its true colours?

THE CONSTELLATIONS ARE LOSING THEIR SHAPE

Constellations – patterns of stars in the sky that have inspired stories, myths and legends across many cultures – are arbitrary pictures traced by ancestors. Many were first imagined thousands of years ago and some didn't look exactly the same as they do today. This is due to a phenomenon called proper motion, which causes constellations to gradually change shape as the centuries go by.

every star in the sky is slowly, unnoticeably changing position

Proper motion is the apparent motion of a star across the sky as seen from Earth. Since all stars are **moving through the galaxy at different speeds** and on different trajectories, every star in the sky is slowly, unnoticeably changing position. Proper motion is easier to detect on nearby stars, where the effect of parallax is more obvious.

Naturally, if the positions of the stars are all changing, so are the lengths and angles of the imaginary lines that we trace between them. The constellations are changing shape. For example, the constellation Orion, which is visible all over the world, has changed shape dramatically over the past 50,000 years. The three stars that make up Orion's belt have stayed in much the same position, but the Hunter's head was once much farther to the north, and his club and shield looked very different. Stargazers at this time may not have jumped to the impression of a man when looking at these stars.

We need not worry about losing our familiar patterns in our lifetimes, but **the constellations are just a snapshot** reflecting the way the sky looks today. Nevertheless, the stories connected with them are enduring and will probably still be told on starry nights thousands of years from now when the patterns are beginning to look quite out of shape.

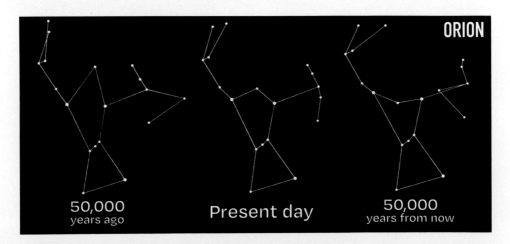

ORION

50,000 years ago

Present day

50,000 years from now

VENUS:
A VOLCANOLOGIST'S DREAM

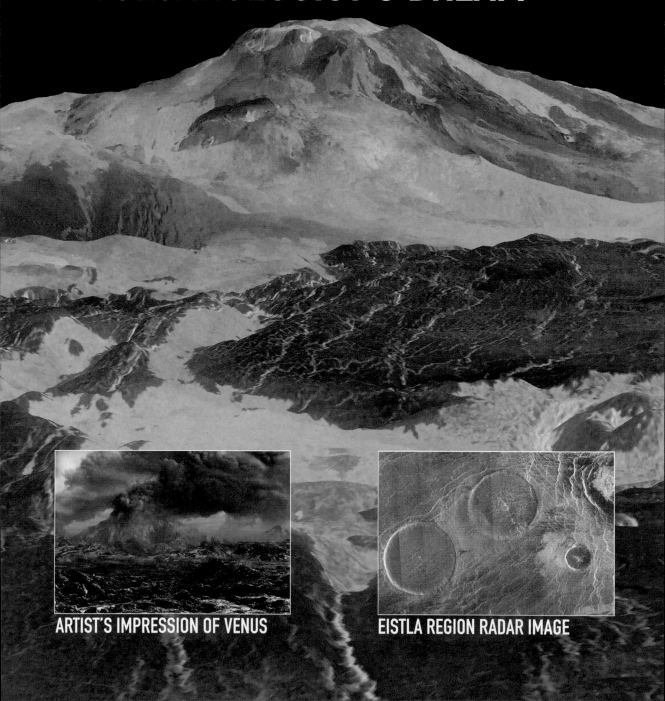

ARTIST'S IMPRESSION OF VENUS

EISTLA REGION RADAR IMAGE

Venus, the second planet from the Sun, is often referred to as the Earth's sister world due to its similar size and composition. But unlike the Earth, Venus is utterly inhospitable, with hellish conditions – it has a surface temperature of over 450 °C and an atmosphere that is composed mostly of carbon dioxide with clouds of sulfuric acid. The pressure exerted on its surface is 92 times greater than we experience on Earth and it would brutally crush our bodies.

Yet, if there's one group of scientists who would be willing to brave the Venusian climate for a closer look, it's volcanologists. That's because it's a volcanic wonderland, with 167 giant volcanoes more than 100 km wide. For comparison, Hawai'i's Big Island is the only volcanic complex on Earth above this threshold. The entirety of the Venusian surface shows signs of volcanic activity – not because Venus is more volcanically active than the Earth, but because its surface is not eroded in the same way.

The volcanoes on Venus can be classified into three main categories: shield volcanoes, stratovolcanoes and pancake domes. Shield volcanoes are the most common type on Venus and are similar in shape to the shield volcanoes found on Earth, such as Mauna Kea and Santorini. They are characterised by their broad, gently sloping cones that are formed by the eruption of fluid lava. They can be tens to hundreds of kilometres in diameter and several kilometres in height.

Stratovolcanoes, sometimes called composite volcanoes, are also found on Earth. Examples include Vesuvius and Mount Rainier. These are steeper and more conical in shape than shield volcanoes and are formed by the eruption of both lava and pyroclastic material, such as ash and rock fragments.

Pancake domes, another form of volcano, are unique to Venus. They present as low, broad and generally circular in shape and are formed by the eruption of highly viscous lava that does not flow far from the vent. Pancake domes on Venus can be many kilometres in diameter, but typically just a few hundred metres in height. In the early 1990s, NASA's *Magellan* spacecraft became the first to peer through the dense, opaque atmosphere of Venus and pancake domes were subsequently discovered.

More recently, in 2008–09, the ESA's *Venus Express* mission detected, for the first time, evidence of active volcanic eruptions. Transient infrared hotspots detected through the clouds betrayed the existence of lava flows emerging from the region around the giant shield volcano, Maat Mons. The frequency and intensity of volcanic activity on Venus is not well understood. Some evidence suggests that it may experience periods of intense, global volcanic activity every few hundred million years, separated by long stretches of relative calm, during which pressure builds up beneath the planet's crust.

COUNTING THE STARS
IN THE MILKY WAY

BETWEEN
100
BILLION
AND
500
BILLION
STARS

Ask an astronomer how many stars there are in the Milky Way and the answer will range from 'hundreds of billions' to an approximate value: 'about 100 billion'; '300 billion'; '500 billion'. There must be a correct answer, so why does the value vary so much? Unfortunately, figuring out the number of stars in our Galaxy isn't just a matter of counting. Most of the Milky Way is obscured from view and the regions we do see are so vast and distant that individual stars aren't readily identified, even with powerful telescopes. Determining the population of the Galaxy relies upon observations, assumptions and informed estimates.

there are probably more stars in the Galaxy than every human that has ever been born

One of the most common methods used to estimate the number of stars in the Milky Way is to **observe and count stars in one small region and then extrapolate the density** across the estimated volume of the Galaxy. A sufficiently representative sample can be used to generate a statistical model, but the result depends sensitively on measurements of local number density, which are hard to constrain. Another technique involves measuring the mass of the Galaxy. The rotation curve of the Milky Way – a profile of its rotation speed between the core and the edges – as well as observations of star clusters can be used to estimate its mass, which is then distributed among its known components, such as dark matter, gas and dust, and, of course, stars. This too relies on a good statistical model.

Missions like the ESA's *Gaia* probe are helping to improve our understanding of stellar distribution, by mapping hundreds of millions, or even billions of individual stars, but **there are still large unknowns about the Galaxy's true extent** that leave us with a wide range of estimates. Thus, the best available answer is that the Milky Way contains between 100 billion and 500 billion stars. Curiously, anthropologists are more confident about the total number of human beings that have ever lived – about 110 billion. So, we can say that there are probably more stars in the Galaxy than every human that has ever been born! As with other measurements, such as the age of the Universe, the most likely answer to the question of how many stars populate the Milky Way will probably go up and down in future, but the margin of error will eventually shrink, leaving us with a clearer picture of our home Galaxy.

ON MARS, SUNSETS ARE
BLUE

FINE-GRAINED DUST

Here on Earth, we are accustomed to beautiful sunsets that fill the western sky with vibrant shades of orange, pink and red. On Mars, sunsets are distinctly blue. What's happening?

the blue sunsets of Mars are a strong reminder that despite some similarities to the Earth, it is an alien planet with a very different environment

The colour of our sunsets is intrinsically linked to the colour of the sky. Sunlight, which contains all visible colours, pours through our atmosphere, primarily encountering oxygen and nitrogen. These gases **scatter blue light in all directions**, casting the daylit sky bright blue. Meanwhile, warmer colours, such as red, are allowed to travel on. In fact, they are forward scattered in the same direction through the atmosphere. When the Sun is low on the horizon, its light passes through much more atmospheric gas to reach us than when it is higher in the sky. As a result, **the low-angle sunlight has most of its blue removed by the time it reaches us**.

Mars has a much thinner atmosphere, composed almost entirely of carbon dioxide. It plays a much smaller role in scattering sunlight on its way to the Martian surface. Instead, **a persistent fine-grained dust permeates the thin air** close to the ground on Mars, and it is this dust that colours the sky during sunset. The dust's scattering profile is almost exactly the opposite to the Earth's atmosphere. It forward-scatters blue light and absorbs red light. The low-angle Sun therefore appears blue and the daytime sky is a drab, pink-orange colour.

The blue sunsets of Mars are a strong reminder that despite some similarities to the Earth, it is an alien planet with a very different environment. For now, we view these blue Martian sunsets through the cameras on board our robotic emissaries, but someone is destined to be the first to witness one with their own eyes.

THE NORTH STAR IS A TEMPORARY TITLE

Across the northern hemisphere, stargazers are used to looking up on a clear night and identifying Polaris – the North Star. It's perhaps the most important navigational star in history, used by nomads and mariners to find their way. But the role of the North Star is a temporary one. Throughout history, different stars have held the position of the North Star, also known as the pole star. This is largely due to a 26,000-year-long cycle, during which the Earth's polar axis rotates in a circle. Astronomers call it precession. The positions of the stars also change gradually as they move through the Galaxy – a phenomenon called proper motion.

One of the earliest recorded pole stars is Thuban in the constellation Draco the Dragon, which was **used to find true north in ancient Egypt** about 5,000 years ago. In 2787 BCE, Thuban almost perfectly marked the north celestial pole. By 1100 BCE, Thuban had ceded the role of pole star to Kochab in the constellation Ursa Minor, the Little Bear. Unfortunately, this was a rather poor marker, not nearly as accurate as Thuban or Polaris, which followed it, becoming the pole star around 500 CE. Polaris, which is also in Ursa Minor, takes its name from its role, but it won't be the pole star forever.

it's perhaps the most important navigational star in history

In about a 1,000 years, **the star Errai in Cepheus will be the most accurate pole marker**. There aren't many bright stars well-placed to mark the pole, so we're lucky to have Polaris now. In 14500 CE, the brilliant Vega in Lyra will give a rough indication of true north, but it will be ten times farther from the north celestial pole that Polaris kept – not very reliable!

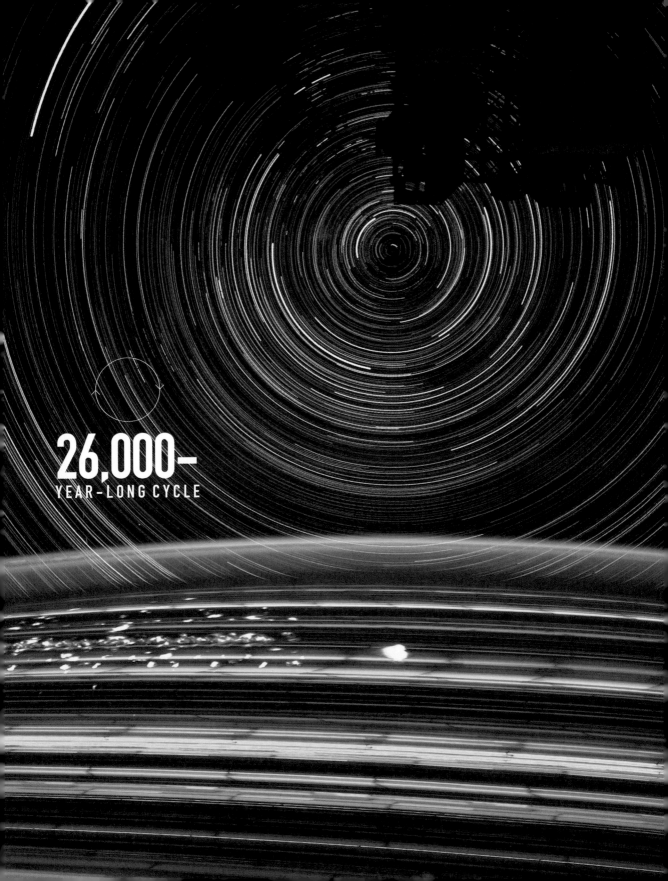

26,000-
YEAR-LONG CYCLE

26,000 LIGHT-YEARS AWAY

WE LIVE IN THE
GALACTIC SUBURBS

For most of human history, stargazers have had no concept of the Milky Way as a galaxy. It appears as a river of light in the sky and its individual stars aren't resolved by eye. We view it from the inside out and some parts of it are forever hidden from our vantage point. Yet, astronomers now understand a great deal about the Milky Way's structure, as well as our location within it.

we are roughly halfway from the centre to the edge of the spiral structure

The Milky Way is a barred, spiral galaxy – shaped like a disk, with an elongated central bulge, known as a bar, and multiple spiral arms sweeping outwards. The galactic disk is much thinner than it is wide. Astronomers have measured the diameter of the Milky Way to be approximately 100,000 light-years, while its disk is typically just 1,000 light-years thick. A diffuse population of stars extends the thickness to, at most, 10,000 light-years, but from a great distance this would not contribute much to the apparent brightness of the Galaxy.

Astronomers have been able to determine our location within the Milky Way by measuring distances to its centre, as well as other spiral arms around our own. We know that the Galactic Core is approximately 26,000 light-years away, so we are roughly halfway from the centre to the edge of the spiral structure, in the galactic suburbs.

The Sun's home spiral arm is called the Orion-Cygnus arm, and it was once thought to be a spur – a minor spiral structure that may have broken away from one of the main arms. However, recent research suggests that the Orion-Cygnus arm is quite substantial at about 10,000 light-years in length and is probably connected to the major Perseus arm. This is one of the two primary spiral arms that connect to the ends of the Milky Way's central bar.

On timescales that are impossible to grapple with, these arms and our place within them are in constant motion, but it would take millions of years for the Sun to migrate to a different spiral arm entirely.

WHERE IN SPACE DID
THE BIG BANG OCCUR?

The Big Bang, the sudden and rapid expansion of space that formed our Universe, occurred 13.8 billion years ago. Its effects are still felt today as space continues to expand, but where did it all happen? It's natural to imagine that the location of the Big Bang defines the geometric centre of the Universe, from which everything is racing away. After all, the Big Bang is often described as an explosion, and explosions occur in one location, pushing everything outward.

But modern cosmology isn't based on common sense. Cosmologists use mathematics and observational evidence to trace the history of the Universe back to the earliest moments of time and the nature of the Big Bang is stranger than our intuition would lead us to believe. According to our models for the expansion of the Universe, the Big Bang occurred everywhere in space, because **every part of the Universe was confined to the same point**, in a volume smaller than a single atom.

Thus, the expansion of the Universe drives galaxies apart from one another everywhere, and is ongoing at every point in space. In fact, **space is expanding inside your own body**! Fortunately, the nuclear forces that bind atoms together, as well as the gravity that keeps the Earth in orbit, exert a much stronger influence on small scales than the expansion of space. It is only over the vast distances between galaxies that this expansion becomes dominant.

its effects are still felt today as space continues to expand

Astronomers have discovered that the expansion of space is accelerating and, if this process continues forever, at some very, very distant point in the future, stars, planets and even atoms will be torn apart!

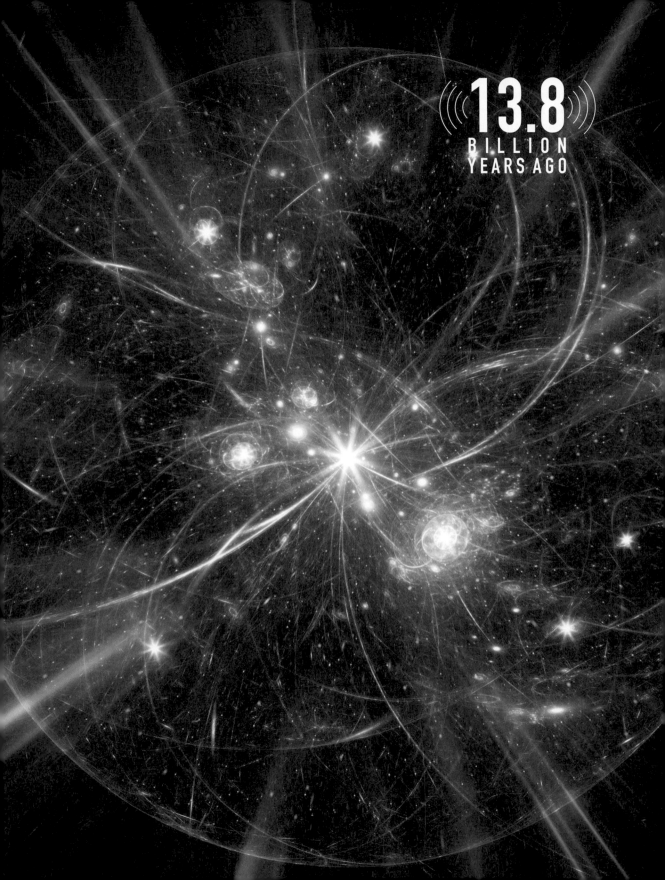

13.8
BILLION
YEARS AGO

Everyone loves the sight of a comet sailing through the sky. They're captivating objects that put on a show for a limited time before disappearing out of view, many never to return. These icy bodies are celebrated for their brightly lit tails that trail behind them, reflecting sunlight. But just how big is a comet's tail?

Many comets actually produce more than one tail. A dust tail, which follows the comet along its orbit, is formed by sublimating ice and rock that breaks away from the comet's nucleus and is heated by the Sun. A separate ion tail is also common. The ion tail is made up of charged particles blasted out of the comet's coma (or atmosphere) by the solar wind. For this reason, **the ion tail always points away from the Sun**. Of the two, the dust tail is usually brighter and may have a curved shape that is so often associated with the typical image of a comet.

Comets consist of a nucleus made up of rock, dust and frozen gases such as water, carbon dioxide and methane. As a comet approaches the Sun, its icy surface begins to vaporise, releasing gas and dust particles into space. The formation of the tail begins when the comet is warm enough, but each comet's surface responds differently. It depends on volatility. For this reason, some comets produce relatively short tails late in their approach to the Sun. These can stretch for some tens or hundreds of thousands of kilometres through the Solar System. These shorter tails are **comparable in length to the distance between the Earth and the Moon**.

On rare occasions, the tail can be much, much longer. One of the most famous examples is the Great Comet of 1843. On its approach to the Sun, it dazzled sky watchers with a bright tail that stretched across a huge swathe of the sky. Astronomers can only estimate the physical length of the tail, but, based on what is known about the comet's orbit and observations from the time, it seems likely that **the tail exceeded 450 million kilometres in length**! This would put the end of the tail well beyond the orbit of Mars and into the asteroid belt.

as a comet approaches the Sun, its icy surface begins to vaporise, releasing gas and dust particles into space

Most comets don't achieve 'great' status but once in a generation, a very beautiful comet will light up the sky, so keep your eyes peeled for the next astonishing cometary tail!

THE AWESOME SCALE OF COMETARY TAILS

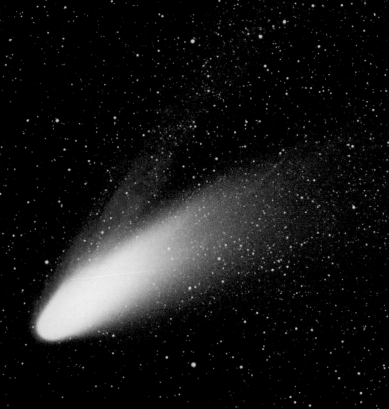

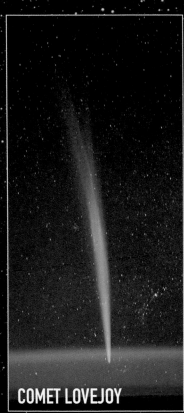

COMET LOVEJOY

In understanding that the Sun is a star, we've come to think of all stars as blazing hot, fiery balls of plasma that could melt any material or alloy we could create. But this isn't true of all stars, and, in fact, there is a category of fascinating, supercool stars lurking within the Galaxy.

Brown dwarfs are colder than any known star, and are classified as sub-stellar objects. They are often referred to as 'failed stars' because they are too small to sustain nuclear fusion in their cores, which is the process that powers the Sun. As a result, brown dwarfs emit very little light and heat, making them quite challenging to detect. Despite being theorised to exist in the 1960s, it wasn't until the 1990s that they were officially discovered.

The surface temperatures of brown dwarfs vary, but one particular subclass – Y-type stars – are the coldest of all. Their surface temperatures are typically only a few hundred degrees Celsius above absolute zero. That corresponds to a temperature of some tens of degrees Celsius. Your skin has a temperature of around 35 °C, and a warm mug of tea is just a bit hotter. Were it possible to touch the surfaces of these Y-type stars, you would be able to feel the warmth without even scolding your hand!

studying brown dwarfs provides insight into the grey area between very small stars and very large gas-giant planets

Despite their low temperatures, brown dwarfs still emit detectable radiation in longer wavelengths than the visible spectrum, such as infrared light. This makes them a prime target for infrared telescopes such as the James Webb Space Telescope (JWST), as well as radio arrays. Studying brown dwarfs provides insight into the grey area between very small stars and very large gas-giant planets, and sometimes they throw up surprising findings. For example, **their atmospheres can contain exotic compounds**, such as methane and ammonia, which would be impossible on stars like the Sun. Could organic chemistry and biochemistry be possible in the atmosphere of a brown dwarf? It's a tantalising thought.

SOME STARS ARE SO COOL, YOU COULD TOUCH THEM WITHOUT SCOLDING YOUR HAND

A FEW HUNDRED
D E G R E E S
CELSIUS ABOVE
ABSOLUTE ZERO

Beyond the orbit of Neptune, drifting in a mysterious region known as the Kuiper Belt, the small, but significant world Pluto orbits the Sun once every 248 years. It was discovered in 1930 by the American astronomer Clyde Tombaugh and was originally classified as the ninth planet in the Solar System. However, in 2006, the International Astronomical Union (IAU) voted to reclassify Pluto as a dwarf planet.

Despite its change of category, Pluto remained an important object of study for scientists, and, in 2015, the *New Horizons* spacecraft conducted an historic first flyby of the dwarf planet. The spacecraft, which was launched in the same year as the IAU vote, travelled over three billion miles to reach Pluto and **provided the first close-up images of its remarkable surface**.

The scientific observations of the *New Horizons* spacecraft have provided valuable insights into the composition and geology of Pluto. One of the most significant findings was **the discovery of mountains made of water ice, which are up to 11,000 feet tall**. These mountains are thought to be relatively young, having formed within the last 100 million years, and their existence suggests that Pluto may have a subsurface water ocean.

Upon its approach to the dwarf planet, *New Horizons* also revealed a collection of large plains taking the shape of a heart, which naturally became very popular with the public. These plains include Sputnik Planitia, composed mostly of nitrogen ice, but with carbon dioxide and methane also present. Strange honeycomb patterns suggest that **water ice is floating on top of the nitrogen layer**, and constantly moving or shifting around. The flowing ice carves valleys in the surface, an abundance of which already exist, leading scientists to believe that Pluto has a long history of geological and hydrological activity.

large plains taking the shape of a heart

Pluto's unusual nitrogen plains behave like a liquid in slow motion, forming a kind of ocean on the surface, which is replenished by nitrogen glaciers sliding down from the mountains, carrying water ice with them. The findings of the *New Horizons* missions were both surprising and compelling, casting little Pluto in a new light and raising many more questions that astronomers one day hope to answer.

PLUTO
IS STRANGER THAN
ANYONE IMAGINED

ONCE EVERY

248

YEARS

Nebulae are the birthplaces of stars – stellar nurseries where thousands of young stars begin their lives before drifting apart and migrating into the Galaxy. Until recently, it's been almost impossible to witness the earliest moments of a young star's life, because they shroud themselves from view.

Stars are born in cocoons of gas and dust, that fragment within larger clouds. **Gravity is the key force at work**, drawing together material that eventually forms a dense globule. As these relatively small and dense clouds collapse under their own gravity, they begin to heat up and when the temperature at the centre reaches tens of thousands of degrees, a protostar is formed. This protostar draws in more material from the cocoon, and it eventually grows into a fully formed star.

Some of these cocoons form in or from striking features known as Bok globules – first discovered in 1947 by astronomer Bart Bok. Dense enough to block virtually all the light behind them, they stand out in stunning silhouettes against the surrounding, luminous nebulosity.

Bok globules are typically about one light-year in size and have masses a few times greater than the Sun. From the outside they are also extremely cold, with temperatures not much greater than the surrounding space, yet **on the inside several stars can be forming** – their intense light absorbed deep within the cloud. Larger Bok globules give rise to multiple star systems, where several stars remain bound by their mutual gravity to travel the Galaxy together.

infrared observations allow us to 'X-ray' a nebula and see the earliest moments of star formation

With progress in infrared astronomy, it's now possible to peer into some of these cocoons and observe protostars that are still growing. Infrared light is not so easily absorbed by the gas and dust surrounding a young star, so, in a way, infrared observations allow us to 'X-ray' a nebula and see the earliest moments of star formation, giving important insights into the life cycles of all stars. Next generation instruments such as the James Webb Space Telescope (JWST) are capable of **peering into cosmic cocoons** with unprecedented sensitivity, revealing the process of star birth in remarkable detail.

INFANT STARS
HIDE IN COSMIC COCOONS

MILLIONS
OF DEGREES

45 MILLION
LIGHT-YEARS
FROM EARTH

THE HAUNTING BEAUTY
OF GALAXY MERGERS

G alaxies are majestic objects that seem to be eternally unchanging, but they are not static objects. They are constantly moving and, occasionally, interacting with each other. When they get too close, a collision becomes inevitable, resulting in a merger – a cosmic dance that takes billions of years to perform.

The Antennae Galaxies (pictured), also known as NGC 4038 and NGC 4039, are a pair of large, spiral galaxies in the constellation Corvus, which are currently in the process of merging together. They're located about 45 million light-years from Earth and are **named after the long antenna-like tails of stars and gas** that are stretching away from the central collision.

Observations of this merger and many others provide fascinating glimpses of physics on a colossal scale. As two galaxies approach each other, their gravitational pull disrupts and distorts their spiral structures. They begin to stretch towards each other and embrace. The central regions – the galactic cores – are more densely populated with stars and feel the strongest compulsion to merge. The sweeping spiral arms, meanwhile, are often dismantled in the process – broken apart and flung out into intergalactic space.

as two galaxies approach each other, their gravitational pull disrupts and distorts their spiral structures

Mergers often trigger a process called 'starburst' as their gas clouds are compressed. Huge quantities of new stars are born, making the events remarkably creative. Eventually, the merger will finish with the completion of a new, larger galaxy. Though many mergers have been observed, most of the galaxies in the Universe today will never touch any of their companions again. The accelerating expansion of the Universe, triggered by the Big Bang, is causing most galaxies, particularly those not bound in dense clusters, to become increasingly isolated.

The Milky Way, however, is **on course to merge with two of its nearest neighbours** – the massive Andromeda Galaxy and the smaller Triangulum Galaxy, both of which are heading towards us.

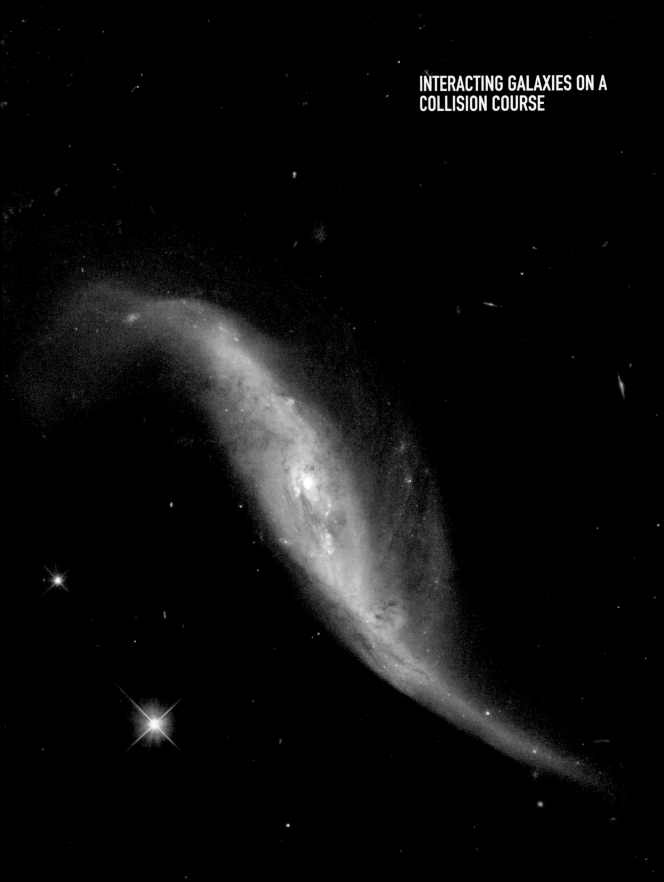

INTERACTING GALAXIES ON A COLLISION COURSE

The main asteroid belt, located between Mars and Jupiter, is a region of our Solar System that contains millions of small, rocky objects, thought to be leftovers from the formation of the planets. They vary greatly in size, shape and composition, and are distributed in a flattened torus-shaped swarm. The asteroid belt's density is often misunderstood or misrepresented in popular media. Science fiction films often mislead us with scenes featuring spaceships dodging and weaving through an 'asteroid field', but, contrary to these depictions, the asteroid belt is not crowded or cluttered – far from it.

Objects in the asteroid belt are separated by approximately one million kilometres on average, which is **more than twice the distance between the Earth and the Moon**. If you were standing on an asteroid within the belt, you probably wouldn't be able to see any other asteroids with your unaided eye and would need binoculars or a telescope to spot one.

However, while the average density of the asteroid belt is very low, there are still some areas where objects are more tightly packed together. So-called asteroid families are formed when a large asteroid is shattered by a collision, creating a swarm of smaller asteroids that share similar orbits and compositions. They may eventually drift apart, but larger pieces can cling onto each other with their mutual gravitational attraction, albeit very weakly.

One of the most well-studied asteroid families in the asteroid belt is the Flora family, which is named after its largest member, Flora. The Flora family contains **more than 13,000 recorded members**, all sharing a similar orbit. Flora itself accounts for about 80 per cent of the mass of the Flora family, while the other members are just fragments by comparison, probably chipped off Flora in past collisions.

leftovers from the formation of the planets

Kirkwood gaps are regions where there are relatively few asteroids due to gravitational interactions with Jupiter. The mighty gas giant's immense gravitational influence causes the orbits of asteroids in these regions to become unstable and they are either ejected from the belt or collide with other objects in a mutually destructive way.

Our understanding of the asteroid belt has surged in the space age, as some of its many members have been visited by spacecraft. The largest objects, Ceres and Vesta, were both seen up close by NASA's *Dawn* mission and, along with Pallas and Hygiea, this collection of just four asteroids makes up around 60 per cent of the total mass of the belt. It generally poses no risk to interplanetary spacecraft, several of which have **cruised through the asteroid belt without incident** on their way to the outer planets.

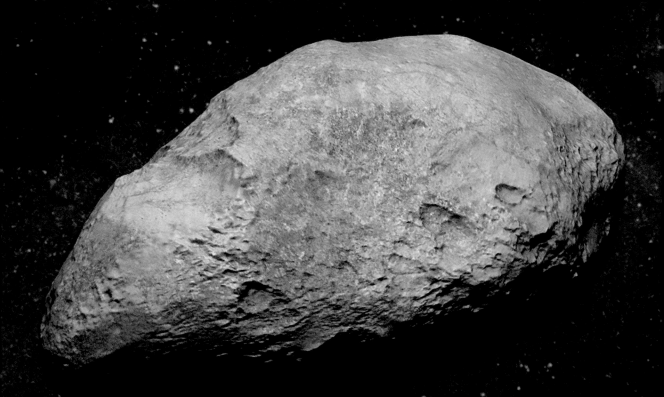

THE ASTEROID BELT:
NOT HOW YOU IMAGINE IT

ONE MILLION KILOMETRES

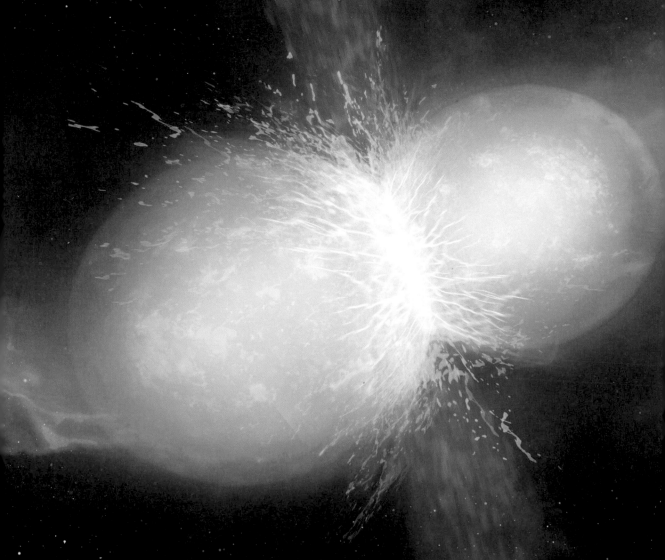

PRECIOUS METALS
ARE FORGED WHEN DEAD STARS COLLIDE

After the Big Bang set the expansion of the Universe in motion, the makeup of ordinary matter comprised almost entirely of just two elements: hydrogen and helium. Despite billions of years of stellar nucleosynthesis – the creation of heavier elements in the fusion cores and atmospheres of stars – the Universe today remains largely dominated by these two light elements. As time goes by, galaxies such as the Milky Way become chemically enriched by dying stars releasing more elements into the space around them, providing the material for planets to form. Every naturally occurring element created after the Big Bang was produced by stars, and the most exotic have spectacular origins.

the energy involved in these collisions is far greater than that released by a supernova

Supernovae and neutron star collisions are **two of the most violent and energetic events in the Universe,** and they play a crucial role in the production of rare and precious elements. Supernovae are the explosive deaths of stars much more massive than the Sun. When a powerful star runs out of fuel, its core rapidly collapses, triggering a cataclysmic, explosive shockwave. For a short time, the immense temperature and pressure enables the fusion of exotic elements, which are then scattered into space.

Meanwhile, the remnants of exploding stars – neutron stars – will sometimes collide, **producing and releasing vast quantities of precious metals** among many other elements. The energy involved in these collisions is far greater than that released by a supernova. As a result, the heaviest naturally occurring elements, including uranium, are produced almost exclusively by these extreme events.

Both supernovae and neutron star collisions fuse heavy elements through 'r-process' nucleosynthesis. They create sufficient temperatures and pressures for atomic nuclei to undergo a rapid neutron capture. These nuclei are forced to absorb neutrons, bulking up their atomic numbers. Merging neutron stars can reach numbers like 47 (silver), 78 (platinum), 79 (gold) and 92 (palladium), making them forges for precious metals. If you invest in these metals, think about where they came from. Perhaps they'll seem more valuable in light of their extreme origins!

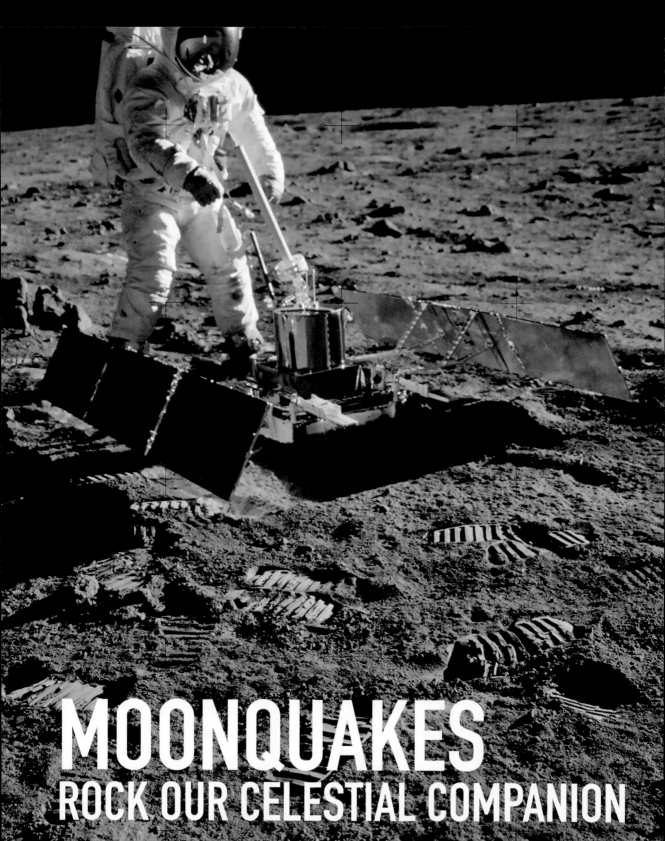

MOONQUAKES
ROCK OUR CELESTIAL COMPANION

Moonquakes, also known as lunar seismic activity, ring through the Moon like a giant bell. Caused by a variety of factors, they provide valuable insights into the Moon's interior and have become a cornerstone of selenology – the lunar equivalent of geology. The study of this activity began in 1969 when the crew of *Apollo XI* placed a seismometer on the lunar surface. Throughout the Apollo programme, several more instruments were deployed and their results are still studied to this day.

There are several known causes of Moonquakes, which produce different signals for seismometers to measure. Scientists have determined that the lunar interior is still cooling, and as it does so the Moon contracts. The interior is also partially molten, and experiences tidal forces from the gravitational pull between the Earth and the Moon. So-called 'deep moonquakes', which occur around 700 km beneath the surface, are thought to be caused by a combination of these effects.

Meanwhile, **moonquakes at a depth of 50–220 km remain mysterious**. They may result from thermal expansion, which occurs when the Moon's crust is rotated into sunlight. Most of the Moon's surface spends about two weeks in the frigid cold of night, followed by two weeks of intense heating from the Sun. They could also be caused by occasional collapses in the walls of shallow craters, triggered by small changes in the size of the crust.

Meteorite impacts on the Moon are another cause of moonquakes, sending vibrations through the lunar interior, that can be detected by sensitive instruments.

Scientists have determined that the Moon's crust is much thinner than the Earth's crust, and that the Moon's mantle is much more rigid than the Earth's mantle. This suggests that **the Moon's interior is less active than the Earth's interior**, and that it has not undergone the same kind of tectonic activity throughout its similar lifespan.

The study of moonquakes also provides insight into the Moon's selenological history. Many of the Moon's largest quakes occur near the rims of its large impact basins, such as Mare Imbrium, Mare Serenitatis and Mare Crisium. This observation suggests that these regions are significant stress points on the lunar surface, where energy is more likely to be released. **This parallels the nature of fault lines on Earth**, which are more prone to serious tectonic quakes.

In recent years, NASA's *Lunar Reconnaissance Orbiter* (LRO) has been monitoring the Moon's seismic activity from orbit. The spacecraft's instruments have detected thousands of seismic events on the Moon, including hundreds of shallow moonquakes. Ongoing observation and analysis will help astronomers to understand the Moon's seismic behaviour in more detail, which could help future settlers on the Moon design and build safe habitats.

THE DAYS
ARE GETTING
LONGER

1.7 MILLISECONDS
PER CENTURY

The Earth is constantly in motion, rotating on its axis as it orbits the Sun, and producing our familiar cycle of day and night. But did you know that the rotation rate of the Earth is gradually slowing down? This may not be noticeable on a day-to-day basis, but, over time, the effect is significant enough that it has been measured and studied by scientists.

the Moon is moving away gradually, at a rate of about 4 cm per year

What causes the Earth's rotation rate to slow down? There may be more than one factor at play. Models of the planet's interior suggest that there is **a gravitational coupling between the core and mantle, which may be rotating at different rates**. It's possible that interactions between the two change the distribution of the Earth's angular momentum over time, though very little is known about this elusive region. According to scientists, the 2004 Indian Ocean earthquake added 2.68 microseconds (approximately one billionth of a day) to the Earth's rotation rate, so sporadic events also play a role.

One thing we can be sure of is the effect of the recession of the Moon in its orbit around the Earth. The Moon's gravitational pull causes the oceans on Earth to bulge, creating a sort of **'tug of war' between the two bodies**. Friction between the oceans and the Earth's surface results in a transfer of energy from our planet's angular momentum to the Moon's orbit. The Moon is moving away gradually, at a rate of about 4 cm per year.

While days are technically getting longer, the rate of change is extremely slow, with a difference of about 1.7 milliseconds per century. This may not sound like much, but over millions of years, it does add up. In fact, some scientists estimate that the Earth's rotation rate was once as much as 20 per cent faster than it is today.

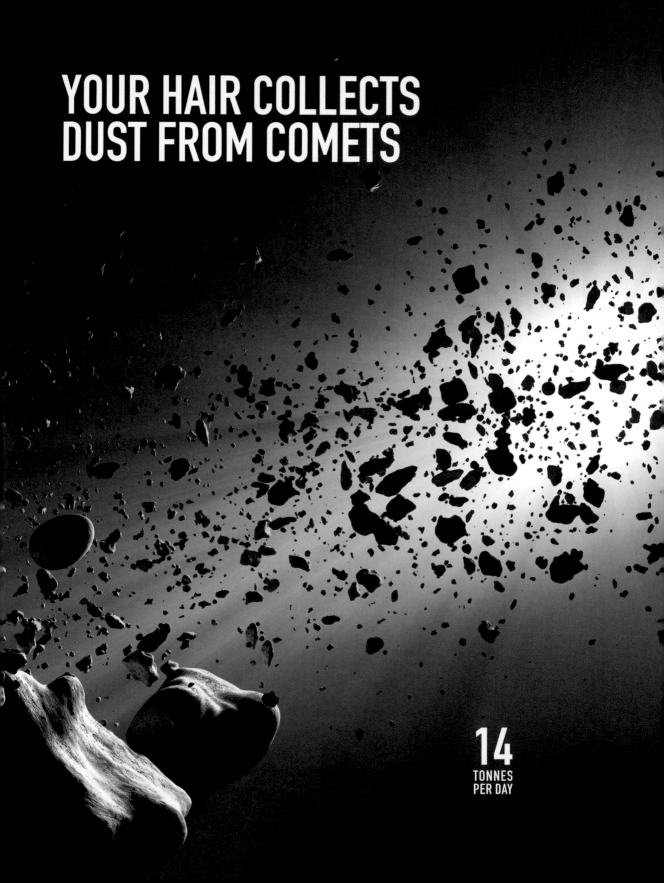

YOUR HAIR COLLECTS
DUST FROM COMETS

14
TONNES
PER DAY

Every day, several tonnes of material falls to Earth from space. Some of it is witnessed on arrival, as a bright meteor may result in a meteorite – a fragment of rock and metal crashing into the ground. But a great deal of this cosmic material doesn't make such a spectacular entrance to our planet. Rather, it falls gently through the atmosphere in the form of space dust that is all but invisible to our eyes.

every time you're outside, you stand a chance of catching some of this space dust in your hair

A surprisingly large quantity of space dust lands on our planet: about 5,200 tonnes per year, or 100 tonnes per week, or 14 tonnes per day. This dust is made up of **tiny particles of rock and metal that have been chipped off asteroids and comets,** either in large collisions or by micrometeoroids. About 80 per cent of all this dust originates from Jupiter-family comets, which have orbital periods of less than 20 years. The particles are so small – at most a few tenths of a millimetre across – that they are not generally visible to the naked eye and can only be detected using specialised instruments.

Every time you're outside, you stand a chance of catching some of this space dust in your hair, and it's very likely you've already caught some and later washed it out without knowing it. Spread out over such a large area, a gentle precipitation of cometary dust may seem insignificant, but astronomers believe it has played an important role in shaping our planet. The ice bound to some of this dust **may have delivered significant quantities of water into Earth's atmosphere** billions of years ago, and its iron content is known to fertilise phytoplankton when it falls into the oceans. These tiny creatures are crucial to our planet's biosphere, affecting the composition of the atmosphere and producing organic compounds in the ocean.

DUST GRAIN

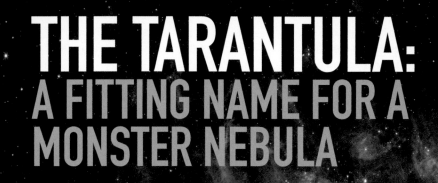

THE TARANTULA:
A FITTING NAME FOR A MONSTER NEBULA

6 5 0
LIGHT-YEARS

The Tarantula Nebula is one of the most spectacular and awe-inspiring objects in the sky. Located about 160,000 light-years away inside the Large Magellanic Cloud, a satellite galaxy of the Milky Way, it's a popular target for both stargazers in the southern hemisphere and astronomers around the world. The nebula spans a width of at least 650 light-years and it's home to several million young stars.

long, sinewy filaments of gas and dust stretching outwards from a central core

Inspired by the family of large arachnids, astronomers named the Tarantula Nebula for its spidery appearance, with long, sinewy filaments of gas and dust stretching outwards from a central core. At its heart is a dense cluster of young, massive stars known as R136. These stars, many of which are over 100 times more massive than the Sun, emit intense radiation that ionises the surrounding gas, causing it to glow in a variety of vivid colours, lending the Tarantula its remarkable appearance in photographs.

The Tarantula Nebula is home to a diverse collection of interesting objects, including supernova remnants, bright HII regions, and powerful Wolf-Rayet stars. One of the most notable findings within the Tarantula is the supernova SN 1987A, which exploded in 1987 and became visible to the naked eye. The remnant of this explosion can still be seen in the nebula today as a bright, expanding ring of gas and dust, and its progress has been scrutinised by the venerable Hubble Space Telescope (HST).

It's easy to see why this nebula has such enduring appeal. It's a treasure chest for astronomers of many disciplines, and we're fortunate to be close to it. In fact, the Tarantula Nebula is the most active star-forming region in the local group of galaxies, and it happens to be in our cosmic backyard. Its luminosity is so great, that if it were as close as the Orion Nebula, it would completely dominate the night sky and cast shadows on the ground. As spectacular as that sounds, perhaps we're lucky this monster is at arm's length, so we can get a clear look at the rest of the Universe.

As students, we learn that stars and planets are made of matter, which comprises particles. But there also exists partner 'antiparticles' which can be produced naturally in space, as well as artificially in particle accelerators. On rare occasions, these particles may bind to form antiatoms, but very little antimatter is presumed to exist. That's because antimatter and ordinary matter annihilate each other when they come into contact, and the Universe is full of ordinary matter. Yet since the 1950s, astronomers have theorised about the possible existence of stars made entirely of antimatter lurking in the Galaxy and beyond.

Antimatter stars, also known as antistars, are a theoretical class of star that appears very much like an ordinary star, but is composed entirely of antiparticles. They shine like ordinary stars, releasing radiation in the form of visible light, and many other wavelengths we can't see. But if ordinary matter touches an antimatter star, the resulting annihilation event will release a burst of a specific type of gamma ray.

Despite being a fascinating concept, there is currently **no direct evidence for the existence of antimatter stars**. However, their existence cannot be ruled out because of observations that may be attributable to them. For example, the Alpha Magnetic Spectrometer (AMS) instrument on the *International Space Station* (ISS) has made rare detections of antihelium. Since these antiatoms are very unlikely to form spontaneously in space, they could have been generated in an antimatter star. Alternatively, the antihelium may have been generated by dark matter interactions, but the models suggest this is highly unlikely.

their existence cannot be ruled out because of observations that may be attributable to them

Physicists believe that **the Big Bang should have resulted in almost equal amounts of matter and antimatter in the Universe**, but somehow antimatter is now extremely rare and ordinary matter dominates. Some scientists have proposed that there may be isolated pockets of antimatter in the Universe that could give rise to antimatter stars and possibly antimatter galaxies. These regions would need to be completely devoid of ordinary matter and shielded from contact with it, so the conditions required for the formation of antimatter stars are extremely rare. Nevertheless, the possibility that they might really exist continues to intrigue astronomers for now, and probably will do for many years to come.

THE LINGERING MYSTERY OF 'ANTIMATTER' STARS

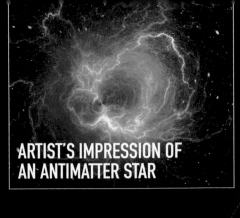

ARTIST'S IMPRESSION OF
AN ANTIMATTER STAR

Just 4.24 light-years away from the Sun, Proxima Centauri – a red dwarf star smaller and fainter than our own – is hosting its own terrestrial world. Proxima b, as it is officially known, is a small, rocky exoplanet that was discovered in August 2016 by astronomers working with the European Southern Observatory. The surprising discovery of this exoplanet has garnered much attention from astronomers and the general public alike due to its close proximity and the open question of whether or not it is habitable.

The discovery of Proxima b came after previous searches had ruled out the existence of any larger, gas-giant planets orbiting the Sun's nearest star. At about 1.07 times the mass of Earth, it orbits its host star once every 11.2 Earth days. This is a very short year, indicating that Proxima b is **much closer to its sun than we are to ours**. But since Proxima Centauri itself is a red dwarf star, much fainter and cooler than the Sun, it transpires that the distance to Proxima b is remarkably favourable for liquid water to exist there, raising the hopes that this could be a habitable exoplanet!

However, there is still much we don't know about Proxima b. Scientists are currently studying its atmosphere to determine whether it has water vapor or other molecules that could be indicative of life. They are also investigating whether the planet has a magnetic field, which is essential for protecting any potential life from harmful radiation. Unlike the Earth, Proxima b is tidally locked, which means **one side always faces the star in permanent day, and the other side experiences permanent night**. It's unclear whether a stable atmosphere could exist under such conditions, which are also susceptible to strong stellar winds and erosion.

Proxima b is remarkably favourable for liquid water to exist there, raising the hopes that this could be a habitable exoplanet

Of course, the relative closeness of this fascinating world invites us to explore it directly, perhaps with some kind of remote probe, but unfortunately the fastest spacecraft we can launch today would take many thousands of years to traverse the gulf of just a few light-years separating us from the Proxima Centauri system. We'll need a paradigm shift in space technology to enable close-up exploration of our not-so-distant neighbour.

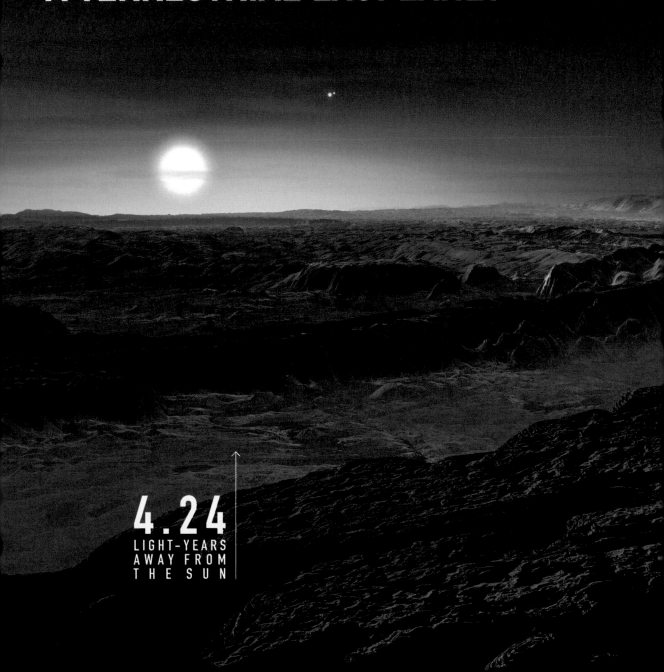

THE NEAREST STAR SYSTEM TO THE SUN HOSTS A TERRESTRIAL EXOPLANET

4.24
LIGHT-YEARS
AWAY FROM
THE SUN

We're used to Saturn's stunningly bright rings, made up of trillions of pieces of ice and rock. As a large gas-giant planet, Saturn casts a powerful gravitational influence on the environment around it and is more than capable of sweeping up material to produce an impressive ring system. The other gas giants – Jupiter, Uranus and Neptune – have ring systems, too, though none are as conspicuous as Saturn's. It stands to reason that any large planet will have a ring system, even if it's made up of dark debris, but much smaller objects aren't capable of sustaining rings. Or are they?

Chariklo is a small celestial body that orbits the Sun between Saturn and Uranus. Discovered in 1997 by James V. Scotti at the Kitt Peak National Observatory in Arizona, **Chariklo is now known to be a Centaur asteroid** – a class of asteroids that are characterised by their unstable orbits, which cross the orbits of the giant planets. It takes its name from a nymph in Greek mythology who was married to the centaur Chiron, another object in the Centaur asteroid group. It takes Chariklo almost 63 years to complete one orbit.

What makes this 250 km-wide asteroid so special is that it has a pair of rings around it, making it **the smallest known object in the Solar System with a ring system**. The rings were discovered in 2013 by a team of scientists led by Felipe Braga-Ribas from the National Observatory in Brazil during an occultation. In this event, Chariklo passed in front of a star, and the dip in the intensity of the starlight was used to measure its size and orbit. However, a sequence of unexpected smaller dips either side of the occultation revealed the presence of the rings.

The discovery of Chariklo's rings was a surprise to astronomers, who had previously thought that only giant planets could have ring systems. How could such a small world even develop rings? One hypothesis is that they were formed when Chariklo collided with another object in the distant past, and the debris from the impact – made up of particles of ice and rock – was captured by the asteroid's weak gravity. With two dwarf planets, Haumea and Quaoar, also known to have rings, **the hunt is on to find other small bodies with ring systems of their own**, and some have speculated that the asteroid Chiron may be a good place to search. All one needs is an occultation of a star and a sensitive telescope to watch it at the crucial moment.

the discovery of Chariklo's rings was a surprise to astronomers

AN ASTEROID
THAT HAS ITS OWN RINGS

250 KM WIDE

OUR NEAREST NEIGHBOURING GALAXY IS GOING TO HIT US

GALAXIES COLLIDING

The Milky Way is one of many galaxies making up the local group – a cluster within a cluster that astronomers consider to be our cosmic neighbourhood. Of dozens of galaxies within the group, it's the second largest. The number one spot is held by our nearest significant neighbour, the Andromeda Galaxy, which looms large in our sky at just 2.5 million light-years away.

it's possible that the Sun and its planets will be flung into new orbits

The Andromeda Galaxy and Milky Way are so close together that their mutual gravity is strong enough to resist the expansion of space between them. As a result, they are destined to collide! In approximately 4 billion years, our galaxy and its neighbour will meet each other for a spectacular and long-anticipated cosmic collision. However, this term could be considered a little misleading. While the galaxies will indeed 'collide', this process doesn't involve individual stars crashing into each other. Rather, the two galaxies **will effectively pass through each other and eventually merge into a single, larger galaxy**. The space between stars is much greater than the sizes of the stars themselves, so collisions will mostly be averted. But the gravitational forces involved, which **will cause a significant disturbance in the shape and structure of both galaxies**, are also likely to create chaos for star systems and nebulae.

The impact of this inevitable collision with our own Solar System is not yet clear, and we would have no way to be certain about its future. It's possible that the Sun and its planets will be flung into new orbits or even ejected from the merging galaxies entirely.

Fortunately, there is no need to panic or make plans for evacuation. While the collision of the Milky Way and the Andromeda Galaxy can't be stopped, it won't happen for billions of years, at which point the evolution of the Sun may well have already rendered the Earth uninhabitable. Our descendants, if they're still around, will probably have figured out how to relocate to safe star systems long before that time.

One thing we can say with confidence is that any astronomers in either galaxy in the distant future will be mesmerised by the approach. The Andromeda Galaxy, which is already visible to the unaided eye in dark skies, will grow in brightness and size to become the most astonishing sight. It will be a perfect opportunity to study another galaxy up close!

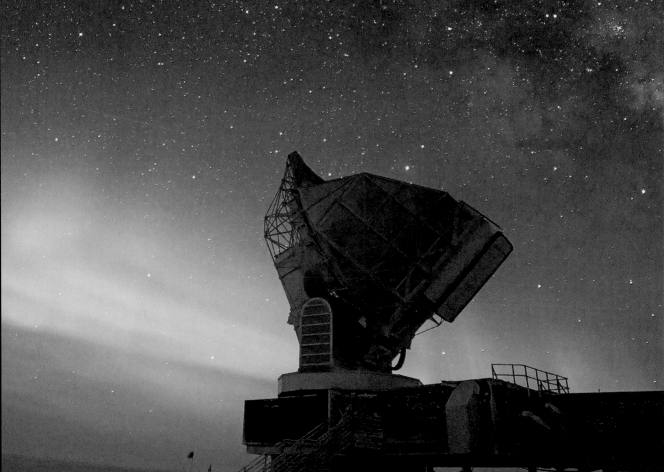

WHY BUILD A TELESCOPE AT THE SOUTH POLE?

With the development of modern cosmology, the expansion of the Universe has become a key mystery for physicists. It seemed reasonable to assume that the expansion, kickstarted by the Big Bang, would slow down due to the gravitational pull of all the matter in the cosmos trying to come back together. After all, gravity is an attractive force and it dominated on large scales. However, in the late 1990s, observations of distant supernovae revealed something surprising: the Universe's expansion isn't slowing down. It isn't even constant. It's accelerating. Today this acceleration is thought to be due to a mysterious facet of the Universe called dark energy.

Dark energy is a hypothetical form of energy that permeates all of space, but very little is known about its true nature. Rather than thinking of it as a force with its own particles and fields, astronomers consider dark energy to be a property of space itself. Its existence was first proposed in the late 1990s by astronomers Saul Perlmutter, Brian Schmidt and Adam Riess, who were awarded the 2011 Nobel Prize in Physics for their contributions to understanding it.

Clues to dark energy's nature lie in the Cosmic Microwave Background Radiation (CMBR) – the afterglow of the Big Bang that can be detected across the entire sky. While this radiation has been mapped by several spacecraft, astronomers needed to determine how the CMBR is distorted by clusters of galaxies in order to measure the influence of dark energy over long timescales. For this task, they required a telescope capable of surveying the CMBR with extreme precision, and there was one perfect place to construct it: the South Pole.

The South Pole Telescope, located at the Amundsen-Scott South Pole Station, is a radio telescope that was designed to probe dark energy. Its location was chosen due to the extremely cold and dry conditions, which allow for clear radio observations. During the polar night, the South Pole receives no sunlight at all, making the atmospheric conditions very stable, and ruling out radio interference from the Sun. The highly sensitive instruments connected to the radio antenna are used in large-scale surveys, the first of which was completed in 2011.

The data from the South Pole Telescope's initial mission is now being used to determine how dark energy may have changed over time, just like the space it is inseparable from, and the findings will steer the course of cosmology in the future. Dark energy is now known to account for about three-quarters of all the energy in the Universe, so its impact cannot be underestimated, and it's fitting that such a strange, faraway phenomenon is being studied from a place on Earth so deeply rooted in the history of human exploration.

EXOMOONS EXIST!
WHY SHOULDN'T THEY?

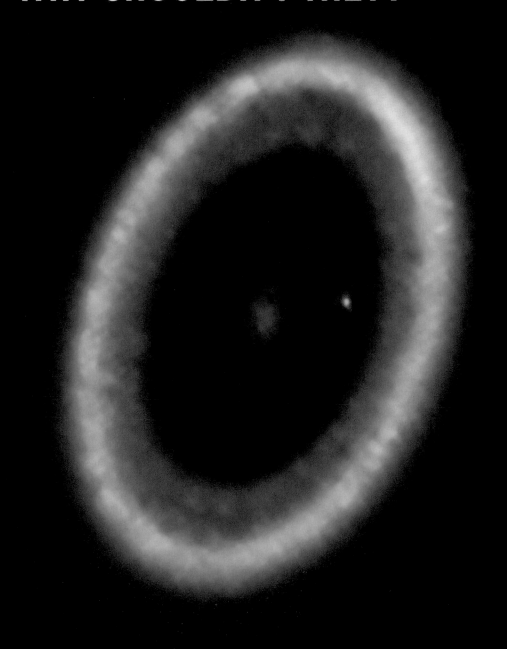

Our Solar System is home to more than 200 moons. They far outnumber the planets they orbit, and offer up a surprising variety of unanswered questions. One question concerns other planetary systems. With the recent progress in exoplanet research and the discovery of large numbers of exoplanets orbiting other stars, shouldn't we also expect to find exomoons orbiting those exoplanets? The answer is yes! Shouldn't those exomoons also outnumber exoplanets? Why not?

future exomoon discoveries could be crucial in the search for life beyond the Earth

The problem is that exoplanets are difficult enough to find on their own, and **exomoons are necessarily much smaller and harder to identify**. Nevertheless, we are now in the age of exomoons and a number of candidates have already been found. The first candidate exomoon discovery came in 2017, when astronomers, using archival data from the Kepler Space Telescope, identified a probable **Neptune-sized moon orbiting a gas-giant exoplanet** called Kepler-1625b. Independent analysis from the Hubble Space Telescope (HST) confirmed the presence of this signal in 2018. Several other candidates have been proposed, including exomoons of rogue planets drifting through the Galaxy without host stars.

In 2021, astronomers using the Atacama Large Millimetre/submillimetre Array (ALMA) in Chile, which comprises 66 radio telescopes, made an extraordinary observation, revealing a young exomoon in the process of forming around the exoplanet PDS 70c. The ALMA image shows the star, planet and moon together along with a circumstellar disk, about 370 light-years away. The star is just 5.4 million years old, and the exomoon is probably much younger.

Exomoons are of interest to scientists for several reasons. They can be used to test theories of moon formation, profile the rarity of different types of natural satellite and, most promisingly, **extend the number of possible habitats in the Galaxy**. Astronomers suspect several of the moons in our own Solar System could be stable habitats for lifeforms of some kind, and perhaps there are more habitable moons than planets. If so, future exomoon discoveries could be crucial in the search for life beyond the Earth!

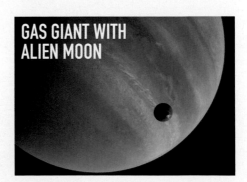

GAS GIANT WITH ALIEN MOON

IS EMPTY SPACE REALLY EMPTY?

We tend to imagine space as a void, vast and empty – a vacuum where, for the most part, nothing is happening. But the reality is quite different. Even 'empty' space is a dynamic domain, with a surprising amount of activity and energy. Galaxies are formed from ensembles of stars and nebulae, but there also exists an interstellar medium of unseen gas and dust that is typically only detected when it absorbs light. Similarly, the voids between galaxies often contain gas, which makes up the intergalactic medium, and these regions may also be filled with faint streams of stars running like rivers between one galaxy and its neighbour.

empty space is actually filled with a sea of 'virtual particles'

But what about *really* empty space? Even in the largest voids in the Universe, there are particles flying around. So-called cosmic rays, high-energy particles that travel through space at close to the speed of light, have been detected. When they collide with atoms in the Earth's atmosphere, they can create **a cascade of secondary particles** that can be measured by instruments on the ground. They're everywhere and are thought to originate from a variety of sources, including supernovae, black holes and other energetic events in the Universe.

Still, there must be some places where cosmic rays rarely pass you by. That's probably the case, but even there, particles come and go. The vacuum of space is constantly challenged by the presence of quantum fluctuations. According to quantum mechanics, empty space is actually filled with a sea of 'virtual particles' that constantly pop in and out of existence. They form in **particle-antiparticle pairs for an extremely brief moment before annihilating each other**. These fluctuations may seem insignificant, operating on such short timescales and involving very little energy, but when the Universe was much smaller than it is today, quantum fluctuations directed its evolution.

Astronomers have carefully measured the energy density of the Universe and determined that, spread evenly, ordinary matter would have a density of one atom for every three cubic metres of space. That is a very, very low density! Of course, matter is not spread evenly, but lumps together where we have galaxies and stars. Yet, this matter is just one small part of the energy in the Universe, which truly can be found everywhere. There's no such thing as empty space!

In 1977 astronomer Jerry R. Ehman was working at the Big Ear radio telescope in Ohio, observing as part of the Search for Extra-terrestrial Intelligence (SETI) project. On an otherwise uneventful night, he suddenly became aware of an unusual signal being received by the telescope, which lasted for 72 seconds and seemed to come from a point in space near the constellation Sagittarius. It was so remarkable that Ehman wrote 'Wow!' on the printout of the data, and the observation then became known as the 'Wow! signal'.

The Wow! signal was **unlike anything detected before or since**. It had a frequency of 1420.4556 MHz, which is close to the frequency of the hydrogen line, emitted by the most common element in the Universe. However, the measured frequency is 50 kHz above the hydrogen line, suggesting a blueshift from a source moving at a speed of 10 km/s in the direction of the Earth. It covered a narrow bandwidth of less than 10 kHz, which indicated that it came from an astronomical source rather than an object in the atmosphere, or even a satellite, and, furthermore, it was very strong, much more so than the background noise that is usually detected by radio telescopes.

So what could the origin of the Wow! signal be? It's not clear, and it leaves the door open for some very interesting speculation.

Initially, some scientists thought the detection may have been caused by a satellite and one hypothesis later suggested that two known comets played a role. But these ideas were ruled out, leaving nothing but guesses on the table. Naturally, **many were attracted to the idea of extra-terrestrial intelligence** and would wish to attribute the Wow! signal to an alien civilisation, but, with no repeat observation, scientists are generally more sceptical. As exciting as such a finding would be, a single observation does not provide enough confidence to be sure.

perhaps a strange, very long burst of radio waves was released from an exploding star or a black hole

The lack of a second detection favours the possibility of a one-off, natural event of, as yet, unexplained characteristics. Perhaps a strange, very long burst of radio waves was released from an exploding star or a black hole, or some interaction between two extreme objects. Either way, the signal certainly inspired a great deal of interest in the hunt for extra-terrestrial intelligence, which continues to this day.

WOW!
WHAT WAS THAT?

The Hubble Space Telescope (HST) was launched into low Earth orbit in 1990 and remains in operation to this day, more than three decades later. Named after the astronomer Edwin Hubble, who is known for his discovery of the expansion of the Universe in the 1920s, it has made countless groundbreaking observations and created a remarkable legacy as one of the great marvels of astronomical science.

The proposal for a space telescope dates back to Hubble's own lifetime in 1923, but construction of the Hubble Space Telescope didn't begin until the 1970s, and was based on a design concept first introduced in 1946 by Lyman Spitzer Jr. The telescope was designed to be placed in low Earth orbit, where it would be **free from the distortions caused by Earth's atmosphere**, to peer at a crystal-clear view of the cosmos. This would allow it to observe the Universe in unprecedented detail.

Originally intended to launch in 1983, Hubble finally journeyed to space on 24 April 1990, on board the Space Shuttle *Discovery*. However, its honeymoon in orbit wasn't particularly rosy. Shortly after its launch, astronomers discovered that the telescope's main mirror contained a tiny flaw. The flaw introduced multiple optical aberrations that resulted in blurry images. This agonising realisation followed a painful teething period, during which Hubble suffered communication dropouts and drift in its tracking cameras, which prevented it from pointing accurately to take deep images. Engineers scrambled to fix the new instrument's problems, but it wouldn't be until a few years later, in 1993, that a mission to correct Hubble's vision could be attempted.

Fortunately, a corrector package installed by astronauts on board the Space Shuttle *Endeavour* gave Hubble a sharp new impression of the Universe, and, since its repair, the telescope has dazzled scientists and the public alike with its stunning images of the cosmos. Hubble has been used in virtually every area of astronomical research. It has provided insights into the lives of extreme objects like black holes and neutron stars, peered into stellar nurseries where young stars are just beginning their lives, revealed some of the earliest stars and galaxies, and even helped to determine the age of the Universe.

Hubble's powerful suite of instruments allows it to image a wide range of wavelengths in superb detail, providing astronomers with **the tools and data they need to advance our understanding**. But a large part of its legacy has been contributions to public engagement. Hubble images are iconic, instantly recognisable and often breathtaking. They have permeated popular culture and influenced the arts, bringing the Universe within reach of the general public and fuelling excitement for astronomical science. The Hubble Space Telescope will long be remembered as a **beloved icon of exploration and discovery**.

HUBBLE

THE HUBBLE SPACE TELESCOPE: A POWERFUL PIONEER

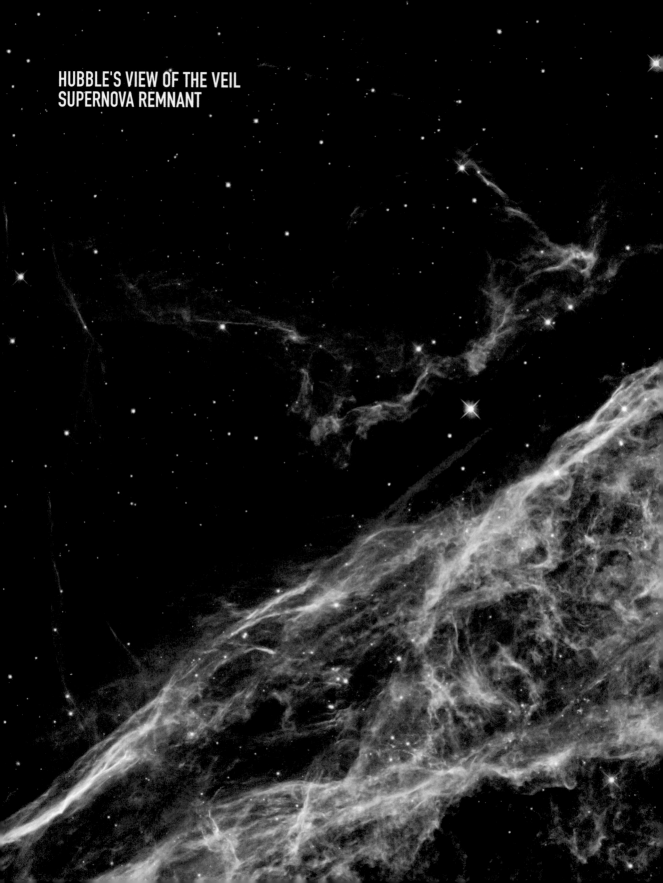

HUBBLE'S VIEW OF THE VEIL
SUPERNOVA REMNANT

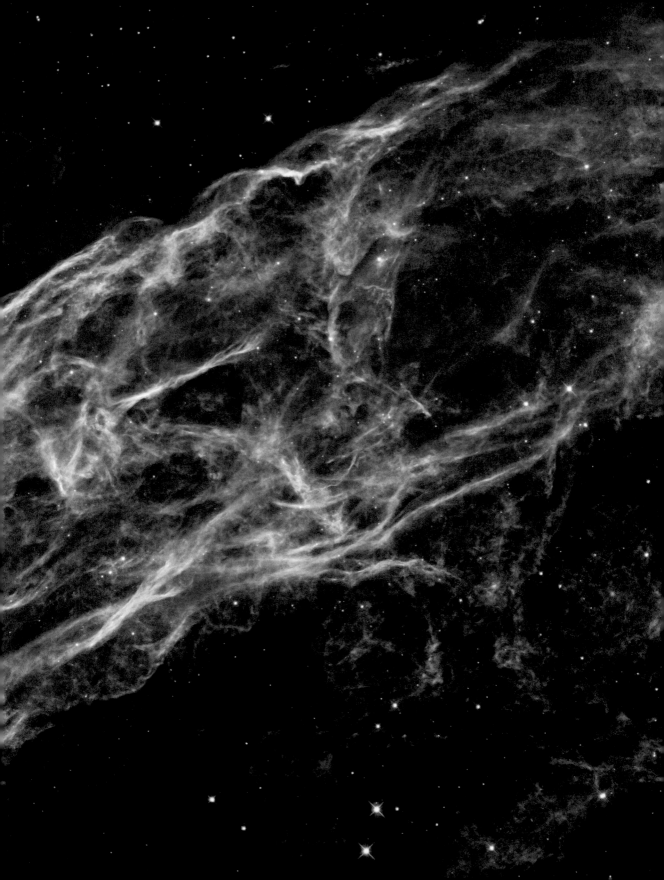

THIS IS STEVE

450 KM

For many years, aurora-chasers would occasionally report sightings of what they believed were proton auroras. Prominent, so-called 'proton arcs' had been sighted and photographed on nights with active auroras, aligned east–west and isolated from the main display. They appeared virtually colourless or faintly pink, stretching for hundreds or thousands of miles across the sky.

STEVE may result from powerful geomagnetic substorms

In 2016, Professor Eric Donovan at the University of Calgary compared various citizen science reports of suspected proton arcs to data from the ESA's *Swarm* satellite constellation, which uses three spacecraft in two different orbits to investigate the Earth's magnetic field. When passing through this strange phenomenon, *Swarm* measured huge temperature surges hundreds of kilometres above the Earth's surface, effectively discovering – in a scientific sense – something that had already been seen thousands of times before, discerning its true nature.

The unusual bands were determined to be **25-km-wide ribbons of hot plasma** at an altitude of about 450 km – much higher than typical auroras. In an effort to give something unknown a mundane name, aurora-watchers agreed upon the new moniker, STEVE. A backronym followed: **Strong Thermal Emission Velocity Enhancement**. It reflects the extreme nature of STEVE, being hot and very fast moving.

More recent research suggests that STEVE may result from powerful geomagnetic substorms, and occurs due to an influx of hot, high-speed particles that reach farther south (or north in the southern hemisphere) in what is known as a sub-auroral ion drift. STEVE's high-altitude arc is not associated with the electron flux that generates typical auroras, so it is categorised as a separate phenomenon.

STEVE is also often accompanied by green 'picket fence' auroras at lower altitude beneath the arc. As with STEVE itself, these appear outside the auroral oval and are also categorised separately from other, more common forms of auroras, even though **they arise from precipitation of electrons through the atmosphere** and shine with a familiar colour. STEVE and the associated picket fence auroras usually appear over both hemispheres simultaneously, but sightings are still rare. If you see them, consider yourself lucky!

STRANGE CRYOVOLCANOES ERUPT ACROSS THE SOLAR SYSTEM

Cryovolcanoes, also known as ice volcanoes, are an otherworldly type of volcano that erupt water, ammonia or methane instead of molten rock. They are found on icy bodies throughout the Solar System, including on moons like Enceladus at Saturn, Europa at Jupiter, and Triton at Neptune, as well as dwarf planets like Pluto.

Cryovolcanoes form in much the same way as traditional volcanoes, through a build-up of pressure beneath the surface. Tidal forces could be a factor in melting ices to fuel cryovolcanism. When the pressure becomes too great, the cold material is ejected through a vent, forming a plume of gas and volatile ices that can reach high into the sky. In many cases, the ejecta escapes the world's low gravity and travels into the Solar System.

Enceladus, a moon of Saturn, is well known for its cryovolcanism. The plumes of water and ice that erupt from its cryovolcanoes have been studied extensively by NASA's *Cassini* spacecraft, which revealed a subsurface ocean beneath the moon's icy crust. Another of Saturn's moons, Titan, is home to the mighty Doom Mons (Mount Doom) which has several identified cryovolcanic calderas.

cryovolcanic worlds are of key interest in the search for extra-terrestrial life

Cryovolcanoes indicate subsurface activity and heating, as well as transport of subsurface material through the crust. These are cornerstones of potential habitability, so cryovolcanic worlds are of key interest in the search for extra-terrestrial life.

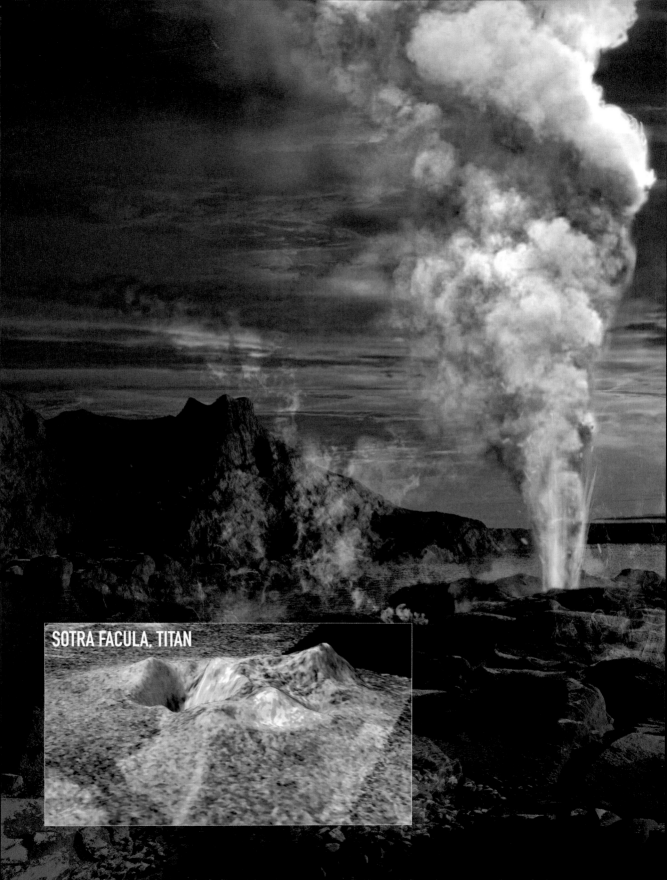

SOTRA FACULA, TITAN

The lowest temperature recorded on Earth was measured at -89.2 °C in the middle of winter in Antarctica. That's staggeringly cold, but compared to some other worlds, it would feel quite toasty. Temperatures on the night side of the Moon, for example, can plummet to around -180 °C. There's no atmosphere to distribute heat there. In 2015, the instruments on board the *New Horizons* spacecraft confirmed that Pluto, which does have an atmosphere, is so far from the Sun that its lows can reach -233 °C!

Still, even this is warm compared to the temperature of space itself. If you were to travel to the most remote corner of the Universe you could find, far from any galaxy in a large cosmic void, you would register nothing but the background temperature of space. Astronomers often use Kelvin as a measurement of temperature. It's defined thermodynamically, such that the lowest point of the Kelvin scale – absolute zero – is **the temperature at which nearly all molecular processes come to a halt**. The interactions necessary for chemistry are impossible at this theoretical temperature, and so nothing complex can happen. This temperature has been calculated to correspond to -273.15 °C. Space itself is slightly warmer than absolute zero, with a background temperature of 2.73 Kelvin or -270.42 °C. It's permeated by the Cosmic Microwave Background

Radiation (CMBR) – the afterglow of the Big Bang. The CMBR is found everywhere in the Universe, and **was once much hotter than it is today**. Spread out over an ever-expanding volume, it has cooled substantially. Space, then, is really cold. But even space doesn't hold the low temperature record.

space itself is slightly warmer than absolute zero

The coldest place in the Universe, as far as we know, is **actually here on Earth**! That's because scientists trying to study the dynamics of supercool atoms have strived to create conditions very close to absolute zero. Researchers at the Massachusetts Institute of Technology (MIT) have successfully cooled sodium gas to a temperature below one nanokelvin. The sodium atoms reached a temperature of about one half of a billionth of a degree above absolute zero, when they were subjected to a special combination of gravitational forces and magnetic fields. The atoms must be shielded from the rest of the Universe itself, which is far too warm to allow close study of such extraordinary conditions. When nowhere in space is cold enough, scientists have to take measures into their own hands.

THE COLDEST PLACE
IN THE UNIVERSE
IS CLOSER THAN
YOU THINK

NASA'S COLD ATOM LABORATORY CHIP

ASTEROIDS
CAN HAVE THEIR OWN MOONS

Ida and Dactyl are a pair of space rocks that captured the world's attention thanks to a striking discovery by NASA's *Galileo* spacecraft, which was first announced in 1994. During a flyby of asteroid Ida in 1993, *Galileo*'s cameras spotted Dactyl, a much smaller 'moon' that orbits Ida. This pair provided the first observational evidence that asteroids can have their own natural satellites.

the mere discovery of Dactyl settled a long-standing debate in astronomy

Ida is located in the asteroid belt between Mars and Jupiter. It's relatively large with an average diameter of 31.4 km. It was first discovered in 1884 and, a century later, it was identified as an object of interest for the upcoming *Galileo* mission to visit on its way to Jupiter. Like most asteroids, Ida has a rocky surface pockmarked with many impact craters, and is believed to be composed of a mixture of rock and metal.

Dactyl is a tiny moon that measures just 1.4 km in diameter. It too is irregularly shaped, though somewhat rounder than its neighbour, and it also has a heavily cratered surface. Dactyl orbits Ida at an average distance of approximately 108 km, and it takes around 1.5 days to complete one orbit. Dactyl takes its name from a race of Greek mythological beings called dactyls, who were said to inhabit Mount Ida – the 'Mountain of the Goddess'.

There are two competing hypotheses describing how Ida, which is far smaller than any planet, ended up with its own moon. It could be that the two formed together in the early history of the Solar System, and their close proximity resulted in a stable two-body system. Alternatively, a collision between Ida and another asteroid may have resulted in a ring of material that gradually coalesced to become Dactyl. This scenario would mirror the formation of our Moon, but on a much smaller scale. Not enough is currently known about Ida and Dactyl to determine whether either of these proposals is correct, but the mere discovery of Dactyl settled a long-standing debate in astronomy about whether such moons could exist.

GRAVITATIONAL DEAD ZONES ARE PERFECT FOR SPACE OBSERVATORIES

THE FIVE LAGRANGE POINTS

Any pair of massive bodies, such as a star and planet or planet and moon, will produce five gravitational dead zones. The Earth and the Sun generate them, and they are called Lagrange points after mathematician Joseph-Louis Lagrange. These strange points, also known as libration points, are regions of space where the gravitational forces of two co-orbiting celestial bodies are balanced with centrifugal forces. Lagrange points have become significant to space-based astronomy because they allow for the stable positioning of space observatories with only a few orbit corrections required.

The first three Lagrange points are located along the line that connects the Earth and the Sun. L1, the first Lagrange point, is located approximately 1.5 million kilometres from the Earth, directly between the Earth and the Sun. At L1, the gravitational pull of the Sun and the Earth are balanced out, **allowing spacecraft to remain in a stable orbit with the Earth** while still maintaining a direct line of sight with the Sun. The European Space Agency (ESA)/NASA Solar and Heliospheric Observatory (SOHO) is stationed here.

L2, the second Lagrange point, is located on the opposite side of the Earth from the Sun, also approximately 1.5 million kilometres from the Earth. L2 is ideal for making observations of the Universe, facing away from the Sun. NASA's Wilkinson Microwave Anisotropy Probe (WMA) and ESA's Planck satellite both mapped the Cosmic Microwave Background Radiation (CMBR) from this region. The NASA/ESA James Webb Space Telescope (JWST) is now stationed here, where it enjoys a clear view of the cosmos.

L3, the third Lagrange point, is located on the opposite side of the Sun from the Earth, approximately 300 million kilometres away. It has been proposed that **spacecraft could be deployed here in order to monitor the far side of the Sun** in detail, but no mission has been attempted yet.

The remaining two Lagrange points, L4 and L5, are located approximately 60 degrees ahead of and behind the Earth, respectively, in its orbit around the Sun. These points are sometimes referred to as Trojan points as they are home to Trojan asteroids, which share their orbits with the Earth, either leading or trailing us. Several spacecraft have passed near L4 and L5, but none are stationed there. ESA's *Vigil* mission, scheduled to launch in 2029, may become the first to be stationed at L5, to watch for solar flares that could affect our spaceweather.

The discovery and exploitation of Lagrange points has enabled cost-effective missions that have been transformative to astronomy. Even though they're esoteric in nature and quite difficult to imagine, their use is a **testament to ingenuity of space mission designers and engineers**, whose efforts are helping astronomers unlock the mysteries of the Universe.

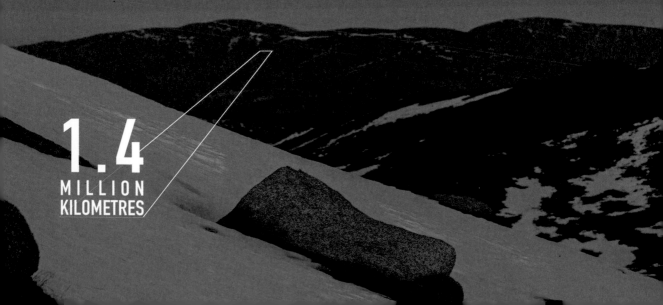

1.4
MILLION
KILOMETRES

THE EARTH CASTS A LONG SHADOW

At sunset on a clear evening, look to the east instead of the west. Those around you might think you're missing out, turning your back on the beautiful colours of the western sky, but due east just after the Sun goes down, you can witness the gorgeous pink hue of the so-called Belt of Venus.

a distinctly dark blue band that touches the horizon

This atmospheric phenomenon is caused by the red light of sunset scattering back off the blue sky in the east and mixing to produce a pink or violet band. Beneath the Belt of Venus is a distinctly dark blue band that touches the horizon. This is the shadow of the Earth itself being cast onto its own atmosphere.

The Earth's shadow reaches out into space and it's been a subject of curiosity for thousands of years. During lunar eclipses, the Moon passes partially or entirely into the shadow of the Earth, which darkens its surface. In fact, **lunar eclipses provided an early insight into the shape and size of the Earth**, as well as the distance to the Moon.

In the modern world, we have extremely accurate measurements of the geometry of the Solar System. We understand the size and scale of the Sun relative to the Earth, and we can calculate the length of the umbra or dark shadow that tapers to a point behind the Earth. So how far does the Earth's shadow reach? The umbral length is about 1.4 million kilometres, reaching almost as far as the L2 Lagrange point where the James Webb Space Telescope (JWST) is stationed. This telescope would certainly benefit from being within the shadow, since **it must keep its instruments very cool to function properly**. However, the JWST's orbit at L2 would be too large to be covered by the Earth's shadow, even if it did reach far enough, so it requires a sophisticated sunshield to shade itself.

Saturn's rings are undeniably one of the wonders of the Solar System. Everyone can picture them. Less well-known, but equally unique, is the planet's extraordinary hexagonal polar vortex. This distinctly six-sided jet stream, located at the planet's north pole, has captured the attention and curiosity of planetary scientists for decades. To this day, it remains a perplexing feature that only appears on Saturn.

The hexagonal polar vortex was first observed by the *Voyager* spacecraft in 1981, but it wasn't until 1987 that it was formally discovered by David Godfrey, who analysed images from the flyby. In 2006, it became a subject of exploration for the *Cassini* spacecraft, which provided much more detailed views. The hexagon measures approximately 30,000 km in diameter, with straight edges about 14,500 km in length – **larger than planet Earth**. It is a high-speed jet stream, with wind speeds exceeding 300 km/h, and remains remarkably stable despite the turbulent nature of the atmosphere around it.

Also intriguing to scientists is its long-term consistency in shape and size. While many other storms have been seen to come and go in the Saturnian atmosphere, **the hexagon may have persisted for much longer than the decades it has been known about**. Curiously, between 2012 and 2016, observations from *Cassini* revealed that the hexagon changed colour, from a mostly blueish tone to a golden brown. This has been attributed to the presence of haze that forms over the hexagon as the seasons change.

Astronomers have proposed several explanations for the hexagonal polar vortex, but none have verified conclusively. One proposal suggests that the hexagon is caused by the interaction between the planet's rotation and its atmosphere, which creates a standing wave that generates the six-sided shape, but atmospheric physics is complex. Perhaps turbulent flow caused by variations in atmospheric density is the cause. Laboratory simulations have created polygonal shapes – particularly hexagons – when mixing two rotating fluids of different densities.

Even though the exact cause is not known, the hexagonal polar vortex has become a fascinating feature, that is now **frequently captured by amateur astronomers using their own telescopes**. It is one of the many open questions about Saturn that fuels the demand for a follow-up to the *Cassini* mission.

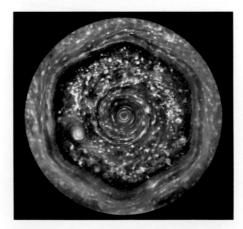

A BIZARRE HEXAGONAL POLAR VORTEX SURROUNDS SATURN'S NORTH POLE

PLANETARY NEBULAE:
SNOWFLAKES IN SPACE

Planetary nebulae are formed when a low mass star like the Sun reaches the end of its life and expels its outer layers into space. The remaining core of the star, which evolves into a white dwarf, illuminates the ejected material, creating a beautiful and intricate display of light and colour. When they were discovered, they reminded astronomers of planets, which led to an awkward name that is still used today, despite the fact that these nebulae have nothing to do with planets.

Planetary nebulae form gently and steadily. They often show pleasing symmetry, as they spiral outwards, shaped by the dying star's rotating magnetic field. As with snowflakes, **no two planetary nebulae are exactly alike**, even though they are highly ordered when compared to the remnants of exploded stars. Some are seemingly perfectly spherical, while others are more elliptical or even bipolar, with two distinct lobes. Still others have intricate patterns of loops, filaments and jets, and these features provide ample opportunities for astronomers to study the dynamics of chemically enriched gases in space.

Another similarity between planetary nebulae and snowflakes is their fleeting nature. On the timescales of stars, planetary nebulae disappear in the blink of an eye. They persist for a few tens or hundreds of thousands of years, before dissipating to obscurity, lending them a certain preciousness among deep-space objects. This is only enhanced by the role they play in enriching the Galaxy. Planetary nebulae contain a wide variety of elements that are fused by the star and cast out into space. **These expanding clouds add chemical variety to the Galaxy**, so future star systems will contain richer material from which to form potentially habitable planets and moons.

they spiral outwards, shaped by the dying star's rotating magnetic field

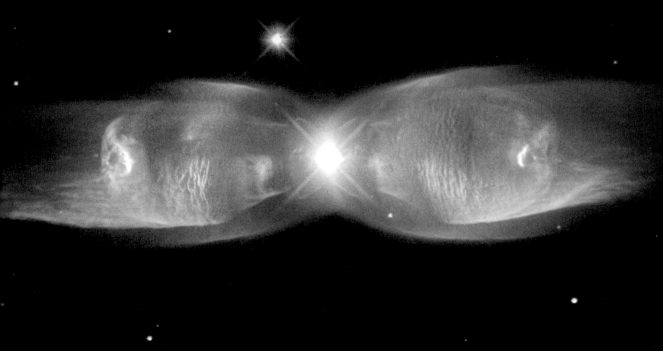

TWIN JET NEBULA

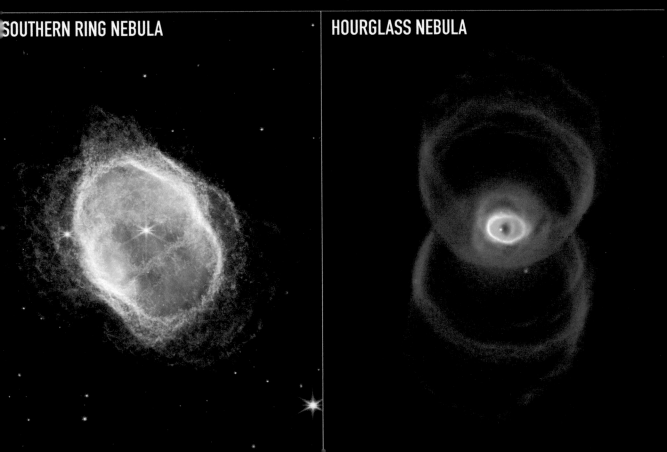

SOUTHERN RING NEBULA

HOURGLASS NEBULA

ABOUT 15,000 KM

JUPITER'S GREAT RED SPOT IS SHRINKING

First observed in the early nineteenth century, Jupiter's prominent Great Red Spot has long been considered one of the wonders of the Solar System. Its age is unknown, but recent changes suggest that it won't be around forever. While it has been observed to vary in size, shape and colour over many decades, it is now shrinking at a rate never seen before.

there is a persistent redness that hasn't been fully explained

The Great Red Spot is **an anticyclonic storm – the largest known on any planet** – that sits in Jupiter's southern equatorial belt. Its origins are mysterious, but the spot has been observed by several spacecraft and studied in detail as a proxy for understanding the complex systems that drive Jupiter's weather. Strangely, despite being its most obvious characteristic, the red colour is quite mysterious. The storm changes colour, particularly when it is covered by high-altitude mist, but there is a persistent redness that hasn't been fully explained. It is probably due to a combination of compounds, which vary in abundance, causing changes to the hue.

Astronomers used to say that the storm was about three times wider than planet Earth. In the early twentieth century, it was estimated to have a diameter of about 40,000 km. But by the turn of the twenty-first century it was known to be closer to 20,000 km wide and at the time of publication it's about 15,000 km. Some astronomers are worried that the spot could disappear altogether before the end of this century, depriving us of one of the Solar System's highlights, but others suspect that the storm is resilient, and simply oscillates in size over its long life. Either way, it's worth taking a look yourself. **The Great Red Spot can easily be admired in small telescopes**, even if it is a little less conspicuous than it used to be.

Look up on a dark night and you'll spot a few shooting stars every hour. Head out during the peak of a meteor shower and you'll see many more. These bright streaks delight us as they flash across the sky, but they can also provide insights into the chemistry of comets and asteroids.

Meteors appear when the Earth slams into unsuspecting flecks of ice and rock drifting around the Sun. They immediately find themselves moving through the atmosphere at hypersonic speeds and the air in front of them can't get out of the way quickly enough. This generates ram pressure, which superheats the air. The air in turn transfers heat to the meteoroid, causing it to vaporise in a flash.

Look carefully when you spot a bright meteor and you may notice some vibrant colour. You can even, on occasion, spot **several different colours as the meteor progresses**. The brightest, most dazzling meteors, known as fireballs, are more likely to show you these colours as they burn for longer.

The colours are associated with different elements, forming compounds trapped in the ice or rock. The compounds are raised to well beyond their burning temperatures and the elements give off varying colours of light. Magnesium shines blue-white or cyan; calcium looks violet; sodium is orange; iron glows yellow-white; nitrogen and oxygen produce distinct reds.

meteors appear when the Earth slams into unsuspecting flecks of ice and rock

Annual meteor showers are associated with the tails of particular comets and each has a unique chemical makeup. When a new meteor shower appears, **the colours of the meteors offer insights into the chemistry of the parent body**, providing an avenue for studying comets long after they leave the inner Solar System behind.

SHOOTING STARS
BLAZE WITH COLOUR

REDSHIFT AND BLUESHIFT: HOW VELOCITY CHANGES YOUR COLOUR

We're used to experiencing the Doppler effect in our everyday lives. An ambulance rushing by with its sirens on illustrates the effect vividly. The pitch of a sound wave is related to its frequency and, in a similar way, so is the colour of a light wave. Higher frequencies of light are closer to the blue end of the spectrum, whereas lower frequencies are closer to the red end. Redshift and blueshift are terms used in astronomy to describe the phenomenon of light being shifted towards either the red or blue end of the electromagnetic spectrum. This shift demonstrates that the Doppler effect also applies to light waves from moving sources.

When an object emitting light is **moving away from the observer, the wavelength of the light appears to increase**, causing the light to shift towards the red end of the spectrum. The resulting redshift causes the entire source to appear redder. The shift can be measured precisely using spectroscopy. When light from a natural source is split into its component colours, some will be missing and others will be more intense. The missing colours create absorption lines, which are visible on the spectrum as gaps. If a source emits certain colours of light, these will appear as bright bands on the spectrum called emission lines. Astronomers look for known absorption and emission lines, measure their frequencies and then compare them to the frequency from a stationary source. The frequency shift can be used to calculate the redshift, which provides a ratio of the speed of the source to the speed of light. Through this measurement, the velocity of a distant galaxy can be calculated and from that we can determine its approximate distance.

When an object emitting light is moving towards the observer, the wavelength of the light appears to decrease and the frequency increases, **causing the light to shift towards the blue end of the spectrum**. Likewise, absorption and emission lines are increased in frequency by the time the light reaches us. This is known as blueshift. Only a few galaxies in the Universe are blueshifted, including our neighbouring Andromeda Galaxy, which is on a collision course with the Milky Way.

Sometimes, combined measurements of redshift and blueshift give us astrophysical insights. For example, the rotation of the Sun at various latitudes can be calculated by measuring the redshift of the leading edge and the blueshift of the trailing edge. When looking to other stars, sometimes we can detect a cyclical redshift to blueshift and back again. This 'wobble' in the position of the star is caused by the presence of one or more exoplanets orbiting around it and displacing its position. Modern astronomical spectrographs are so sensitive, that **they can detect the motion of a star to a precision of less than one metre per second** – the speed of a person walking slowly!

THE HYDROGEN SKY

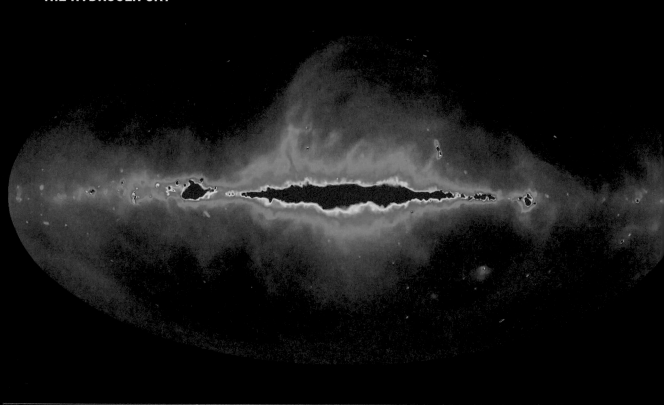

RADIO TELESCOPES

VOYAGER GOLDEN RECORD

UNDERSTANDING THE HYDROGEN LINE

The hydrogen line, also known as the 21-centimetre line, is an important concept in astronomy. It refers to a specific wavelength of electromagnetic radiation emitted by neutral hydrogen atoms in interstellar space. The radiation is released when a ground-state hydrogen electron undergoes a rare change of state called a spin-flip transition. Hydrogen is the most abundant element in the Universe and, even though the spontaneous spin-flip transition is rare, the sheer amount of hydrogen in free space results in a constant chorus of microwave radiation across the cosmos.

used to study the structure and motion of parts of the Galaxy that are hard to see

The wavelength of the hydrogen line is 21.11 centimetres, which corresponds to a frequency of 1420.406 MHz. Conveniently, this radiation can pass through dust clouds, which often obscure other wavelengths of light. Therefore, the hydrogen line is often used to study the structure and motion of parts of the Galaxy that are hard to see. By studying redshift and blueshift, the hydrogen line has been **used to calculate the rotation of the Milky Way** and its spiral arms. It is also employed to make indirect measurements of the masses of other galaxies. The hydrogen line was first observed in 1951, early in the history of radio astronomy. Fittingly, it has become a cornerstone in the very same field.

Perhaps the most important application of the hydrogen line is in cosmology. Early in the Universe's evolution, during a period known as the Dark Ages, neutral hydrogen flooded space and there were no stars or galaxies. Thus, studies of highly redshifted hydrogen-line radiation provide opportunities to directly observe this enigmatic period of cosmic history.

Some scientists have suggested that the hydrogen line frequency, or a multiple of it, should be a **high priority in the Search for Extra-terrestrial Intelligence (SETI)**. Knowledge of the line would indeed require technological prowess and it could serve as the basis for an extra-terrestrial broadcast frequency. NASA's *Pioneer* and *Voyager* probes carry plaques which include a description of the hydrogen line. Should any extra-terrestrials recover them, they would recognise our intelligence, just as we would recognise theirs.

The sky is filled with cold microwaves called the Cosmic Microwave Background Radiation (CMBR). They were emitted at much higher frequencies when the Universe was a tiny fraction of its current age. The CMBR was the first radiation to permeate the Universe after it became transparent, about 379,000 years after the Big Bang. Prior to this time, free protons and electrons were flying everywhere with tremendous energy, absorbing and re-emitting radiation. After 379,000 years, the expanding Universe cooled sufficiently for these electrons and protons to pair up and form neutral hydrogen atoms – an event called recombination.

So began the Dark Ages – a period of about 400 million years during which nothing shone. Across the Dark Ages, the Universe cooled down from about 4,000 to 60 Kelvin. For hundreds of millions of years, **only two sources of radiation travelled through space**. The first is the CMBR, and the second was 21-cm radiation produced by neutral hydrogen atoms at the so-called hydrogen line. With no stars or galaxies present at this time, astronomers are very limited when it comes to observing the Dark Ages. Fortunately, both the CMBR and hydrogen line have provided an avenue to profiling this patchy chapter in the cosmological story.

It's theorised that, about 150 million years into the Dark Ages, the large-scale structure of the Universe started to take shape. Dark matter formed a cosmic web, which drew in surrounding gas, increasing its density and temperature. The Dark Ages began to end as the **first generation of stars were born in giant primordial galaxies** and, slowly but surely, the lights came on. The illumination of the Universe occurred gradually and the ending of the Dark Ages is quite poorly understood.

the Universe cooled down from about 4,000 to 60 Kelvin

The answers to what happened here rely upon precise observations of extremely faint, high-redshift galaxies and stars. Every generation of telescopes improves our ability to look back and the James Webb Space Telescope (JWST) has been designed specifically to detect primordial objects as one of its key science goals. In the decades that follow, our picture of the Dark Ages is set to become much brighter.

WHAT HAPPENED DURING
THE DARK AGES?

ABOUT
400
MILLION
YEARS

URANUS AND NEPTUNE MAY HAVE SWITCHED PLACES

Astronomers have long been puzzled by how the planets in the Solar System formed and stabilised in the orbits they inhabit today. The outermost planets, Uranus and Neptune, are often referred to as the ice giants because they are primarily composed of water, ammonia and methane ice. Some simulations suggest that, early in their history, they effectively changed places, meaning Uranus might once have been the last planet in the Solar System, but it gave the role to Neptune.

An advanced model of the young Solar System's dynamics, called the Nice model, has been developed and refined since its inception in 2005. There are no direct ways to observe this period of the Solar System's history, so astronomers must run simulations and see how well they match up with indirect sources of evidence that are present today.

In the Nice model, **the giant planets formed closer to the Sun** and then migrated outwards to their present orbits as the protoplanetary disk dissipated. The migration hypothesis explains many aspects of the Solar System's present arrangement, as well as major events like the Late Heavy Bombardment, which formed most of the Moon's large impact basins.

There are many variations of the Nice model, which has been run multiple times to generate statistics about the likelihood of certain scenarios.

Curiously, a significant number of simulations show Uranus and Neptune switching places as they both migrate away from the Sun. It's possible that Uranus was originally the outermost planet. While this hypothesis is speculative, **it could explain one puzzling mystery surrounding Uranus** – that the entire planetary system is tilted on its side. Uranus, along with its collection of rings and moons, has an axial tilt of 98 degrees. Models show that if Uranus once had a dense ring system, it may have wobbled towards a tilt of up to 70 degrees. It may also have been struck by other objects as a result of migration, taking it all the way to 98 degrees. Alternatively, impacts played a much greater role. The intriguing mystery is **unlikely to be solved any time soon**, but one of several proposed missions to Uranus may one day be greenlit, providing new insights into the planet's enigmatic past.

migrated outwards to their present orbits

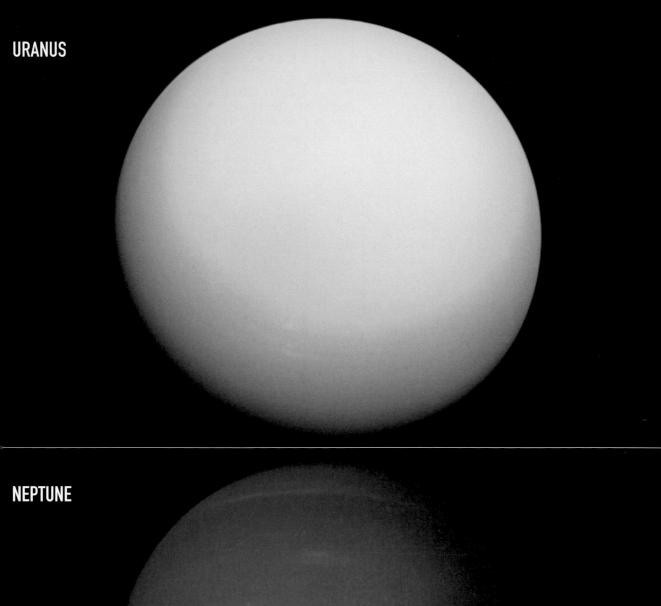

URANUS

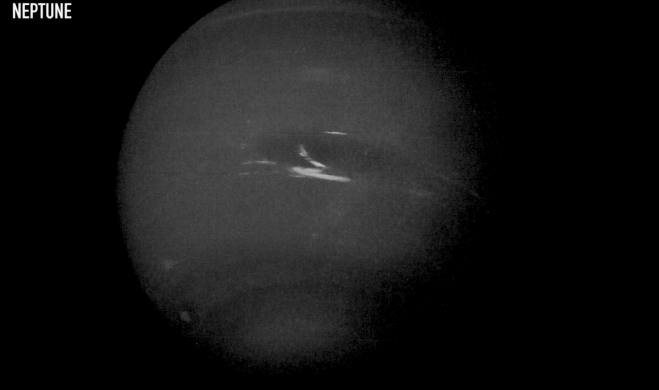

NEPTUNE

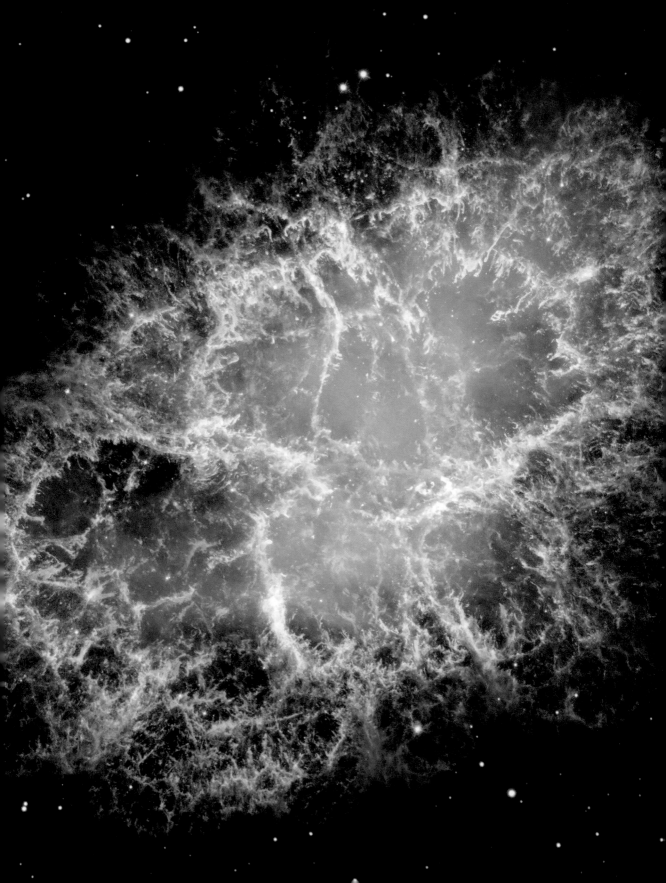

THIS IS A SUPERNOVA, NEARLY ONE THOUSAND YEARS LATER

In 1054 CE, Chinese astronomers recorded a 'guest star' in the sky that was visible for several weeks. Nearly a thousand years later, in the same spot, we find the Crab Nebula. This is a supernova remnant, blasted out into space by the cataclysmic death of a massive star.

contains a strange, helium-rich torus that defies explanation

The Crab Nebula is approximately 6,500 light-years away from Earth and has a diameter today of about 11 light-years. It is a complex structure of gas and dust that is expanding at a rate of about 1,500 km/s, which is 0.5 per cent of the speed of light.

The central pulsar at the heart of the Crab Nebula, known as the Crab Pulsar, was discovered in 1968. It is a neutron star with a mass roughly 1.4 times that of the Sun, but it is only about 20 km in diameter. It **rotates once every 33 milliseconds**, completing just over 30 revolutions per second, and emits a stream of radiation that sweeps across the sky like a lighthouse beam. The pulsar was created by a core collapse, greatly increasing its rotation rate, such that if you stood on its equator, you would be travelling at approximately 1,885 km/s.

The Crab Nebula is a popular target for amateur astronomers, visible in small telescopes in the constellation Taurus. It's also a well-studied object, complete with its own enduring mysteries. For example, the nebula contains a strange, helium-rich torus which defies explanation. As one of the most spectacular supernova remnants in the Galaxy, **it's a fascinating snapshot of an explosion** – as chaotic and complex as the event that created it.

Barnard's star is a red dwarf star located just 6 light-years from the Sun, making it one of the nearest stars in the Galaxy. It is named after American astronomer E. E. Barnard, who discovered its high proper motion in 1916. Proper motion is a measure of the speed at which a star moves through the sky, typically measured in arcseconds per year. Barnard's star holds the speed record at 10.3 arcseconds per year. At this rate, the star's position will change by one degree (about twice the width of the Full Moon) every 350 years. It's far too slow for us to notice without taking repeated observations, but compared to most of the other stars we see in the sky, it's positively flying!

Barnard's star is small and dim compared to the Sun – **about five times smaller, seven times lighter and 2,500 times fainter**. But that doesn't mean it can't host its own planets. In fact, Barnard's star has a long history of exoplanet research and some of it is quite controversial. In 1963, astronomer Peter van de Kamp claimed to have discovered at least one planet (later revised to two) orbiting Barnard's star, based upon years of observations of tiny perturbations in its position. For a decade, his ideas were popular in the astronomical community, but in 1973, other astronomers using more sensitive observations failed to confirm van de Kamp's hypothesis. Van de Kamp probably fell victim to errors within his telescope,

but never acknowledged them. Recently, in 2018, an international team of astronomers announced the discovery of a candidate world orbiting Barnard's star, believed to be a super-Earth, but this too was then ruled out in 2021.

It appears that Barnard's star doesn't host any exoplanets – at least not in orbits that are of interest to astronomers studying habitability. Perhaps this makes Barnard's star somewhat unusual, as several other red dwarfs have been shown to have their own exoplanets, including the Sun's nearest neighbour Proxima Centauri.

one of the nearest stars in the Galaxy

Barnard's star was once considered a potential target for Project Daedalus – an ambitious interstellar spacecraft concept proposed in the 1970s. Engineers believed that near-future technology would enable a probe to reach about 12 per cent of the speed of light by using a nuclear pulse rocket. Today's proposals look a bit different, but **the idea of sending a spacecraft to a nearby star is still popular**. However, Barnard's star was chosen at a time when people believed it may host planets. Today, a different candidate, such as Proxima Centauri, would be the likely choice.

BARNARD'S STAR
IS RACING ACROSS THE SKY

10.3
ARCSECONDS
PER YEAR

In 2004, the European Space Agency (ESA) launched the *Rosetta* spacecraft on a ten-year journey to catch up with a comet called 67P/Churyumov-Gerasimenko. **This ambitious mission would see *Rosetta* enter an orbit around the comet for an unprecedented, long-period study of one of these icy travellers as it makes its closest approach to the Sun.**

After its arrival at 67P, *Rosetta* prepared to deploy an arguably even more ambitious spacecraft, which had piggybacked a ride from Earth – the *Philae* lander. Named after the Philae obelisk in Egypt, this plucky probe was sent to the surface of 67P to **provide a close-up look at the surface of a comet for the first time**. Around the size of a washing machine, the lander had a weight of 100 kg. Heavy on Earth, it weighed very little in the comet's low-gravity environment. On 67P the 100-kg *Philae* had a weight equivalent to an AA battery on Earth.

On 12 November 2014, the *Philae* lander was released from the *Rosetta* spacecraft and successfully landed on the surface of the comet. However, the landing did not go entirely as planned, and the lander bounced several times before finally coming to rest in a shadowy spot that limited its ability to generate power from its solar panels. Despite these challenges, the *Philae* lander was able to conduct a number of scientific observations during its brief period of operation. **It confirmed the presence of primitive ice**, including water ice inside boulders, and surprisingly hard surface material, which astronomers previously assumed would be soft and powdery.

One of the most significant discoveries made by the *Philae* lander was the detection of abundant organic molecules on the surface of the comet. A total of 16 were found, including four that had never been seen around any other comet before. Scientists suspect that **comets may have delivered water and organic material to the primordial Earth**, potentially seeding the oceans with the ingredients necessary for life to emerge.

Philae operated for about 60 hours on the surface of the comet before its batteries ran out and it went into hibernation. Although attempts were made to re-establish contact with the lander and intermittent signals were received, it was ultimately declared lost in July 2016. Despite its short operational lifespan, the *Philae* lander is considered a successful mission, which will always be remembered as the first soft landing on a comet. As a technical achievement, it ranks high in the world of space missions and data from the probe has been used to enhance our knowledge of the small but significant snowballs that encircle the Solar System.

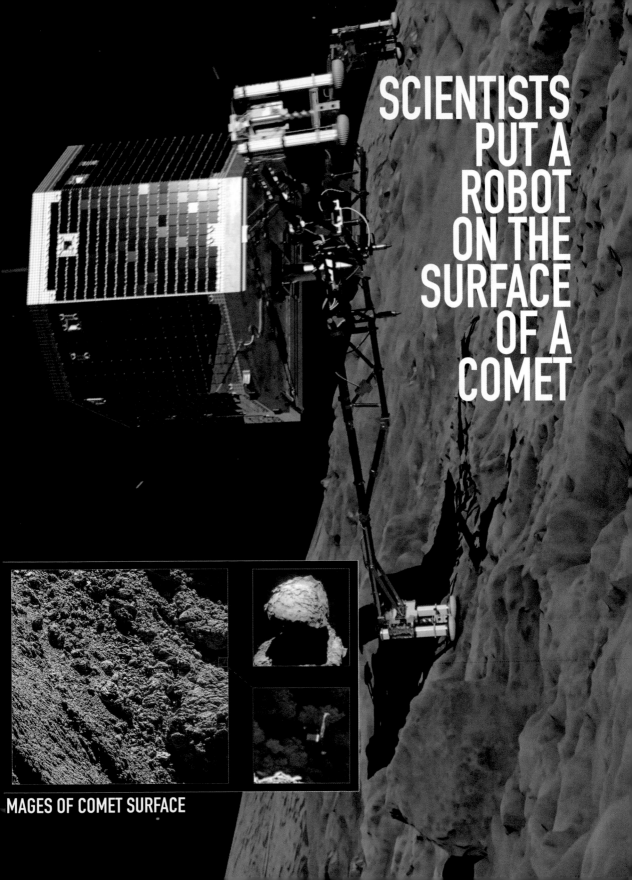

SCIENTISTS PUT A ROBOT ON THE SURFACE OF A COMET

MAGES OF COMET SURFACE

THE MYSTERY OF THE CERERIAN FACULAE

NASA's *Dawn* mission was launched in 2007 with the goal of studying two of the largest objects in the asteroid belt between Mars and Jupiter: Vesta and Ceres. After spending 14 months observing Vesta, *Dawn* arrived at Ceres in March 2015 to begin a comprehensive investigation of the dwarf planet.

the spots shine conspicuously in sunlight, in stark contrast to the fairly dark material across most of the surface of Ceres

Perhaps the most intriguing discovery made by the *Dawn* spacecraft on its approach to Ceres was the presence of several very bright spots on its surface. Called faculae (from the Latin for 'little torch'), the spots shine conspicuously in sunlight, in stark contrast to the fairly dark material across most of the surface of Ceres.

Initially, *Dawn* identified a pair of spots in the large and shallow Occator crater. They have since been named Cerealia and Vinalia Faculae and closer inspection has revealed that they are really **clusters of several smaller features**. Subsequently, more spots were found, begging the question of how they were formed.

Scientists believe the spots on Ceres are a few million years old – relatively recent features in the dwarf planet's long history. The *Dawn* spacecraft's Visible and Infrared Spectrometer (VIR) gathered information about the chemical makeup of the faculae, revealing that they contained salty material – primarily sodium carbonate, which is found on Earth in areas where briny water has evaporated.

Various hypotheses emerged when the spots were first discovered and a consensus was reached that they are salty deposits produced by salt water escaping through the crust from subsurface aquifers – possibly even an ocean. Ceres is a water-rich body and fissures in its crust would allow for a form of cryovolcanism, in which icy water evaporates into space. Salts in this briny mixture are left behind, building up into highly reflecting deposits. A thin haze associated with the faculae in the Occator crater has been detected, **providing evidence that this process is still happening today** and that even if salty material sublimes into space, it is being replenished by ongoing water transport.

The 'rare Earth' hypothesis, which gained momentum around the turn of the twenty-first century, posits that intelligent, extra-terrestrial life should be extremely rare. It depends upon many factors such as a habitable planet, emergence of life and complex evolution. The likelihood that we share the Galaxy with other intelligent beings can be expressed as a long series of probability multiplications and it becomes very small very quickly. Yet potentially habitable worlds might not be rare.

Currently, the term 'Earth-like' lacks a very strict definition, but there are certain characteristics that are widely agreed upon. An Earth-like planet would be similar in size and composition to our own and orbit within its star's habitable zone – **potentially supporting liquid water and therefore the development of life**. The host star should be stable over long periods and, ideally, the planet should have a magnetic field to protect its atmosphere from erosion.

One of the most widely cited studies on this topic was published in 2013 by a team of researchers at the University of California, Berkeley. Using data from NASA's Kepler Space Telescope, which was designed to search for exoplanets using the transit method (detecting dips in a star's brightness as a planet passes in front of it), the team estimated that there could be as many as 40 billion Earth-sized planets orbiting within the habitable zones of Sun-like stars in the Milky Way.

Another study published in 2015 by researchers at the University of California, Los Angeles, used a different approach to further constrain the probable number of Earth-like planets. The team analysed the frequency of planets that were both Earth-sized and located within the habitable zone of their star, as well as the likelihood that these planets would have a solid surface and the necessary elements for life. They estimated that **there could be as many as 10 billion Earth-like planets in the Milky Way**.

Recent research may be cause for still more optimism. In 2019, astronomers combined data from the Kepler Space Telescope with new results from ESA's *Gaia* mission, concluding that, on average, as many as one in six stars hosts an Earth-sized planet in its habitable zone. Potentially tens of billions of such worlds are strewn across the Milky Way. While the search for Earth-like planets continues, the range of environments that can be considered habitable is widening. An exact Earth analogue may not be necessary for complex life, and **the number of life-supporting havens may be higher than we think**.

A substantial number of interesting, potentially Earth-like exoplanets have already been discovered and, while little is known about them now, a slew of future missions designed to profile exoplanets in detail will help astronomers narrow the search for life outside the Solar System. It might be surprisingly common!

THE NOT-SO-
RARE EARTH HYPOTHESIS

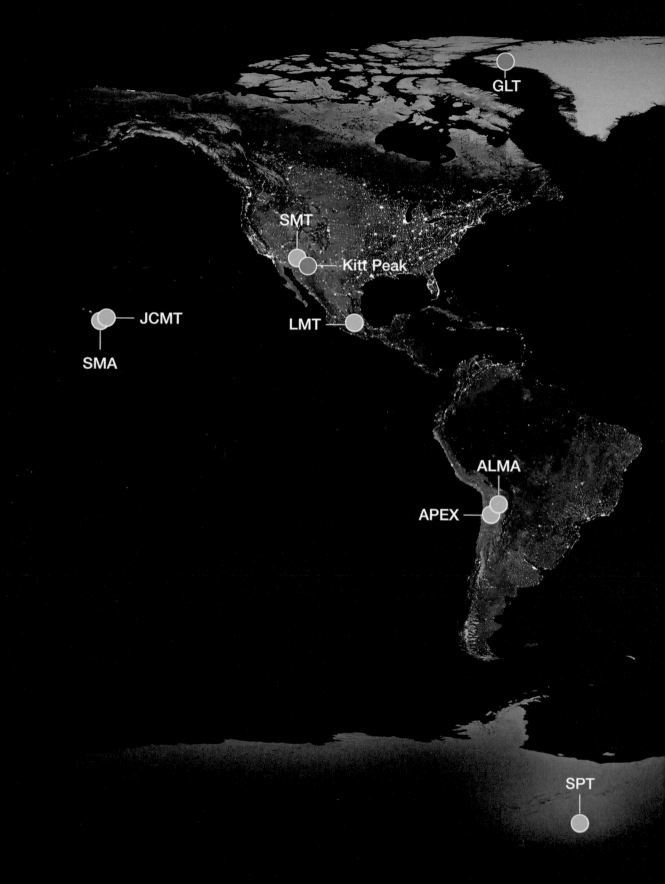

NOEMA

-M

THE EHT:
ONE TELESCOPE TO
RULE THEM ALL

M87*

SGR A*

There was once a dream among astronomers: to take a direct image of the region around a black hole. The idea lingered for decades, as theoretical and technological developments progressed and, in 2009, astrophysicist Sheperd Doeleman founded the Event Horizon Telescope (EHT) project, bringing together teams from multiple observatories to collaborate on achieving their collective dream.

25 millionths of an arcsecond

The project was named after the event horizon, which is **the point of no return for matter and radiation that falls into a black hole**. At this point, the gravitational pull is so strong that not even light can escape and this makes direct observations of black holes impossible. However, if an image could be obtained of the environment around the event horizon, astronomers could indirectly study the properties of black holes and test Einstein's theory of general relativity.

The EHT employed a technique called very-long-baseline interferometry (VLBI) to combine data from multiple telescopes around the world, creating a **virtual telescope approximately the size of the Earth**. This enabled a ridiculously high resolution of just 25 millionths of an arcsecond (where each arcsecond is 1/3600th of a degree)

at a wavelength of 1.3 mm. An optical telescope with the same resolution would be **capable of seeing the app icons on the screen of a smartphone lying on the Moon**!

Carefully timed observations of the supermassive black hole at the centre of the galaxy M87 were conducted by eight telescopes over five nights in April 2017 and the enormous wealth of data was then reduced to produce the resulting image. On 10 April 2019, the EHT team released their image to the world and it became one of the most publicised stories in the history of science.

The orange ring depicts material around the event horizon of a supermassive black hole, which is located 55 million light-years from Earth and has a mass billions of times greater than that of the Sun. This image provides **direct evidence of the existence of black holes** and confirms predictions made using Einstein's general theory of relativity.

The significance of the EHT's achievement can't be overstated. A second observation of the Milky Way's central black hole, Sgr A*, was made a year later using the same method and the EHT collaboration has since grown, involving hundreds of astronomers at 60 institutions. Ultimately, the EHT project served as a proof of concept that captured the world's attention. It has ushered in a new era of millimetre-wave astronomy, which will surely yield remarkable discoveries in the future.

In 2017, astronomer Robert Weryk, working in Hawai'i, detected a strange object travelling through our Solar System. It was given the name 'Oumuamua, from the Hawaiian for 'scout', after observations confirmed that it was of extrasolar origin. **This bizarre, cigar-shaped object was unlike anything that had been seen before and its temporary visit to the Solar System sparked a fierce debate about its origins that continues to this day.**

At the time, astronomers believed that the newly discovered object was a comet or an asteroid and it first carried a cometary designation, C, then an asteroid designation, A. However, once it was confirmed to be of interstellar origin, it became the first object to be given the designation I. Thus, its catalogue number is 1I/2017.

Observations of 'Oumuamua revealed that it has an unusual shape. It's long and narrow, with a length of about 1,000 metres and a width of only about 100 metres. Some imaginative astronomers speculated that these dimensions were **too strange to be natural** and that the object could be some kind of alien spacecraft. It does have unusual surface characteristics, and a very high velocity, but the

this bizarre, cigar-shaped object was unlike anything that had been seen before

proposal that 'Oumuamua is technological in nature is generally not entertained by most scientists. After all, extraordinary claims require extraordinary evidence.

Since 'Oumuamua was only passing through our Solar System briefly, **scientists had to act quickly to gather as much data as possible**. They employed a variety of telescopes and other instruments to study the object's size, shape, composition and trajectory, but only limited information could be gathered before 'Oumuamua reached an unfavourable distance for observation. As such, little is known about it, leaving the door open for speculation.

In 2019, 2I/Borisov – the second known interstellar object – was discovered. It is a rogue comet initially spotted by an amateur astronomer. Astronomers now think such **interstellar objects pass through our Solar System on a regular basis**.

'OUMUAMUA:
THE FIRST KNOWN
INTERSTELLAR OBJECT

ABOUT
1,000
METRES

WE MAY LIVE IN A MULTIVERSE

Is the Universe unique? Is it all there is? Or is it part of something larger? For decades, scientists and science-fiction enthusiasts alike have been fascinated with the idea of a multiverse, in which uncountable universes co-exist. While the idea may seem far-fetched, popular theories in cosmology and physics have given scientists room to consider the possibility.

there would be effectively an infinite number of universes

Inflation is a concept in modern cosmology that seems to have played a key role in the early history of the Universe. It describes a period of rapid expansion that is believed to have occurred very soon after the Big Bang. According to inflation theory, the Universe expanded exponentially in a fraction of a second, resulting in a nearly uniform distribution of matter and energy. Crucially, some formulations of the theory allow for **the creation of many bubble universes, each with its own physical laws and properties**.

These formulations are based upon the model of eternal inflation, which hasn't been ruled out.

The many worlds interpretation of quantum mechanics is an alternative route to creating a multiverse. Quantum mechanics is **the study of particles and their interactions at the smallest scales of matter**. According to this theory, particles exist in multiple states simultaneously, only collapsing into a single state when they are observed or measured. The real nature of what is happening depends on interpretation and, according to the many worlds approach, particles continue to exist in multiple states, with each state corresponding to a different, parallel universe. If this were true, there would be effectively an infinite number of universes.

Direct evidence of the existence of a multiverse may be impossible to find. If other universes never interact with our own, we can never observe them and we are forever condemned to assume that they do or do not exist based upon ideas that can never be fully ruled out. It's not a great situation for scientists seeking answers, but no one really knows what the future holds. A paradigm shift in physics may offer new ways to test the multiverse hypothesis.

THE INCREDIBLE POWER OF
ADAPTIVE OPTICS

STAR CLUSTER RCW 38

When astronomers study distant objects in space, they are often hampered by the distortion of light caused by the Earth's atmosphere. As the air moves, it causes point sources to scintillate, resulting in the familiar twinkling of stars. While this looks romantic to the eye, it indicates poor astronomical *seeing* – a term that describes the steadiness of the sky – and thus bad conditions for observing.

giant observatories fire laser beams into the Galaxy at night

Poor seeing results in blurry images, lacking in fine details. One way to tackle the effects of the atmosphere is to place a telescope in space, but this is expensive and fundamentally limited. Enormous telescopes on the ground can't be relocated to space, so to overcome this challenge, engineers have developed a system called adaptive optics, which is now in use at many cutting-edge ground-based observatories.

Adaptive optics systems work by measuring the distortion of light caused by the Earth's atmosphere and then using a deformable mirror to correct for this distortion in real time. This mirror is made up of hundreds of tiny actuators that can alter the shape of its surface thousands of times per second, compensating for the atmospheric turbulence and producing a much clearer image.

The first step in the adaptive optics process is to measure the distortion caused by the Earth's atmosphere. This is done using a wavefront sensor, which measures the difference between the actual light waves and a reference wavefront. The wavefront sensor sends this information to a computer, which calculates the adjustments needed to correct for the distortion. This calculation requires a guide star, which may be a real star or an artificial star created by a laser. The creation of laser guide stars looks quite spectacular, as giant observatories fire laser beams into the Galaxy at night.

Once the computer has calculated the necessary corrections, it sends commands to the deformable mirror to adjust its shape in real time. The mirror responds rapidly to these commands, constantly adjusting its shape to compensate for the atmospheric distortion.

Adaptive optics systems are used in a variety of different telescopes and observatories around the world, such as the Keck Observatory in Hawai'i and the European Southern Observatory's Very Large Telescope (VLT) in Chile. Advancements in adaptive optics have breathed new life into ground-based astronomy, allowing large telescopes to perform as though they were in orbit, free of the distortions of the atmosphere.

THE MILKY WAY
HAS A TURBULENT HEART

Looking between the **constellations of Sagittarius and Scorpius on a dark night, you can peer directly at the centre of the Milky Way. Roughly 26,000 light-years away from us, shrouded by gas and stars is the heart of our galaxy. It's a complex and fascinating region, which has only come into sharp focus in recent decades.**

a supermassive black hole at the very centre of the Galaxy

Observations of the Milky Way's core have become possible with advances in infrared and radio astronomy. Light in these wavelengths reaches us relatively unimpeded, giving us the opportunity to look directly at the Galactic Core. One of the most significant discoveries has been that of a supermassive black hole at the very centre of the Galaxy. Known as Sagittarius A* (abbreviated Sgr A*), it has been weighed by watching stars in close orbit around it and shown to have **a mass about four million times greater than the Sun.**

Observations of the Milky Way's core have also revealed a dense cloud of gas and dust known as the Central Molecular Zone (CMZ). This region is **thought to be the birthplace of new stars**, with dense pockets of gas and dust collapsing under their own gravity to form new star systems. The CMZ is also home to a number of impressive star clusters, including the Arches and Quintuplet clusters, which contain some of the most massive stars in the Galaxy.

In addition to these observations, astronomers have also detected a number of unusual phenomena near the centre of the Milky Way, including energetic bursts of X-ray and gamma-ray radiation, and a population of stars with extremely high velocities that seem to have been ejected from the Galactic Core. The central supermassive black hole is also surrounded by **a remarkably young population of stars in a region where star formation was once considered unlikely** due to tidal forces. The centre of our galaxy is as rich with treasures as it is difficult to observe and will surely provide future generations of astronomers with untold opportunities for discovery.

TITAN IS A MOON BUT IT LOOKS MORE LIKE A PLANET

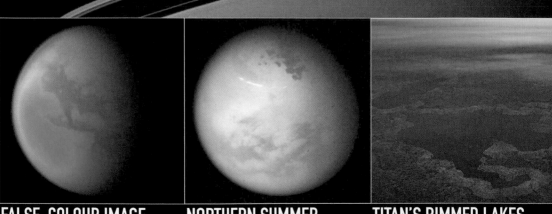

FALSE-COLOUR IMAGE NORTHERN SUMMER TITAN'S RIMMED LAKES

The largest of Saturn's 83 known moons, Titan orbits the ringed planet every 16 days and shines conspicuously even in small telescopes. It was discovered by Christiaan Huygens in 1655 and named by John Herschel in 1847. Aside from its brightness and orbital period, little was known about Titan until the space age. When interplanetary probes got close to it, scientists were intrigued by an enigmatic world, blanketed in a thick atmosphere which hides its surface. Titan is unlike any other moon in the Solar System.

Titan's hazy atmosphere is primarily composed of nitrogen, with traces of methane and other hydrocarbons. **It's so thick that it completely obscures the surface of the moon**, making it difficult to observe with traditional telescopes. In 2004, NASA's *Cassini* spacecraft entered orbit around Saturn and began to explore Titan in detail, using radar imaging and other instruments to penetrate its dense atmosphere and reveal its secrets. The spacecraft also deployed a probe supplied by the ESA, the *Huygens* lander, which touched down on the surface of Titan in 2005. It is, to date, the only mission to land on a moon orbiting a planet other than the Earth.

The exploration of Titan by the *Cassini-Huygens* mission generated very exciting results. Radar imagery of the moon revealed **the presence of liquid lakes and seas on its surface**. These liquid bodies aren't composed of water, but rather of liquid methane and ethane, which are gaseous in Earth's warm atmosphere, but cold enough to remain on the surface of Titan. The moon's average temperature is just 94 Kelvin (-179 °C) yet it has weather, including rain, and cryovolcanic activity. The discovery of these lakes and seas, as well as climatological activity, has led scientists to **speculate about the possibility of life on Titan**. Despite the low temperature, chemistry could be possible there in specific conditions. Research conducted on Earth suggests that low-energy pathways to biochemistry are possible in conditions mirroring the Titanian environment.

The moon also has a complex geological landscape. It's covered in mountains, valleys and dunes, which are thought to be made of a combination of water ice, rock and organic compounds. Changes in weather are driven by seasons, and Titan experiences a 'methane cycle' that is very similar to the water cycle on Earth. It is **the only moon in the Solar System to have a significant atmosphere**, and seems to have more in common with a terrestrial planet than most of the other natural satellites we find. Interest in Titan has only grown with time, leading to calls for more missions to explore it. Numerous concepts for landers, drones, boats and even balloons are under development, so hopefully we can expect to learn much more about this unique moon in years to come.

EVERYONE WANTS
TO SEE BETELGEUSE
EXPLODE

NEARLY 1,000
TIMES GREATER
THAN THE SUN

Betelgeuse, also known as Alpha Orionis, is a red supergiant star located in the constellation Orion, at a distance of 500–600 light-years away. It's among the brightest and most recognisable stars in the night sky, known for its unmistakeably orange colour. As a red supergiant, it has a diameter nearly 1,000 times greater than the Sun's, and, were it placed in the centre of our Solar System, it would swallow the terrestrial planets and the asteroid belt, making Jupiter the innermost planet.

it is nearing the end of its life in stellar terms

Betelgeuse is a variable star – its brightness fluctuates over time. The variability was first documented in the 1830s by astronomer John Herschel, who noted that the star seemed to be about three times dimmer to him than it had appeared to his father William Herschel in the eighteenth century. Recently, more dramatic changes in the brightness of Betelgeuse have captured the public's attention. In late 2019, the star's brightness dropped to its lowest level in more than a century, leading to media speculation that it might be on the verge of a supernova explosion.

Betelgeuse is a mature star that is close to the end of its life. Having swollen into a red supergiant, it's expected to explode in the future and leave behind a neutron star about one and a half times the mass of the Sun. The prospect of witnessing a supernova in the local part of our galaxy is exciting to astronomers, as it would provide an opportunity to study the violent death of a massive star in acute detail. However, despite the frenzy of misinformation that appears whenever astronomers mention Betelgeuse, it probably won't explode any time soon. It is nearing the end of its life in stellar terms, but it's expected to survive another few tens of thousands of years. Follow-up observations of the 2019 fading of Betelgeuse suggested that the star's dimming was likely due to a combination of factors, including changes in its surface temperature and the presence of large-scale dust clouds in its vicinity. It was a notable event, but probably not that unusual for a red supergiant star with a pulsating, extended envelope of gas surrounding it.

What would it look like if Betelgeuse did explode in our lifetimes? The shoulder of Orion would suddenly brighten to compete with the Full Moon, casting shadows at night for a period of about three months, before dimming to obscurity. The neutron star produced by the collapse of the core would be too faint to see and so Orion's shoulder would disappear from visibility forever. It's unlikely, but everybody secretly hopes it will happen very soon.

SATURN'S
RINGS ARE INCREDIBLY THIN

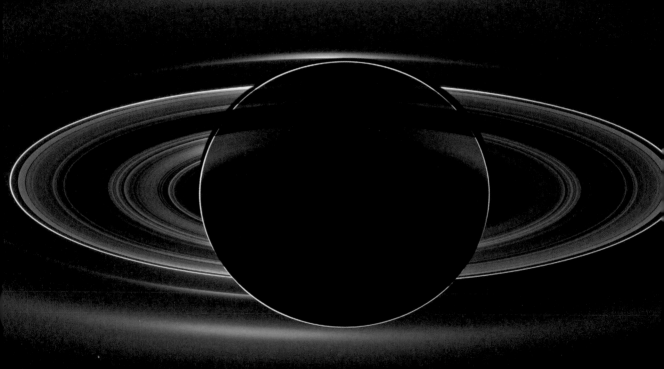

↑ A FEW
HUNDRED
↓ METRES THICK

Saturn, the sixth planet from the Sun, is known for its spectacular rings that encircle the gas giant. Considered to be one of the wonders of the Solar System, these rings are a striking sight in a telescope, and have fascinated astronomers for centuries. While they appear to be solid and continuous from afar, the reality is that they are made up of trillions of individual pieces of ice and small amounts of rock, ranging in size from tiny dust-like particles to giant boulders.

the rings are hundreds of thousands of times wider than they are tall

One of the most remarkable things about Saturn's rings is their incredible thinness. Despite stretching out to a distance of nearly 140,000 km from Saturn's equator, the rings are only a few hundred metres thick at most. Put another way, the rings are hundreds of thousands of times wider than they are tall. For comparison, a Blu-ray disk is 120 mm wide and 1.2 mm thick. To match the scale of Saturn's rings at this thickness, the Blu-ray disk would need to be about one kilometre wide!

So how is it possible for the rings to be so thin? The answer lies in the gravitational forces at work. Saturn has dozens of moons orbiting it, and **these moons have a gravitational effect on the particles in the rings**. In particular, some of the larger moons create gaps in the rings where there are no particles, while others shepherd the particles into narrow bands. This gravitational influence also means that the particles in the rings are attracted to one another, and throughout history have constantly collided with one another. Over time, these collisions cause the particles to flatten and align their orbits, until subsequently fewer collisions occur. However, the ring particles do still collide, causing them to lose energy and spiral towards the planet. This process, which causes particles to precipitate into the saturnian atmosphere, is known as 'ring rain', and **it results in the rings being eroded away**. In fact, it is estimated that Saturn's beautiful rings will completely disappear in about 300 million years. Enjoy them while they last!

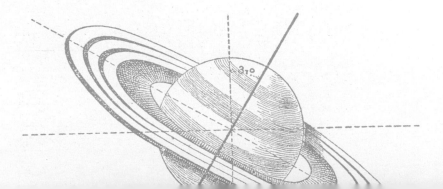

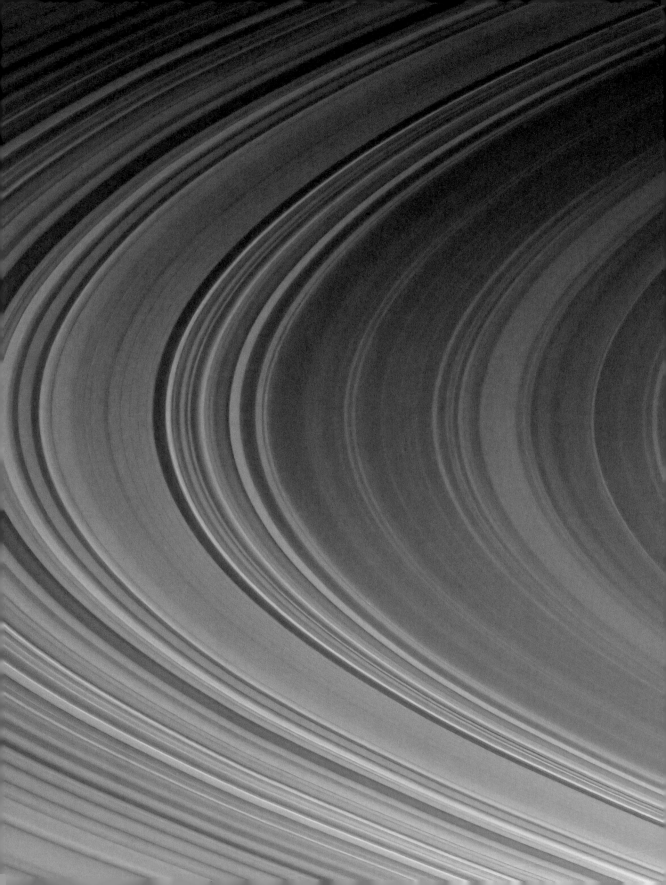

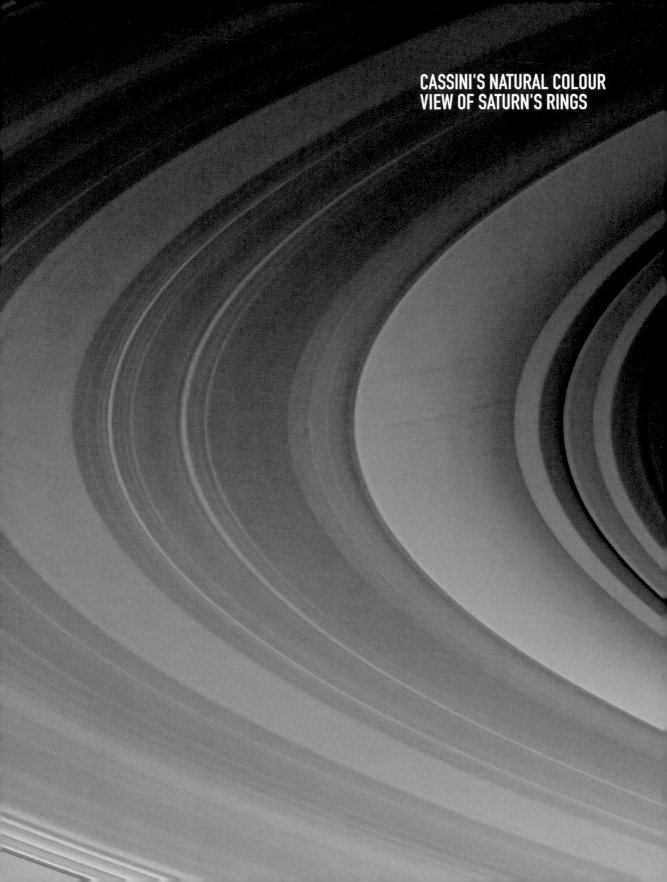

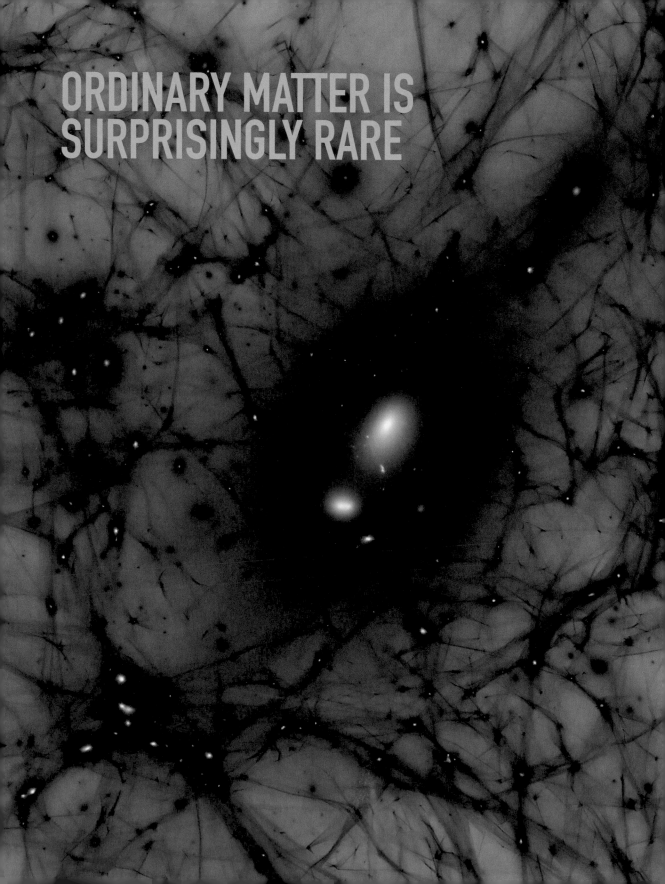

ORDINARY MATTER IS
SURPRISINGLY RARE

Looking into the sky, everything we see – stars, planets, nebulae, galaxies – is made up of ordinary matter. This term describes matter which is made up of atoms and subatomic particles, such as leptons (including electrons) and baryons (including protons and neutrons). One of the remarkable findings of modern astronomy is that such matter accounts for only a very small fraction of the Universe's total energy content.

the largest slice of cosmic energy content is called dark energy

Ordinary matter has been measured to contribute just 4.9 per cent to the energy distribution of the Universe, meaning only one twentieth of its content can be measured directly. The rest, just over 95 per cent, is shared between two enigmatic phenomena called dark matter and dark energy.

Dark matter, theorised to be an exotic type of matter, does not interact with light or other forms of electromagnetic radiation. It doesn't even absorb light, so it is misleading to call it dark. A better term might be invisible matter, since this substance can only be detected indirectly. Dark matter makes up 26.8 per cent of the energy distribution of the Universe – it is **over five times more abundant than ordinary matter**. This leaves 68.3 per cent unaccounted for.

The largest slice of cosmic energy content is called dark energy and it remains one of the most mysterious properties of the Universe. Dark energy exerts a kind of pressure on space, causing it to expand at an ever-accelerating rate. Cosmologists speculate that it is a facet of space itself, but little is known about its origin or physical makeup. Thus the most familiar energy in the Universe is actually one of the rarest, whilst the most common is a near total enigma!

ENERGY DISTRIBUTION OF THE UNIVERSE

MATTER
4.9%

DARK MATTER
26.8%

DARK ENERGY
68.3%

Billions of years ago, the planets in our Solar System formed from a disk of material rotating around the young Sun. While we have no way of picturing this directly, and must infer what happened by studying the results we see today, we can look to other young systems elsewhere in the Galaxy and watch the process from the outside.

Protoplanetary disks, also known as proplyds, are **vast disks of gas and dust that surround young stars**. They are fertile regions for the formation of planets, where particles slowly clump together and grow in size over time.

The study of proplyds has become essential to filling in the gaps in our understanding of the birth of the Solar System. The famous Orion Nebula, a massive star-forming region located approximately 1,350 light-years away, is the perfect place to hunt for proplyds. The Hubble Space Telescope (HST) has observed the Orion Nebula in great detail, bringing many young systems into sharp relief, allowing astronomers to study the properties and dynamics of proplyds.

The beautiful images reveal systems at various stages of their formation, some appearing more distinctly circular than others. The radiation from powerful stars within the nebula can disrupt the fragmentary clouds of material from which new stars are born, causing them to grow tails that billow in stellar winds. **Our Solar System probably didn't form in a large star nursery** like the Orion Nebula, but it did at one time look very similar to some of these stunning objects.

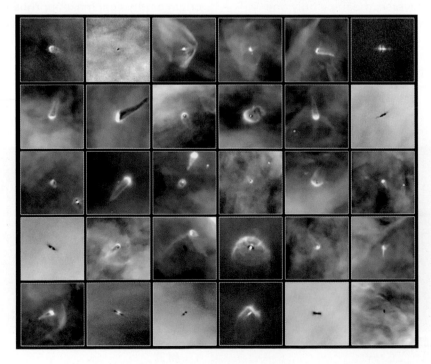

1,350
LIGHT-
YEARS
AWAY ↑

THIS IS WHAT BABY SOLAR SYSTEMS LOOK LIKE

QUASARS:
A DECADES-LONG
MYSTERY SOLVED

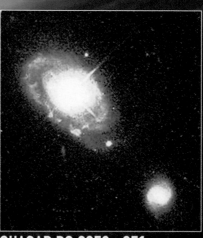

QUASAR PG 0052+251

Starting in the 1950s, astronomers began to record enigmatic, bright sources of radio waves all over the sky. Termed 'quasars', their existence sparked a debate that wouldn't be fully settled until the late 1990s.

The name quasar (sometimes QSO) is short for 'quasi-stellar object' and was originally a contraction of 'quasi-stellar radio source', inspired by the fact that these sources appeared as points, like stars, but emitted radio waves. Visible-light images suggested that they could be originating from faint or very distant stars.

In 1963, astronomer Maarten Schmidt measured the redshift of the light emitted by a quasar called 3C 273. Redshift is a measure of how much the wavelength of light from an object has been **stretched by the expansion of the Universe**, and it can be used to estimate the distance to the object. Schmidt found that 3C 273 had an incredibly high redshift, among the highest recorded at the time, which implied it was too distant to be just a star.

Some scientists at the time suggested that the high redshift could be a result of an enormous mass or some other unexplained mechanism. After all, for 3C 273 to appear so bright at such a tremendous distance, it would have to be an immensely powerful object. For many years, the idea that quasars were local stars in the Milky Way surrounded by deep gravitational wells could not be ruled out.

However, observations continued to support the notion that quasars were indeed very distant objects. Schmidt also observed the quasar 3C 48, which was surrounded by visible nebulosity. Both the quasar and its surroundings had the same, ultra-high redshift and it was clear that the objects were in a distant galaxy. He originated the theory that quasars were **likely to be formed by supermassive black holes**.

His idea, that quasars were powered by the accretion of gas clouds into supermassive black holes, was revolutionary at the time, but it soon gained traction as more and more evidence was uncovered to support it. In the 1970s, astronomers discovered more quasars that were surrounded by enormous gas clouds, being illuminated by their radiation, and in the 1990s, with the arrival of the Hubble Space Telescope (HST), the quasar debate would be settled.

Hubble's sensitive cameras captured many quasars, **showing that they are all surrounded by galaxies**. It would be an extraordinary coincidence for them all to be exactly along the line of sight of the centre of a distant galaxy. The Hubble observations proved that they were extreme kinds of active galactic nuclei, which are difficult to comprehend. Many quasars are trillions of times brighter than the Sun and, were they anywhere within a few tens of light-years of us, they would outshine the Sun in the night sky!

MARS HAS THE STRANGEST AURORAS IN THE SOLAR SYSTEM

Auroras are a common feature in our Solar System, having been found on every planet except Mercury, and even on a number of moons. Among the planets, Mars surely has the strangest auroras of all, but what makes them so different? Auroras are formed when streams of electrons are accelerated into the atmosphere of a planet by its magnetic field. The magnetic field lines give the electrons energy, generating a current that excites the gases in the atmosphere. But Mars experiences a phenomenon called proton auroras.

Unlike the Earth, Mars has a very weak magnetic field, so the proton auroras aren't directed to the poles. Instead, they form all over the Sun-facing side of the planet where a stream of high-energy protons from the solar wind directly impacts the planet's atmosphere. When these protons collide with atoms high above the Martian atmosphere, they steal electrons and then precipitate down towards the surface, radiating as they collide with other atoms.

The protons can collide many times on their journey through the atmosphere and each time the stolen electron will give up some of its energy in the form of light. Occurring on the day-side of the planet, the resulting auroras are impossible to see visually, but NASA's Mars Atmosphere and Volatile Evolution probe (MAVEN) has detected their UV signature from space. Particularly dense bursts of solar wind arrive at Mars with a speed exceeding 3 million km/h and the planet's ailing magnetic field only has a limited capacity to deflect them. This causes the auroras to flare up.

The Earth also experiences proton auroras, but they are undetectable to the eye. What were once thought of as terrestrial proton auroras, arcs of pinkish-white light during strong auroral displays, are now known to be a unique phenomenon called STEVE.

particularly dense bursts of solar wind arrive at Mars

3 MILLION KM/H

WELCOME TO YOUR
EXTENDED NEIGHBOURHOOD

The Milky Way is one member of a supercluster of galaxies called Laniakea. This name is taken from the Hawaiian language and it means 'immense heaven'. The full extent of Laniakea was profiled in 2014 by a team of astronomers led by Brent Tully. Before this time, astronomers were already aware of the Milky Way's 'local group' and the neighbouring Virgo Cluster, which were collectively called the Virgo Supercluster. However, the official discovery of Laniakea greatly expanded the known size of the megastructure that the Milky Way is associated with.

Laniakea spans a whopping 520 million light-years, and is home to approximately 100,000 galaxies. It is one of the largest known structures in the Universe, which contains a number of other similar superclusters. We are on the outskirts of Laniakea, about 200 million light-years from its gravitational centre, which is known to astronomers as the Great Attractor – a long-studied region of space that is difficult to observe because it is obscured from our view by our own Galaxy.

we are on the outskirts of Laniakea, about 200 million light-years from its gravitational centre

The discovery of Laniakea was made using data from the Cosmic Flows project, which measured the velocities of galaxies in the local part of the Universe. The astronomers used this data to map galaxy distribution and define the approximate boundary of Laniakea. It is so large that calculations show it will eventually break apart as dark energy drives the accelerating expansion of the Universe. However, most of its constituent galaxy clusters will remain intact, as they are dense enough to be bound together by gravity.

100,000
GALAXIES

MILKY WAY

PUSHING THE LIMITS: ASTROPHYSICAL JETS THAT REACH RELATIVISTIC SPEEDS

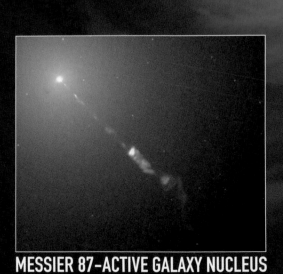

MESSIER 87–ACTIVE GALAXY NUCLEUS

The speed of light is the speed limit for radiation in the Universe and, according to physics, it's impossible for anything with mass to reach it. But in very extreme environments, matter can be forced to approach the speed of light – all it takes is a staggering amount of energy. The Universe offers many extreme and highly energetic objects for astronomers to study, and it turns out that some of them are powerful enough to put physics through its paces.

outflows of gas and plasma that are emitted from the vicinity of black holes

Relativistic jets are outflows of gas and plasma that are emitted from the vicinity of black holes, neutron stars and other extremely massive objects. These jets have been observed originating from galaxies with highly active nuclei and **can extend for thousands of light-years into the surrounding space**. There are many sources of astrophysical jets, but relativistic jets are particularly interesting, as they propagate at close to the speed of light and thus experience relativistic effects.

The giant elliptical galaxy M87 creates one of the most famous relativistic jets. Located approximately 55 million light-years away, M87's jet was first observed in 1918 by astronomer Heber Curtis, but it wasn't until advances in radio astronomy in the 1950s that its true nature was discerned. The jet is **powered by a supermassive black hole at the heart of the galaxy**, which is estimated to have a mass billions of times greater than that of the Sun. It's surrounded by a swirling cloud of ionised gas, or plasma, which is heated to millions of degrees as it spirals inwards.

The exact mechanism by which the jet is formed is not well understood and is a subject of ongoing research. The black hole's intense magnetic field appears to accelerate ions into two narrow beams at its poles, of which one is clearly visible. This would mirror the physics of other astrophysical jets, which have been observed to be released by powerful stars, but with much higher energies. The visible region of M87's jet propagates into space at about 85 per cent of the speed of light and stretches to thousands of light-years away from the galaxy's core.

BRILLIANT SIRIUS
HAS A TINY, HIDDEN COMPANION

Sirius is the brightest star in the night sky. At just 8.6 light-years away, it dazzles with its brilliance. But unseen to our eyes, Sirius has a much smaller and fainter companion in orbit around it, named Sirius B. Also known as the Pup (after Sirius' moniker, 'The Dog Star'), it is a white dwarf star – one of the most massive known to exist.

astronomers suspect that Sirius B formed from the remnants of a larger star

Sirius B's mass is very slightly greater than that of the Sun, yet its diameter is less than one per cent of the Sun's, making it similar in size to the Earth. As a result, Sirius B is an extremely dense star with a surface temperature of 25,000 Kelvin – more than twice as hot as Sirius itself.

As with most white dwarfs, astronomers suspect that Sirius B formed from the remnants of a larger star that **exhausted its fuel and collapsed in on itself**. At its core, Sirius B is composed primarily of carbon and oxygen, with a thin layer of hydrogen surrounding it. It now orbits its larger, brighter sibling once every 50.1 years and at an average distance of roughly 20 Astronomical Units (AU) or 20 times the distance between the Earth and the Sun.

Though it is not visible to the unaided eye, Sirius B can be found with a sufficiently large telescope. It was first observed directly in 1862 by telescope-maker Alvan Graham Clark, and has since been imaged by the Hubble Space Telescope (HST) (pictured). You can find Sirius B yourself, but don't wait too long. The two stars are **gradually converging for their next close approach in 2044**, so with each passing year seeing Sirius B becomes more challenging.

GORGEOUS GREEN
IS A RARE TREAT

Green is a very unusual colour in astronomy. Images showing apparently green nebulae or stars are usually captured in wavelengths of light not visible to our eyes, such as infrared light, and the green colour is chosen by an artist arbitrarily to bring out details in the scene. This false colour doesn't reflect the way things would appear to us and there are simply no green stars. It's a shame, because our eyes are particularly sensitive to this colour and green spaces are genuinely beneficial to us here on Earth. We love to surround ourselves with the greenery of nature, but the night sky seems to offer very little greenery of its own. Yet there are a few green phenomena, which rank among the most curious subjects of study for astronomers.

On Earth, the rich oxygen content of the atmosphere gives rise to green auroras. Ribbons of green light dance across the sky during an active auroral display, complimented by other colours which are less intense. The green light is released when excited electrons bind to atomic oxygen in the upper atmosphere. The electrons temporarily sit in higher energy states, but when the oxygen atoms collide their excited electrons jump back down and release green photons. The aurora isn't necessarily an astronomical phenomenon, as it occurs in the Earth's atmosphere, but some other objects in our Solar System are green.

The comas of many comets appear visibly green, particularly with telescopes. They are rich in diatomic carbon, which produces a strong green emission when exposed to ultraviolet (UV) light from the Sun. The UV rays excite the carbon molecules, which fluoresce green photons. Away from the coma, the continued exposure to solar UV rays causes photodissociation, breaking the molecules apart such that they no longer emit green light. This is why a comet's atmosphere can appear green while its tail remains colourless. The ice giant Uranus is admired for its cool green colour, which is the result of methane ice in its hydrogen-rich atmosphere. Though the planet's true colour is closer to cyan or aquamarine, it can appear greener in a telescope due to the eye's relatively high sensitivity in this part of the spectrum.

Outside our Solar System, many visible nebulae appear faintly green to our eyes. The Orion Nebula, for example, is greyish-green when viewed through a telescope. Photos of this nebula show strong pinks, violets and blues, so why does it appear green? Although most of the nebula's emissive light is released by hydrogen in the red part of the spectrum, it also contains oxygen that releases some green when excited by the energy of young stars. Adapted to the dark, our eyes lose most of their colour sensitivity and the pinks and blues are difficult to discern. Meanwhile, a faint oxygen

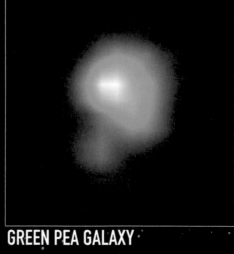

GREEN PEA GALAXY

emission is perceptible to us, close to the peak sensitivity of the human eye, making the nebula appear green, if any colour is seen at all.

There are two more families of green objects, discovered only relatively recently. Green Peas are unusually light, yet very active, galaxies, first discovered by citizen scientists as part of the Galaxy Zoo project in 2007. They are characterised by their blue-green colours, which are produced by the emission of ionised oxygen atoms, just like terrestrial auroras and emission nebulae. Green Peas are **thought to be powered by vigorous star formation** that is triggered by galaxy mergers or interactions.

Voorwerpjes (Dutch for 'objects') also turned up as a result of the Galaxy Zoo project in 2007. They are visibly, prominently green 'ionisation echoes' – gas clouds containing oxygen, which is ionised by the intense energy of a quasar at the centre of a galaxy. These extraordinary and beautiful objects are helping astronomers understand the turbulent process that occurs around supermassive black holes when they feed.

there are simply no green stars

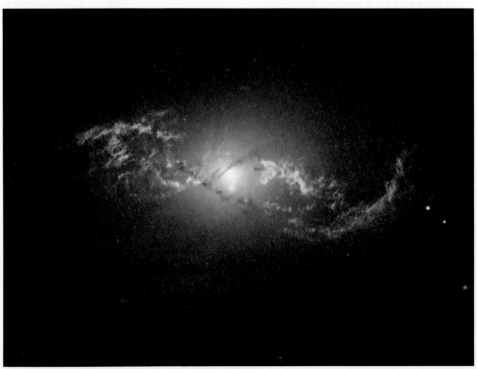

GREEN FILAMENT IN GALAXY NGC 5972

THESE 'HOLES IN SPACE' ARE NOTHING TO FEAR

Look up at the Milky Way on a dark night and you may spot some apparent holes in space, where no stars seem to shine. Don't worry, they're just dark nebulae. Dark nebulae, also known as absorption nebulae, are vast clouds of dust and gas that appear as empty patches or holes against the brighter background of stars. Due to their density, they obscure the light from the stars behind them, creating a striking contrast between the bright and dark regions of the sky. In some cases, these nebulae may be bright from other angles, but we see them in silhouette.

One of the most famous dark nebulae is the Horsehead Nebula, located in the constellation Orion. This nebula is shaped like a horse's head and is visible against the backdrop of the bright emission nebula IC 434. The Horsehead Nebula is approximately 1,500 light-years away from us, and is a site of active star formation with several young stars embedded within its dusty clouds. Another notable dark nebula is the Coalsack Nebula (pictured), located in the constellation Crux. The Coalsack Nebula is one of the largest and most prominent dark nebulae visible in our night sky and is located approximately 600 light-years away. It's about 35 light-years wide. The Pipe Nebula is located in the constellation Ophiuchus, and is named for its distinctive pipe-like shape.

One large, widely seen collection of dark nebulae is called the Great Rift. It's a vast stretch of dark dust clouds that extends from the constellation Cygnus through to the southern hemisphere. While the Great Rift is composed of many discrete dark nebulae, it looks convincingly like one gigantic structure, vertically bisecting the Milky Way.

these dark nebulae appear to change shape and position

That we see these clouds in silhouette is a reminder that the Galaxy is a three-dimensional volume of stars, gas and dust. On timescales that defy the human span, these dark nebulae appear to change shape and position as they, and we, orbit the Milky Way.

35
LIGHT-
YEARS
WIDE

HOW LONG IS A GALACTIC YEAR?

We don't feel the motion of the Earth's orbit around the Sun, but we can appreciate the passage of the year, with the changing seasons and the march of the constellations. After all, a year is only 365.25 days and, if we're lucky, we get to experience many of them. But on a larger scale, the Sun also has a kind of year of its own.

The Sun is in orbit around the centre of the Milky Way and the entire Galaxy – including its sweeping spiral arms – is rotating. Remarkably, astronomers have been able to calculate the rotation rate of the Milky Way and define the length of a galactic year – the period of the Sun's orbit.

The Solar System orbits the Galaxy at an average speed of about 828,000 km/h and **takes a full 230 million years to complete an orbit**. The galactic year is a vast span of time, which becomes clear when we measure events by it. For example, life began on Earth a little under 17 galactic years ago. The Cambrian explosion, in which complex lifeforms emerged, was just 2.4 galactic years ago. **Modern humans appeared only 0.0013 galactic years ago**.

Looking to the future, the Earth's continents will possibly fuse into a new supercontinent in just one galactic year and, by 30 galactic years from now, the Milky Way and the Andromeda Galaxy will have merged into a new giant elliptical galaxy.

life began on Earth a little under 17 galactic years ago

230

MILLION
YEARS

DEMYSTIFYING THE COLOURS OF THE STARS

WESTERLUND 1

STELLAR CLASSIFICATION

Class	Temperature
O-type	> 31,500 K
B-type	10,000–31,500 K
A-type	7,300–10,000 K
F-type	6,000–7,300 K
G-type	5,300–6,000 K
K-type	3,900–5,300 K
M-type	2,300–3,900 K

To our eyes, most stars appear white. A few are distinctly yellow or orange, others a pallid blue. But their colours, generally appear more subtle than vibrant and often go unnoticed by casual stargazers. Yet photographs of the sky reveal that most show a prominent colour, and only a fraction are actually white. That's because stars behave similarly to theoretical objects called black bodies, which absorb all the radiation incident on them. In physics, a black body will radiate as it's heated up, and its apparent colour will depend on its effective temperature. The same is true of a star and, since every star has an effective temperature, it also has peak output colour.

only a fraction are actually white

Astronomers use a system of stellar classification, which is based on the colours of stars, in order to compare them by temperature, mass and other characteristics. According to Planck's law, **hotter stars appear bluer and cooler stars appear redder**. Blue light has a higher energy and red light has a lower energy. A very cool star will radiate mostly in the infrared, whereas a very hot star will peak in the ultraviolet. This relationship is codified in the Harvard spectral classification system, which has seven main categories.

In order of decreasing temperature, stars are labelled by type as O, B, A, F, G, K or M. O-type stars are the hottest and bluest, with surface temperatures exceeding 30,000 Kelvin, while M-type stars are the coolest and reddest, with surface temperatures below 3,700 Kelvin. The Sun has a surface temperature of 5,700 Kelvin making it a G-type star with a yellow colour. Only F-type stars, whose surface temperatures range between 6,000 and 7,500 Kelvin are visibly white. Of course, the Sun appears white to us because we are close to it and it is overwhelmingly bright in our skies, but from a distance of several light-years, it would appear yellowish-white in our telescopes.

Star colours change over time, since as any given star evolves its temperature will change. For example, the Sun wasn't always a yellow star. When it was much younger, it was hotter and would have had a slightly blueish tint. In billions of years to come, **it will expand to become a red giant, and its outer layers will cool down**. As the name suggests, it will be reddish in colour.

The colour-temperature relationship is of important scientific interest to astronomers, since it makes rigorous classification possible. Until spectroscopy enabled the true colours of stars to be determined, they had to be estimated by eye. Observers seldom agreed on the subtler colours, and often claimed to see colours that are not emitted narrowly enough to become prominent, such as green or purple!

Looking at the stars, we look back in time. It's elementary to state this fact, but difficult to grapple with it. Our ability to perceive something out in space is contingent on light from it reaching us. We feel as though light gets around instantaneously. If you turn the lights on, the room seems to be instantly lit. But light travels at a finite speed, that is simply too fast to notice on the scale of the world around us.

The speed of light in a vacuum, denoted c, has been measured to be 299,792.458 kilometres per *second*. That's fast! A signal propagating at lightspeed could circumnavigate the Earth more than seven times in a single second, so it's hardly surprising that we don't notice it flying through our rooms or even down the street. But the gulf of space is vast, and even light takes a noticeable amount of time to get around.

Light from the Moon takes about 1.3 seconds to reach the Earth. Light from the Sun, takes about 8.3 minutes to reach us. The light from the next nearest star takes over four years. Astronomers often express distances to the stars and other objects in light-years. Put simply, one light-year is the distance light travels through free space in one year. This unit allows us to imagine how far back in time we are looking when gazing at the stars.

most of the light we see coming from the night sky departed on its journey to us before we were born

Most of the stars we see with our eyes are a few tens or hundreds of light-years away. Some are a few thousand light-years away. We can also see globular clusters outside the Milky Way, which are tens of thousands of light-years distant, and our nearest galaxy – the Andromeda Galaxy – appears as a faint smudge, it's light reaching us from over 2.5 million light-years away. We look back in time over 2.5 million years when viewing this Galaxy, seeing it as it was when, here on Earth, there were no human beings at all, and our distant ancestor Australopithecus roamed the plains of Africa.

Most of the light we see coming from the night sky departed on its journey to us before we were born. By stargazing we are able to interact with the past as it becomes our present. Likewise, astronomers in a neighbouring galaxy looking at our star would see it at a time before humans emerged, and see no evidence of our civilisation – even if their telescopes were powerful enough.

THE NIGHT SKY
IS A TIME MACHINE

2.5
MILLION
YEARS

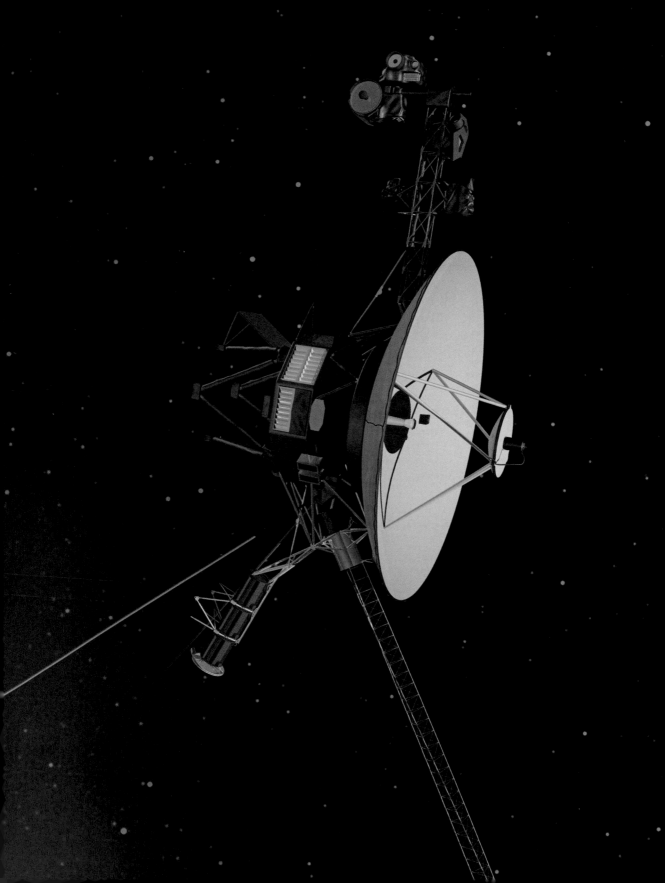

HAS ANY SPACECRAFT DEPARTED THE SOLAR SYSTEM?

At various times in the twenty-first century, journalists have reported that NASA's *Voyager* probes have 'left the Solar System'. Is this true? The answer is somewhat complicated. The 'edge' of the Solar System doesn't have a strict definition and several different criteria are used to define it.

the Sun rules over the space inside the heliosphere, and everything outside this bubble is considered interstellar space

In one definition, the Solar System ends at the heliopause, which is a transition region between the influence of both the solar wind and of deep space particles reaching us from other stars. In essence, the Sun rules over the space inside the heliosphere, and everything outside this bubble is considered interstellar space.

However, there are many objects beyond the heliopause that are bound by the Sun's gravity. In fact, the Oort Cloud – the source of long-period comets – extends to a distance about a thousand times farther from the Sun than the heliopause! The objects in this cloud are members of our Solar System, so it may be more reasonable to consider the edge of the Solar System to be defined by **the orbit of the most distant object bound to the Sun**.

Both *Voyager* probes, the most distant spacecraft ever launched, have traversed the heliopause and, therefore, can be considered interstellar explorers. However, their now unbound orbits are still guided by the Sun's gravity, and therefore they belong to the Solar System. It will take tens of thousands of years for them to fully leave the Sun behind.

The opposite page displays one of the most famous and groundbreaking images in the history of astronomy: the Hubble Ultra-Deep Field (HUDF). Captured by the Hubble Space Telescope (HST) over a number of sessions between September 2003 and January 2004, it has a total exposure time of 963,930 seconds, which corresponds to 11 days, 3 hours and 44 minutes!

The HUDF is the result of an ambitious project that aimed to capture the deepest and most detailed image of the Universe to date. Astronomers chose a small patch of sky in the constellation Fornax, with very few foreground stars in the Milky Way, in order to peer out into the seemingly dark and empty cosmos beyond. The telescope's Advanced Camera for Surveys (ACS) was used to capture colour information in four wavelengths, and the field was subsequently revisited in 2009 after the newly installed Widefield Camera 3 (WFC3) was awarded 66 orbits of the Earth (just under 105 hours) to add three more wavelengths to the data. The

HUDF and subsequent follow-up observations contain over 10,000 individual galaxies, each made of hundreds of billions of stars. Even the smallest, faintest objects are entire galaxies – star cities like our own Milky Way.

an ambitious project that aimed to capture the deepest and most detailed image of the Universe to date

With such striking depth and resolution, this image has cemented its place in virtually every astronomy book published since it was released – including the one you're reading! But such deep field images will, at least in the near future, show us only small portions of the sky. It would take Hubble a million years of continuous observation to capture the whole sky with the same amount of sensitivity.

IT TOOK HUBBLE NEARLY A MILLION SECONDS TO CAPTURE THIS IMAGE

10,000 INDIVIDUAL GALAXIES

Our nearby neighbour, the Red Planet, has captured the imagination of scientists and space enthusiasts for centuries, and interest has grown in recent decades with the intriguing realisation that Mars once held water across its surface – a key factor in the search for life beyond the Earth.

Evidence of ancient Martian water has been found across the planet's surface in the form of features that resemble dried-up riverbeds and lakes. The findings suggest that Mars was once a warmer and much wetter world, which may even have harboured a large ocean. Rocks from Mars that have arrived on Earth – Martian meteorites – also provide evidence of a wetter past. Some contain hydrated carbonates and sulphates, which **indicates exposure to liquid before being ejected into space** by an impact from an asteroid.

Some scientists think up to a third of the Martian surface was once covered with water, due to the presence of an ocean in the planet's northern hemisphere. Called Oceanus Borealis, it would have filled what is now the Vastitas Borealis basin around 4 billion years ago. But it seems that **Mars has been mostly dry for at least two billion years**, with very little water present there today and no significant quantity of liquid water on the surface.

So how did Mars lose its water? The answer is probably connected to the planet's interior. Mars has a weak magnetic field, which we know used to be stronger. As it weakened, the Martian magnetosphere could no longer protect the atmosphere from erosion due to solar wind. As the atmosphere thinned, the surface cooled and **the pressure necessary to prevent water from boiling was lost**. Today, the boiling point of water on Mars is -5 °C. Evidence from impact craters suggests that some sizeable asteroids striking Mars may have disrupted its atmosphere further, causing it to be lost more rapidly. Mars simply dried up.

features that resemble dried-up river beds and lakes

The disappearance of Martian surface water is still something of a mystery, but the fact that it existed at all has fuelled interest in determining whether the Red Planet was once habitable or even inhabited in the distant past.

MARS

WAS ONCE A WETTER WORLD

−5 °C

OMEGA CENTAURI:
KING OF THE
GLOBULAR CLUSTERS

STARS INSIDE THE GLOBULAR CLUSTER

In 1677, Edmund Halley was charting the southern stars from the island of St Helena, when he noticed that Omega Centauri – a 'star' that had once been catalogued by the great Greek astronomer Ptolemy in the second century CE – was distinctly 'non-stellar', appearing in his telescope as a fuzzy patch of light. In the 1830s, John Herschel resolved the object and realised it was a globular cluster.

Globular clusters are quasi-spherical ensembles of many thousands of stars, bound together by their tremendous mutual gravity. These clusters orbit our galaxy, outside its spiral arms, and they are much more populous than those found within the Milky Way. Globular clusters are among the oldest objects in the Universe and many contain truly ancient stars that formed within 1–2 billion years of the Big Bang. **At least 150 globular clusters are known to be associated with the Milky Way**, each typically with a dense core and relatively sparse halo. Omega Centauri looks much like any of the others, but in scale it is off the charts.

Omega Centauri is the largest, most populous globular cluster bound to our Galaxy, home to an estimated 10 million stars! At about 17,000 light-years away, it spans a diameter of approximately 150 light-years. Its population density is extremely high and, were we living on a planet orbiting one of the stars near its core, the night sky would be overwhelmingly bright, blazing with millions of points of light.

There is more to Omega Centauri than its colossal mass. It is also one of the most complex known globular clusters, with multiple populations of stars of different ages and chemical compositions. Among them are a large number of variable stars – stars that vary in brightness over time. Measurements of their change in luminosity provide valuable information about the cluster's age and composition. Omega Centauri also contains several interesting pulsars, which are rapidly rotating neutron stars that emit beams of radiation producing periodic pulses as they sweep in and out of view.

multiple populations of stars of different ages and chemical compositions

Due to its overall brightness, Omega Centauri **is easily visible from the southern hemisphere** and is a popular target for amateur astronomers. In fact, it is quite clearly not a star, even to the unaided eye, and looks absolutely spectacular in a large telescope. Thus, Omega Centauri is a treat for both stargazers and professional astronomers looking to understand its wide offering of astrophysically curious targets.

Einstein's theory of relativity rules that mass increases with speed, making it virtually impossible to get anywhere near the speed of light. It would take an infinite amount of energy to accelerate something even as tiny as a proton to the speed of light. But this rule only applies to objects with mass. Photons – particles of light or other electromagnetic radiation – have no mass, and can freely travel at the speed of light, but something much stranger is happening across the Universe. Space itself knows no speed limit at all. It can expand at any rate, and this expansion can and does exceed the speed of light... by a lot!

The expansion of the Universe as cosmologists understand it is driven by dark energy, which **produces a mysterious force that permeates the cosmos**. At any given moment, the expansion has a measurable speed, which is gradually increasing. The rate of the expansion of the Universe is called the Hubble constant (not really a constant!) and it has been measured with limited confidence to be about 70 km/s per megaparsec (where one megaparsec is 3.26 million light-years).

This strange unit tells us that any two galaxies which are one megaparsec apart will recede from one another at a rate of 70 km every second. At double the distance, the recession is twice as fast and so on. Theoretically then, at a great enough distance, the recession rate will reach and exceed the speed of light.

By measuring the redshift (denoted z) of galaxies, astronomers can estimate their recession velocity. For low redshift values, z corresponds to a ratio of the speed of the object to the speed of light. This relationship is derived from the concept of Doppler shift, but it ceases to be reliable at higher redshifts. We might assume that for $z = 1$, the object is receding at the speed of light, but cosmology is more complicated. In our standard model of cosmology, galaxies have a recession velocity greater than the speed of light when their measured redshift $z \gtrsim 1.5$. There are many galaxies with redshifts higher than this value.

This ought to be a huge violation of physical law. Objects with mass cannot reach or exceed the speed of light. However, galaxies always move *through* space at subluminal speeds. It is the *expansion* of space that causes them to appear to recede from one another so rapidly. It creates the illusion of motion, as the distances between galaxies increase.

space itself knows no speed limit

If we could move the space we were sitting in, **we could develop a warp drive and traverse the Universe at superluminal speeds**. Fortunately, the concept hasn't yet been ruled out, because with ever increasing distances, we're going to need one!

The Milky Way is a fairly large spiral galaxy that exerts gravitational influence in the extragalactic environment around it. Like every significant galaxy we see, it has its own satellites. In fact, the Milky Way commands the orbits of dozens of small galaxies buzzing around it, and at least 59 such objects are known to be bound to it. Some of these dwarf galaxies are quite substantial in their own right, and a couple are even visible with the unaided eye.

The largest and most well-known of the Milky Way's satellites are the Magellanic Clouds, named after the Portuguese explorer Ferdinand Magellan, who got his own first look at them during his voyage around the world in the early sixteenth century. The Magellanic Clouds are in the southern celestial hemisphere, and are therefore **visible by eye from most of the southern hemisphere**, including Australia, New Zealand and South America.

The Large Magellanic Cloud (LMC) is, as the name suggests, the larger of the two and is about 32,000 light-years wide, at a distance of about 160,000 light-years. It's home to roughly 20 billion stars, as well as several star clusters and nebulae. The LMC also harbours the most active star-forming region in the local part of the Universe, known as the Tarantula Nebula. The Small Magellanic Cloud (SMC) is located about 200,000 light-years away and contains just a few billion stars spread sparsely across its 19,000-light-year diameter. The presence of a bar feature in the SMC has led astronomers to believe that it was once a spiral galaxy like the Milky Way, but it has been disrupted by tidal forces.

In addition to the Magellanic Clouds, **there are many other satellite galaxies orbiting the Milky Way**. They include the Sagittarius Dwarf Elliptical Galaxy, which is being slowly torn apart by the gravitational influence of our own, and the Canis Major Dwarf Galaxy, which is the closest known satellite galaxy to the Earth at a distance of just 25,000 light-years. As the list goes on, the satellites get smaller with some being comparable to large star clusters. But at one time they were likely competing to form from the same material as the Milky Way, which came out on top.

It's hardly surprising that we find similar situations in other galaxies like our nearest neighbour, the Andromeda Galaxy. It too dominates its environment, and has many satellites orbiting it. Studies of satellite galaxies provide numerous **insights into the formation and evolution of the Milky Way** and other galaxies like it. For example, astronomers can use the positions and velocities of satellite galaxies to probe the distribution and density of dark matter in the galactic halo. As new methods for peering through our own galaxy improve, we can expect to find more satellites associated with the Milky Way.

THE MILKY WAY
IS A QUEEN BEE

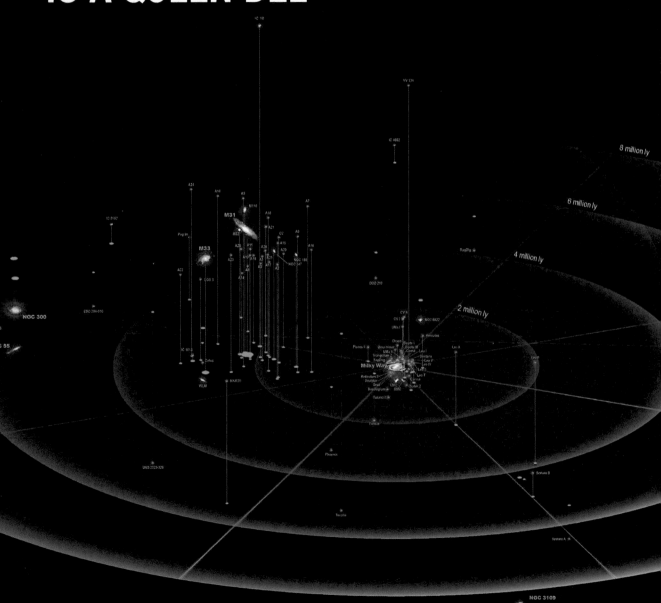

EXPLOSIONS? ALIENS? SUPERCONDUCTING STRINGS? WHAT'S CAUSING THESE STRANGE SIGNALS FROM SPACE?

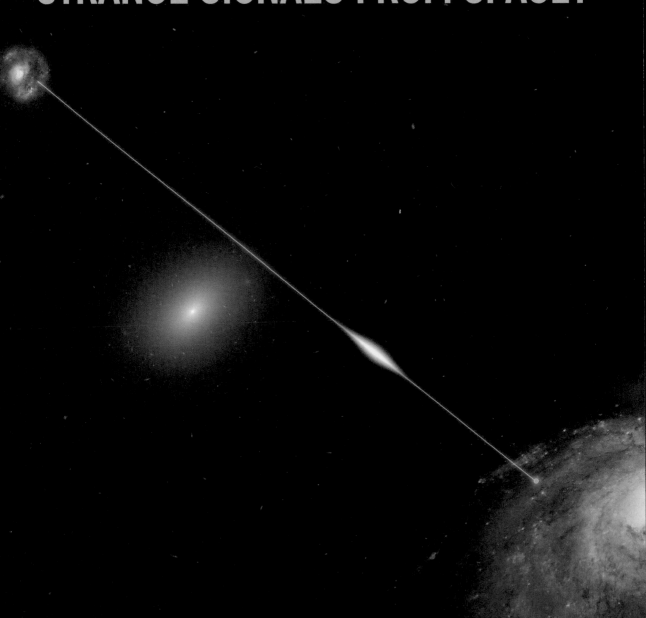

Fast Radio Bursts (FRBs) are intense, short-lived bursts of radio waves that probably originate from distant galaxies. First discovered in 2007, these mysterious flashes have puzzled astronomers ever since, as they seem to defy conventional explanations of astrophysical phenomena. There are many speculative explanations, some much stranger than others.

One of the defining features of FRBs is their duration. Most FRBs last just a few milliseconds, with the longest lasting about three seconds. However, in a single millisecond, a powerful FRB releases as much energy as the Sun does over a period of three days. FRBs therefore rank among the most powerful events ever recorded in the Universe, but being so short-lived, they are difficult to detect and therefore very challenging to properly characterise.

There are several proposed explanations for FRBs, but none have gathered consensus agreement from astronomers. One possibility is that they are caused by highly magnetised neutron stars, known as magnetars. Magnetars are extremely dense and rotate at tremendous speed, generating strong magnetic fields. If a magnetar were to suddenly release some of its extraordinary magnetic energy by an unknown process, it could produce an FRB. Another proposal is that FRBs are caused by the merging of two neutron stars or a neutron star and a black hole. When two objects of this nature collide, the resulting release of energy could generate an FRB as detected on Earth. It could be that FRBs result from particularly energetic supernovae or even theoretical hypernovae, when short-lived, super luminous stars explode catastrophically.

Another, stranger explanation is that FRBs are caused by cosmic strings – hypothetical structures that are central to String Theory. Within the framework, strings are thought to exist in the fabric of space-time. It's been calculated that if a superconducting cosmic string were to vibrate or move in a particular way, it could, under certain circumstances, produce an FRB. Some have even suggested that FRBs may be of intelligent extra-terrestrial origin. They could be signals deliberately sent to other galaxies to demonstrate the existence of an advanced, technological civilisation. While this explanation is highly speculative and lacking corroborative empirical evidence, it remains an intriguing possibility that cannot be completely ruled out.

The study of FRBs is ongoing, with new discoveries being made each year. Several repeating FRBs have been discovered, suggesting that one or more specific processes are involved, and that the objects responsible aren't destroyed. In 2021, more than 500 FRBs were reported by astronomers. As detections gather pace, it's just a matter of time until this mystery is resolved, but for the time being the FRB question invites speculation. What do you think is the cause?

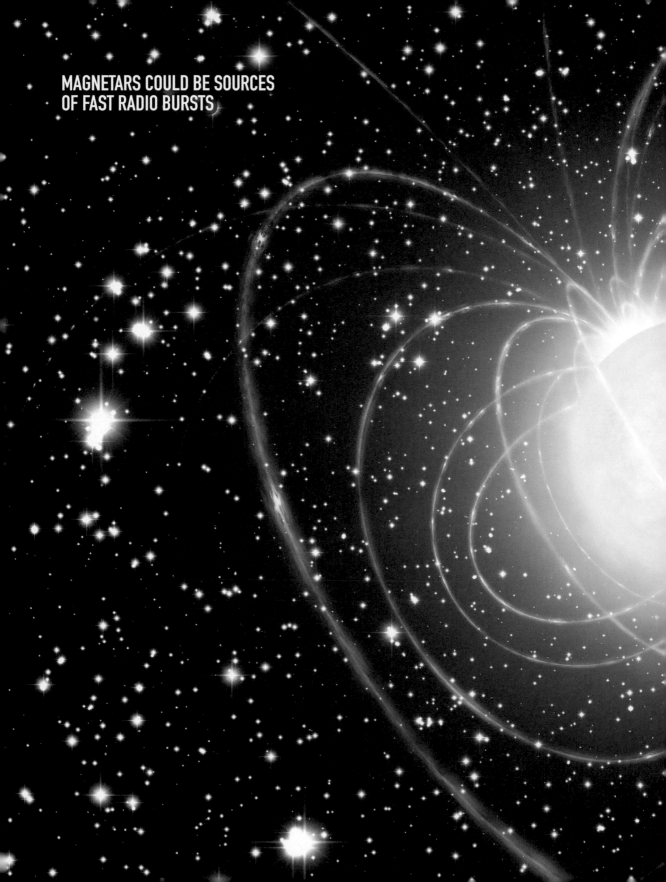

MAGNETARS COULD BE SOURCES
OF FAST RADIO BURSTS

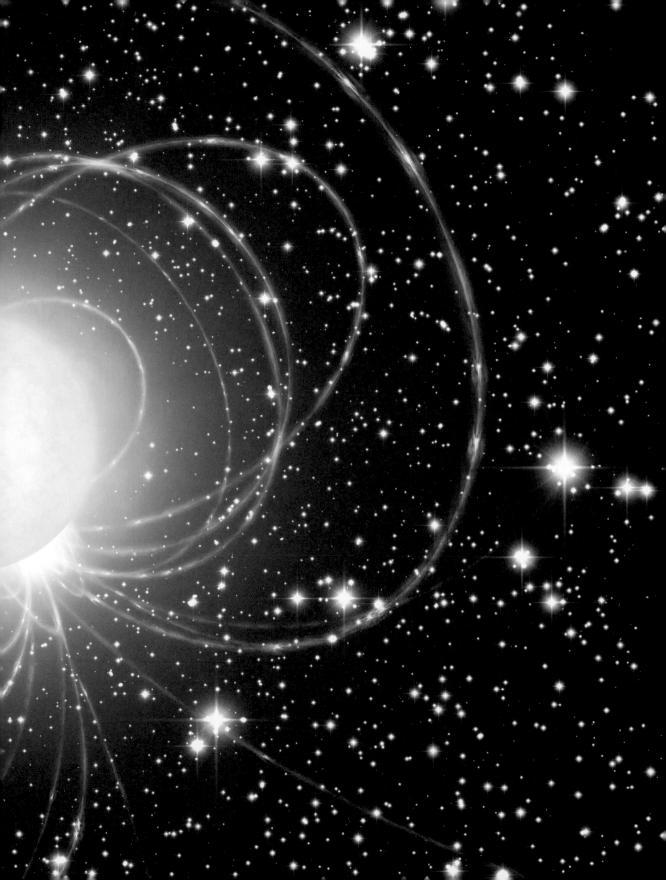

The Sun is a colossal object in our Solar System, large enough to fit every single planet, moon and asteroid inside it, with plenty of room to spare. Yet, on the scale of star sizes, the Sun is very close to the smaller end. Technically, it is a 'dwarf star' in astronomical nomenclature. Many other stars are much larger, some drastically so.

One of the largest known stars is called UY Scuti. It's considered to be a red *hypergiant* star, a class of star so large, that **it challenges the limits of what astronomers usually call supergiants**. Located approximately 9,500 light-years away in the constellation Scutum, UY Scuti appears as a mere point of light, too faint to be seen with the unaided eye. Yet, if we were to travel closer to it, we would see something remarkable. UY Scuti has a diameter approximately 1,700 times larger than the Sun, and perhaps up to 1,900 times larger. To put this into perspective, if this star were placed at the centre of our Solar System, its photosphere – or fluid surface – would extend to beyond the orbit of Jupiter. Put another way, it would swallow all the inner rocky planets, including Earth, as well as the asteroid belt and Jupiter, leaving Saturn as the innermost planet.

UY Scuti was first catalogued in 1860 by German astronomer Hermann Mayer Salomon Goldschmidt, and its probable diameter was determined using a technique called interferometry, which involves combining the light from multiple telescopes to create a very high-resolution image. Despite its impressive size, **it is not necessarily the largest known star**. There are several other candidates for the top spot, that are each also enormous in size. The list includes VY Canis Majoris, NML Cygni and KY Cygni. Of these, NML Cygni could be the largest, with one calculation suggesting it is 2,700 times wider than the Sun. However, UY Scuti has the largest, well-constrained diameter of any known star to date.

it would swallow all the inner rocky planets, including Earth, as well as the asteroid belt and Jupiter

Of course, size isn't everything. These hypergiant stars may be impressive up close, but at a great distance they're points of light like any other. Such stars are unlikely to be suitable hosts for habitable worlds, so to us at least, our little Sun proves to be much more significant. But UY Scuti and others like it offer fascinating insights into the extreme stars that lurk elsewhere in the Universe.

A 'HYPERGIANT'
STAR THAT MAKES THE SUN SEEM TINY

1,700
TIMES LARGER
THAN THE SUN

UY SCUTI

THE SUN,
OUR LOCAL STAR

DIAMONDS EVERYWHERE: THE PRECIOUS STONE LITTERING THE GALAXY

UP TO
100
KILOMETRES DEEP

The prevalence of diamonds in space is a topic that has long fascinated scientists and the general public alike. Diamond, one of the hardest and most lustrous materials on Earth, is formed under extreme pressure and heat deep beneath the surface of the planet. But it turns out that diamonds are not exclusive to our own planet, and may be found throughout the Solar System, Galaxy and beyond.

Scientists have proposed that **diamonds may be formed in the atmospheres of both Uranus and Neptune**, the two outermost planets in the Solar System. These planets, collectively known as the ice giants, have particularly harsh weather conditions, with temperatures plummeting to as low as -200 °C. Despite these extreme conditions, astronomers have discovered the presence of hydrocarbons in both atmospheres and, under the right conditions, they become the building blocks of diamonds.

At Stanford's SLAC National Accelerator Laboratory, researchers recreated the conditions of the Uranian and Neptunian atmospheres and discovered that diamonds do indeed form from the mixture of hydrocarbons observed at both planets. Their findings strongly suggest that **sheets of diamond rain form deep within the atmospheres** and rain down onto the cores. Though they remain well out of reach for now, perhaps in the distant future companies will endeavour to extract them and sell them back home on Earth.

In recent years, astronomers have discovered a number of potentially diamond-rich exoplanet candidates – worlds orbiting stars other than the Sun. One such example is 55 Cancri e, which is located about 41 light-years from Earth, orbiting closely around a star that is slightly cooler and smaller than the Sun every 2.8 days. It is thought that nearly one-third of the planet's composition could be carbon, which researchers believe would form into very large quantities of diamonds under the extreme interior heat and pressure. In fact, some scientists estimate that the surface of 55 Cancri e could be covered in a layer of diamonds up to 100 kilometres deep!

Another diamond-rich candidate is BPM 37093, located about 53 light-years from Earth. It is a white dwarf star, once somewhat similar to the Sun, and has since matured into a much smaller, carbon- and oxygen-rich star. Its brightness varies with a pulsating pattern, and astronomers were able to use this characteristic to measure how much of the star's interior has crystalised as the star has cooled. The calculations indicate that as much as 90 per cent of the star's mass is now a crystal structure – **a solid core made of diamond**, measuring about 2,000 miles across. Nicknamed Lucy (after the Beatles song *Lucy In The Sky With Diamonds*) this star may well be hiding the most valuable diamond yet known, comparable in size to the Moon and 100,000 times heavier than the Earth!

IC 1101: A MONSTER GALAXY THAT DWARFS THE MILKY WAY

Lurking in the sparse constellation Serpens, an elliptical galaxy called IC 1101 sits unassumingly among many others. But this one is not like other galaxies. IC 1101 is of a scale not commonly seen in the Universe. Located approximately 1.15 billion light-years from Earth, it appears faint to us, as a member of the Abell 2029 galaxy cluster.

Measurements of the size of IC 1101 vary, but its diameter is about 400,000 light-years. What makes it a monster, however, is the diffuse halo of stars surrounding it. IC 1101's halo is very extensive, measuring more than 4–6 million light-years across! This makes IC 1101 considerably larger than the Milky Way, which has a disk diameter of about 100,000 light-years and a halo roughly 2 million light-years wide.

Naturally, such a large galaxy is also home to a very large number of stars, measured in the tens of trillions, whereas the Milky Way numbers in the hundreds of billions. The two are also very different in structure. The Milky Way is a barred spiral galaxy, with a central bar and spiral arms containing stars, gas and dust.

In contrast, **IC 1101 is an elliptical galaxy, which means that it lacks a well-defined spiral structure**. Instead, it has a more diffuse and spheroidal appearance, with a smooth distribution of stars and no visible spiral arms.

such a large galaxy is also home to a very large number of stars, measured in the tens of trillions

Another key difference between the two galaxies is their evolutionary history. The Milky Way is considered to be a relatively ordinary galaxy, with a stable rate of star formation. In contrast, **IC 1101 is thought to be a 'relic' galaxy**, meaning that it formed early in the history of the Universe and has undergone significant evolution. It is believed to be the result of the merger of many smaller galaxies, which has led to its enormous size and colossal halo of stars.

4–6
MILLION
LIGHT-YEARS
ACROSS

BLACK HOLES:
CREATORS OF GALAXIES AND DESTROYERS OF WORLDS

Black holes are some of the most mysterious and enigmatic objects in the Universe. Characterised by their incredibly high density and extreme gravitational influence, which is strong enough to bend light on its path through space, they are usually imagined to be incredibly destructive forces in nature. Yet, while black holes may occasionally swallow star systems, they can also be creative and have played a crucial role in the formation and evolution of the galaxies that populate the Universe, including our own Milky Way.

a Universe without black holes would probably look very different

Astronomers have suggested that early in the history of the Universe, powerful supermassive **black holes formed from the collapse of massive stars**. This early generation of black holes, created by gigantic, overfed stars, were much larger and more massive than the ones which typically form today, and they exerted a significant influence on the material around them. Disrupting clouds of gas and clusters of stars, they built up galactic structures around themselves. In a twist that belies their reputation, it seems that black holes of this kind actually **curate and tend to their galaxies**, helping them grow and evolve.

Black holes also form today as a result of supernova explosions, which create shockwaves that can trigger star formation in the gas clouds around them. Observations suggest that some black holes, which release powerful jets of ionised material as they feed, actually stimulate the formation of yet more stars by producing clouds of gas that are cool enough to condense and collapse. These active black holes are like engines of star formation, which is essential for new worlds – including planets that support life – to emerge. A universe without black holes would probably look very different to ours, and it's improbable that Earth would exist were it not for these strange, dead stars.

Of course, stray too close to a black hole and you will see its angry side. Despite their creative potential, black holes are still capable of immense destruction. As they consume matter, **they can devour entire star systems, including any planets they may host**. Fortunately, it's not a risk we need to consider in our corner of the Galaxy, so we can enjoy the spectacle and continue to study the duality of these fascinating objects from afar.

CAN A DAY BE
LONGER
THAN A YEAR?

243.025
EARTH DAYS

On our home planet, we're very used to our long years, each lasting 365.25 solar days. Almost every living thing on the planet is influenced by these cycles. However, on our nearest neighbouring planet, the relationship between the day and the year is very different.

it would seem that a Venusian day is longer than its year

Venus, the second planet from the Sun, is sometimes referred to as Earth's 'evil twin' due to the pair's similar sizes and compositions, but very different climates. While Earth has a rotation period of 23 hours, 56 minutes and 4.1 seconds, Venus takes much longer to make a full rotation on its axis, with a period of about 243.025 Earth days. By comparison, it takes Venus just 224.7 Earth days to orbit the Sun, so it would seem that a Venusian day is longer than its year. But is that really the case?

This depends on how we define a day. **The rotational period of a planet, or any other celestial body, is called its sidereal day**, but we started keeping time by measuring the position of the Sun in the sky, so our calendar is based on solar days. On Earth, the average solar day is 24 hours long, just a few minutes longer than the sidereal day. On Venus, the sidereal day is so long that the planet's orbit has a much greater influence on the Sun's position in the sky than it does on Earth. The result is a solar day lasting 116.75 Earth days.

Therefore, on Venus, there are 1.92 solar days in a year. Another curiosity about the rotation of Venus is that **the Sun rises in the west and sets in the east**, due to the fact that the planet's rotation is retrograde, or in the opposite direction of the Sun and most other planets in the Solar System. In reality, the thick atmosphere appears so hazy, that the Sun would be impossible to see from the surface.

Why does Venus rotate so slowly? Scientists believe that it may be due to the planet's atmosphere creating a drag force that slows down the planet's rotation. Another possibility is that **Venus may have been impacted by a large celestial body early in its history**, which could have caused it to slow down. This may also have reversed its rotational motion, or possibly knocked the young planet upside down.

The innermost and smallest planet, Mercury, also experiences a long sidereal day, rotating once every 176 Earth days and orbiting the Sun in just 88 Earth days. However, as with Venus, at 59 Earth days its solar day is shorter than its year. It rotates three times for every two orbits of the Sun, indicating a 'spin-orbit resonance' that occurs quite frequently where small bodies orbit much larger ones.

Neutron stars rank among the most extreme objects in the Universe, alongside their siblings, black holes. These incredibly dense, often rapidly spinning objects are formed when a massive star collapses at the end of its life. The ensuing explosion, called a supernova, can result in a rapid core collapse that will produce either a black hole, or more commonly a neutron star.

Neutron stars are so dense that if we could extract a single cubic centimetre sample from the surface of one, it would contain a mass of about a billion tonnes. As with black holes, their **incredible density creates gravitational forces that can influence the direction of light**.

Neutron stars often rotate rapidly as a result of a sudden increase in angular momentum when a star explodes. The core is compressed extremely quickly, and must spin faster in much the same way as an ice skater bringing their arms in closer to them.

if you could stand on its equator, you would be travelling at over 70,000 km/s

Some neutron stars are able to spin **hundreds of times per second**, despite being typically a few tens of miles wide. As a result, their surfaces can reach astonishing speeds.

The fastest spinning neutron star known to astronomers is called PSR J1748-2446ad, located about 18,000 light-years from us in a globular cluster in the constellation Sagittarius. It has been measured to rotate 716 times per second, producing a 716 Hz radio pulse as it spins like a lighthouse mirror. The extreme speed at which PSR J1748-2446ad spins is more impressive when viewed from the surface. If you could stand on its equator, you would be travelling at over 70,000 km/s, approximately 24 per cent of the speed of light. At such speed, you would experience minor relativistic effects, including time dilation, length contraction and increased mass.

Rotating neutron stars that produce regular pulses of radio waves are called pulsars. Not all are quite as fast as PSR J1748-2446ad, but they do share a common trait: they are all very reliable. As a result, scientists have considered using numerous pulsars to establish a new time standard, alongside atomic clocks, with which to make extremely accurate cosmic measurements.

THE NEUTRON STAR THAT SPINS AT 24 PER CENT OF THE SPEED OF LIGHT

716
TIMES
PER SECOND

Eta Carinae is a binary star system located in the constellation Carina, approximately 7,500 light-years away from Earth. It is one of the most massive, unpredictable and extreme systems to have been studied in detail.

Collectively, its two members are more than five million times as luminous as the Sun and they interact as they orbit each other every 5.5 years, resulting in a volatile relationship. The two stars in the Eta Carinae system are both very massive, with the larger star being over 100 times the mass of the Sun. The smaller star is at least 30 times the mass of the Sun.

Towards the middle of the nineteenth century, astronomers noticed the smaller star had unexpectedly brightened and it would continue to do so, **temporarily peaking as one of the brightest stars in the night sky**. It underwent what would become known as the 'Great Eruption' over a period of 18 years. The outburst released an enormous amount of energy and material, and created a stunning, hourglass-shaped cloud around the stars known as the Homunculus Nebula.

The cause of the Great Eruption is not fully understood, but it is attributed to the turbulent relationship between the two stars. The larger star is nearing the end of its life and is **expelling material at an incredibly fast rate**. Some of this ejecta is accreted by the smaller star, which in turn heats up and emits intense radiation. Variations in the amount of material falling onto the smaller star result in an unpredictable change in brightness over time.

turbulent relationship between the two stars

Eta Carinae is also a source of high-energy radiation, including X-rays and gamma rays. These emissions are thought to be produced by the interaction between the stars and their surrounding material, including the Homunculus Nebula. Eventually, the primary star's core will run out of fuel and it will collapse to **trigger a supernova explosion that may destroy its partner** and completely disrupt the surrounding nebula. These two stars are both living on the edge!

ETA CARINAE:
LIFE ON THE EDGE

FIVE MILLION TIMES AS
LUMINOUS AS THE SUN

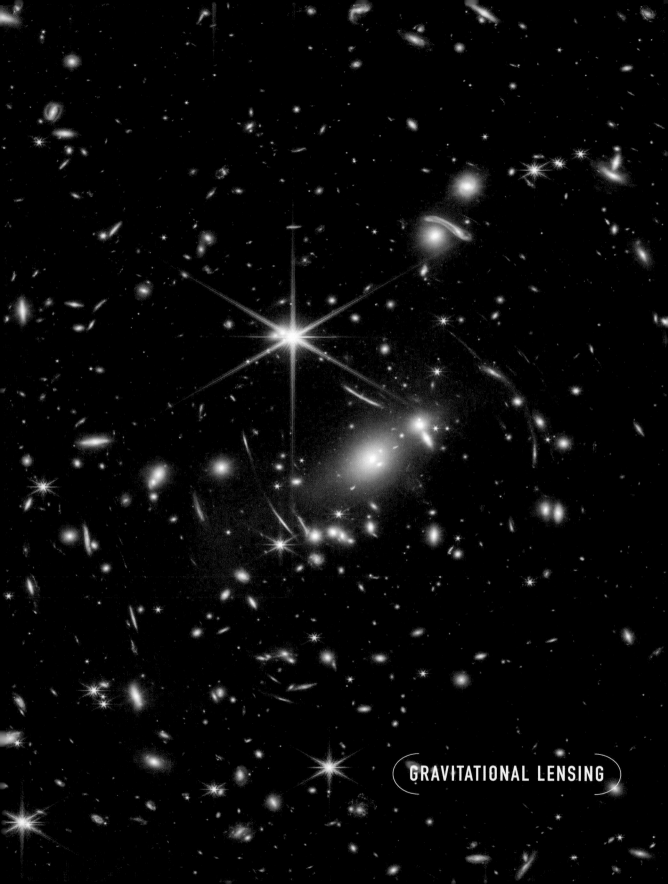

GRAVITATIONAL LENSING

GIGANTIC LENSES MADE OF DARK MATTER DISTORT OUR VIEW OF THE UNIVERSE

In 1915, Albert Einstein published his general theory of relativity, which revolutionised our understanding of gravity, not as a force but as a geometric distortion of space-time. Among the many novel predictions of this theory was the idea that light, like massive objects, can be affected by gravity. Light's path should be altered when it passes close to a heavy object.

images that result from these observations are among the strangest in astronomy

The phenomenon, which has become known as gravitational lensing, was confirmed during observations of a solar eclipse in 1919. Background stars appeared to change position when close to the edge of the Sun, the gravity of which altered the paths taken by their light. There are **far larger and heavier concentrations of mass** in the Universe, which act as visually striking gravitational lenses on enormous scales. Massive galaxies or galaxy clusters, infused with large amounts of dark matter, are capable of smudging, smearing and multiplying images of the galaxies that lie beyond them.

As such, gravitational lensing offers an indirect way to study the properties of dark matter and profile the mass distribution of the Universe. By observing the lensing of background sources, astronomers can map out the density of dark matter to better understand its influence at different times in cosmic history. The images that result from these observations are among the strangest in astronomy, appearing as though **galaxies are being seen through turbulent water or a strange glass sculpture**. Yet these are real lenses formed of imperceptible, exotic matter on a scale that defies our everyday experience.

ROGUE PLANETS ARE
LURKING IN THE DARKNESS
BETWEEN THE STARS

For most of the history of astronomy, scientists assumed that planets could only exist within the confines of a star system, forming and orbiting around a star. But recent discoveries have revealed that there may be a vast population of rogue planets, free-floating through space without a star system to call home.

the number is comparable to the number of stars in the Milky Way — hundreds of billions

The first observations of probable rogue planets arrived in 2011 when a team of researchers, using the Subaru Telescope in Hawai'i, peered at 50 million stars, detecting ten cases of 'microlensing' from objects approximately the size of Jupiter. Microlensing occurs when **a compact object with a large mass passes in front of a star, boosting its brightness**. It requires astonishing sensitivity to detect this distortion from something as small as planet.

In the years that followed, many more rogue planet candidates were discovered using this technique, and various statistical estimates have been made about the number of rogue planets that may be floating freely through the Galaxy. Some calculations suggest that the number is comparable to the number of stars in the Milky Way –

hundreds of billions. Others claim the true figure may be much higher. The lightest known candidate, OGLE-2016-BLG-1928, has an estimated mass about ten times that of the Earth. It seems the discovery of Earth-sized rogue planets is just a matter of time.

How do these rogue planets come to be? One theory suggests that they are formed in much the same way as regular planets, through the accretion of gas and dust within a protoplanetary disk. However, rather than staying captured by a nearby star's gravitational pull, **these planets are ejected from their home system** by gravitational interactions with other planets or nearby stars during their formation. Young solar systems can be very chaotic, and simulations suggest that some protoplanets may have been ejected from our own Solar System billions of years ago.

So-called 'sub-brown dwarfs', which are even smaller than brown dwarfs and can have masses similar to planets, could account for at least some rogue planet candidates. They form by themselves in a similar way to stars, and thus **already float freely without a system of origin**.

Understanding the nature and quantity of rogue planets is important to astronomers seeking to accurately measure the mass and density of the Milky Way. They also stand to teach us about the dynamics of ejected worlds and the fuzzy line between large planets and very small, supercool stars.

The Sun is a lone star, travelling through the Galaxy with its collection of planets, dwarf planets, comets and asteroids in tow. The stars we see in the night sky also appear to travel alone, but things aren't quite the way they seem. The Sun making its own way was once thought to be quite atypical for a star, because astronomers used to think that most stars in our Galaxy exist in binary or multiple star systems, meaning that they have one or more companion stars in close proximity.

It was estimated that **up to 85 per cent of all the stars in the Milky Way are bound in binary or multiple star systems**, and this is indeed true of a sizeable proportion of stars. They are born in large, star-forming nebulae, which supply ample material for new systems to arise. These nebulae are many billions of times larger than our entire Solar System, and contain pockets of higher density, where fragments of a larger cloud collapse due to gravity.

The fragmentation of a large nebula will seldom result in just one star. Rather, multiple stars will be born within the same cloud in close proximity to one another. Stable systems can only emerge when the dynamics of the cloud are just right. A pair of stars, for example, must co-orbit each other without spiralling inwards lest they destroy one another. More complex multiple star systems are also possible and can remain stable for billions of years, though these are less common than binary systems.

Astronomers are fortunate that binary systems are as common as they are. By studying their orbits, it becomes elementary to determine the masses of both companions, and build a profile comparing stellar masses to their ages and temperatures. The long history of observing binary pairs has provided **a deep insight into how different types of stars evolve** throughout their lives. Recently the discoveries of exoplanets in binary systems, which were previously thought to be unsuitable for planetary systems, have raised hopes of finding life elsewhere in the Galaxy.

lonely red dwarfs outnumber them all

But more recent research, which takes into account red dwarf stars, shows that most stars are solitary. Red dwarfs, which are challenging to observe due to their faintness, account for the majority of stars in the Milky Way, and most of them travel alone. These diminutive stars usually form in small nebulae, starved of material that is so richly available in giant star-nurseries. About 25 per cent of red dwarf stars, and over half of the more massive and brighter stars have companions, but lonely red dwarfs outnumber them all.

SOME STARS LOVE COMPANY,
MOST DON'T

A COLLISION OF TWO GALAXY CLUSTERS MADE DARK MATTER IMPOSSIBLE TO IGNORE

OVER 16 MILLION KM/H

The Bullet Cluster is well-known to astronomers for providing observational evidence of the elusive substance known as dark matter, but it isn't just one cluster. Rather it's a pair of galaxy clusters that collided with each other at speeds of over 16 million km/h. Slamming into each other with such tremendous force, the gas clouds between the galaxies were superheated to millions of degrees, emitting X-rays (shown in pink) that were detected by the Chandra X-ray Observatory.

dark matter is a form of matter that does not interact with light or other electromagnetic radiation

Much more surprising was the distribution of dark matter (shown in blue). Dark matter is a form of matter that does not interact with light or other electromagnetic radiation, making it invisible to telescopes. **It can only be detected indirectly through its gravitational effects on visible matter**.

Astronomers have long suspected that dark matter exists because galaxies and galaxy clusters move as if they are being pulled by more mass than can be accounted for by the visible matter alone. The Bullet Cluster provided one of the most compelling pieces of evidence for dark matter.

When the two clusters collided, the visible matter (primarily composed of gas and stars) slowed down and heated up due to the collision, while the dark matter in each cluster continued to move forward, unaffected by the collision. As a result, **the visible matter became separated from the dark matter**, and the two lobes of dark matter are clearly detectable at the edges of the merger. The dark matter distribution was mapped by measuring the gravitational lensing effect, in which the gravity of a massive object bends and magnifies the light from more distant objects behind it. The distorted images of many background galaxies provided ample data for astronomers to map the Bullet Cluster.

The astonishing result was consistent with the theory of dark matter – specifically that it interacts almost solely through gravity and has limited capacity for self-interaction, relative to ordinary matter. The observation was not only an impressive confirmation of the existence of dark matter, but also important to characterising it more fully, and helping astronomers understand its influence on the evolution of the Universe.

Gravitational waves are among the strangest phenomena observed in the Universe. They are ripples in the fabric of space-time that are created by the motion and interaction of incredibly massive objects. The prediction that these invisible waves could exist was originally drawn from Albert Einstein's general theory of relativity, which was first published in 1915. But it wasn't until a century later, in 2015, that they were directly detected for the first time.

Gravitational waves are created when massive objects, such as black holes or neutron stars, move around each other rapidly. In close orbits, they create ripples in the fabric of space-time, which radiate outwards at the speed of light. The ripples take energy away from the system, causing the objects to spiral towards each other until they eventually merge in a spectacular collision. The intensity of the gravitational waves increases dramatically in the moments before the two dead stars merge.

The events that form them are very energetic, but at great distances the detection of gravitational waves is an incredibly challenging task. The waves are extremely faint, and their effects are only noticeable over large distances. To record them, scientists use sensitive instruments called interferometers, which work by splitting a laser beam into two separate beams, and then sending them down separate arms that are several kilometres long. The two beams are then reflected back to a central detector, where they are combined. If a gravitational wave passes through the detector, it will cause the arms to change length very slightly, which will result in a small shift in the phase of the beams when they are combined. By measuring this shift, scientists can detect the presence and strength of gravitational waves, as they alter the size and shape of the Earth by a tiny amount.

The first detections of gravitational waves were by the Laser Interferometer Gravitational-Wave Observatory (LIGO). The first signal recorded was produced by the collision of two black holes, which were located about 1.3 billion light-years away from Earth. The detection provided yet another line of evidence confirming Einstein's theory and opened up a new window on the Universe. Needless to say, it sent ripples (no pun intended) through the world of astronomy.

Since then, even more detections have been made by LIGO and its European counterpart, the Virgo detector. These observations have included collisions of both black holes and neutron stars, and they have provided scientists with a wealth of new information about their behaviour. The collisions of neutron stars in particular are thought to play an important role in the chemical evolution of the Universe, so being able to observe them – even indirectly – is a fantastic milestone for astronomers.

COLLIDING BLACK HOLES AND NEUTRON STARS RELEASE RIPPLES IN SPACE-TIME THAT CHANGE THE SHAPE OF THE EARTH

1.3 BILLION
LIGHT-YEARS AWAY

229
DAYS

SOME PLANETS HAVE MORE THAN ONE SUN

In 1977's *Star Wars* film, the farm boy Luke Skywalker dreams of adventure as he gazes out at the binary sunset of his home world Tatooine. It's an iconic scene that lends an otherworldly quality to the film's setting, but what was once science fiction is now science fact.

In 2011, NASA's Kepler Space Telescope discovered a curious planet approximately 200 light-years away: Kepler-16b. What made the finding remarkable is that Kepler-16b is a circumbinary planet, meaning that **it orbits around two stars, rather than just one**. On this world, binary sunsets really do occur! What's more, its host stars are approximately yellow and red in colour, somewhat like the twin suns of Tatooine.

Excitement about Kepler-16b peaked when astronomers calculated that it was in the habitable zone of its host stars, but unfortunately it is unlikely anything is living there. Kepler-16b is a gas-giant planet, with a mass about the same as Saturn, and it has no solid surface to support life as we know it.

The two stars that Kepler-16b orbits around are both smaller and cooler than the Sun. The larger star, Kepler-16A, is a K-type star, while the smaller star, Kepler-16B, is an M-type star. The exoplanet orbits around both stars at an average distance of approximately 105 million kilometres, with an orbital period of 229 days.

what was once science fiction is now science fact

The discovery of Kepler-16b surprised astronomers, who expected binary stars to be too unstable for planetary systems. The discovery suggests that **circumbinary planets may be more common than previously thought**, and several more have turned up since. These findings open up new possibilities in the ongoing search for habitable worlds.

THE **YOUNG MOON** CREATED 'SUPERTIDES' UNLIKE ANYTHING SEEN TODAY

20 TIMES HIGHER

The Moon is thought to have formed approximately 4.5 billion years ago from a giant impact between the proto-Earth and another large object. After its formation, it receded from the Earth and cooled to become the remote, barren world we see today. It is the master of the tides, gently pulling on the oceans, which seem to rise and lower as our planet rotates. The tides play an important role for a wide variety of lifeforms today, but the Moon's influence on us is quite subtle. However, it once had a much greater impact on the oceans, and possibly shaped the pace of the emergence and evolution of life on Earth.

supertides would have had a significant impact on the emerging climate of our young planet

Scientists have calculated that the young Moon likely created 'supertides' in the oceans of the young Earth. Research using computer simulations suggests that, approximately a billion years after the Moon's formation, when it was **much closer to the Earth than it is today**, its stronger gravitational influence raised tides that were up to 20 times higher than those we experience now.

Supertides would have had a significant impact on the emerging climate of our young planet, and the thermal and chemical properties of the oceans. Such tides may have helped to distribute warm water and nutrients, widening the range of habitats suitable for primordial lifeforms to flourish and accelerating the global habitation of the Earth. The tides also **caused the Earth's rotation to slow down, as they still do today**, and this change in rotation rate lengthened the days and nights, allowing for longer periods of sunlit heating and unlit cooling in the atmosphere. This changed the climate and influenced all forms of life.

The study of supertides is fascinating, but the extent of their impact is difficult to study directly. The Earth's geological record from this early period is quite incomplete, but future research will fill in the gaps and one day we'll know much more about the Moon's true role in our own deep history.

The afterglow of the Big Bang, also known as the Cosmic Microwave Background Radiation (CMBR), is the oldest light to be emitted across the Universe, and one of the most significant discoveries for modern cosmology. It is the residual radiation from the Big Bang, which occurred approximately 13.8 billion years ago, and is considered as the key evidence supporting the Big Bang theory.

The CMBR was first discovered by accident in 1965 by two American scientists, Arno Penzias and Robert Wilson, who were working on a radio antenna in New Jersey. They **found a faint hissing noise** that was present in every direction and across a wide range of frequencies. Initially, they thought it was due to noise or interference from birds, but after ruling out all other possible sources of interference, they realised that they had discovered something remarkable in space.

The CMBR is a form of electromagnetic radiation that permeates the entire Universe and is present in every direction in the sky. It has a temperature of approximately 2.73 Kelvin (-270.42 °C), which is just a few degrees above absolute zero, the coldest theoretical temperature. The radiation is almost uniform in temperature across the sky, with very small variations of only a few parts in a million.

These variations, called anisotropies, were first detected by NASA's Cosmic Background Explorer (COBE) satellite in 1992, and later confirmed by other missions, such as the Wilkinson Microwave Anisotropy Probe (WMAP) and the European Planck satellite. The anisotropies in the CMBR are believed to be **caused by the density variations in the early Universe**, which were amplified by gravitational instability to form the large-scale structures, such as galaxies and clusters of galaxies, that we see today. By studying the anisotropies, cosmologists can infer the properties of the Universe, such as its age, geometry, and composition, and test various cosmological models.

When the CMBR was emitted 379,000 years after the Big Bang, it had a temperature of about 3,000 Kelvin, but as the Universe has expanded, it has been spread out, effectively lowering its temperature and frequency. What was once high-frequency, high-energy radiation is now microwaves with a peak frequency of 160.23 GHz. If you're old enough to remember analogue television, you'll be familiar with the static seen when not tuned to a channel. Since the receiving antenna is sensitive to the waveband covered by the CMBR, it is picked up and interpreted on the screen! Unfortunately, other sources of noise are far stronger, so only a tiny fraction of what is seen on screen is contributed by the CMBR. Nevertheless, **the afterglow of the Big Bang is still being broadcast** all over the Universe for those looking to tune in, accidentally or not.

THE UNIVERSE
HAS ITS OWN TV CHANNEL

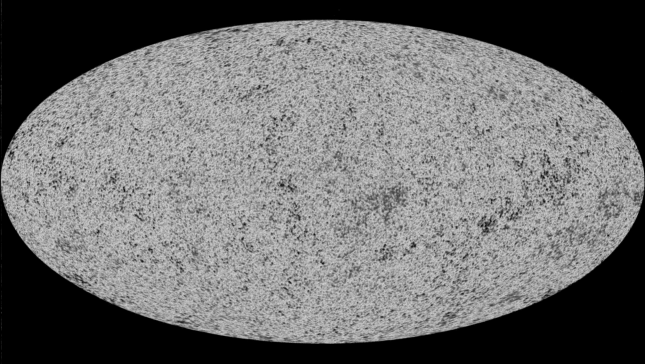

160.23 GHZ

At Jupiter – the king of the planets – everything is bigger. A big planet with big storms and big moons. It's hardly surprising that when it comes to auroras – a feature seen on almost every planet in the Solar System – Jupiter's are the most intense. Auroras on Jupiter are simply unlike anything we see on Earth.

Our planet's auroras are a spellbinding sight. The Northern Lights, which are more commonly seen than the Southern Lights, draw millions of tourists to northern climes every year. They form as a result of charged particles (mostly electrons) in the solar wind being driven into the atmosphere at high speed by the Earth's magnetic field. The interactions between accelerated solar electrons and the gases in the atmosphere result in visible light being emitted where the magnetic activity is most intense.

Jupiter's auroras are generated in much the same way, but its magnetic field is about twenty times stronger than the Earth's. At a much greater distance from the Sun, the solar wind is less dense, offering fewer electrons. But Jupiter has its own source, which supplies most of the charged particles that generate its auroras. They're mostly fed by Jupiter's supervolcanic moon Io.

Pressure in the volcanoes on Io frequently builds up due to tidal interactions with Jupiter and the other large moons. Inevitably, they erupt, blasting charged particles into Jupiter's magnetosphere.

These bursts of electrons and other ions, coupled with the intense power of the Jovian magnetic field, create flare-ups in Jupiter's auroral oval that would be truly spectacular to witness up close.

incredibly bright, varicoloured ribbons of light dancing across the sky

Unfortunately, Jupiter's radiation environment is utterly lethal to humans. Moreover, being a gas giant, it offers nowhere to stand, so it's unlikely anyone is going to go aurora-chasing there. But we can imagine how it would appear. Floating above the clouds under a Jovian aurora storm, we would witness incredibly bright, varicoloured ribbons of light dancing across the sky. The variety of colour on display would far exceed that of terrestrial auroras, which are typically green, with a hint of pink or red during an excellent display. Meanwhile, on Jupiter, enormous arcs of lightning shoot through the clouds.

Recently, spacecraft such as NASA's *Juno* mission have provided new and detailed observations of Jupiter's auroras, allowing scientists to study them in greater detail than ever before. We stand to learn a lot about the planet's atmosphere and magnetic environment in the process.

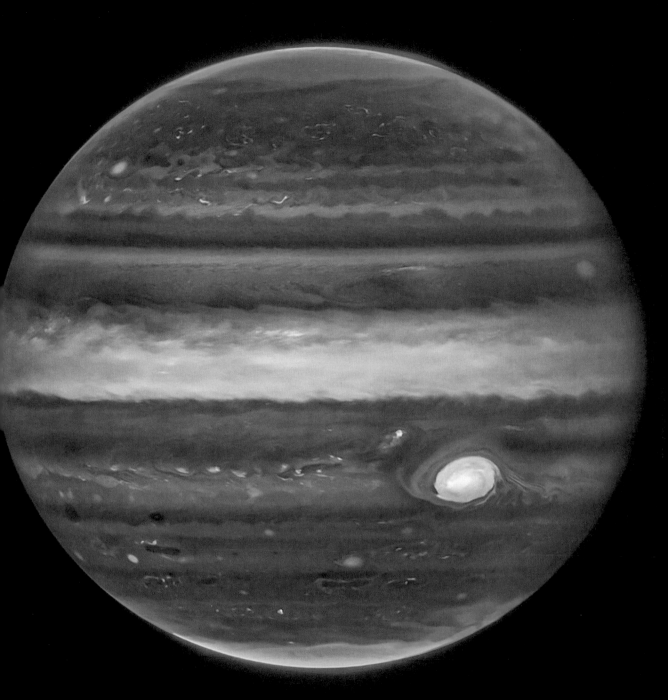

JUPITER HAS THE WILDEST
AURORAS IN THE SOLAR SYSTEM

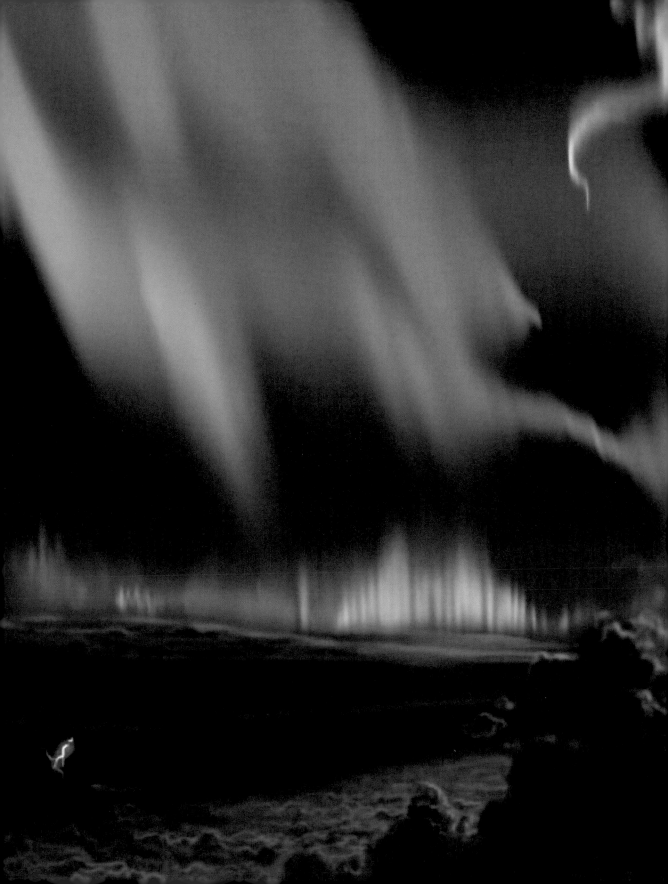

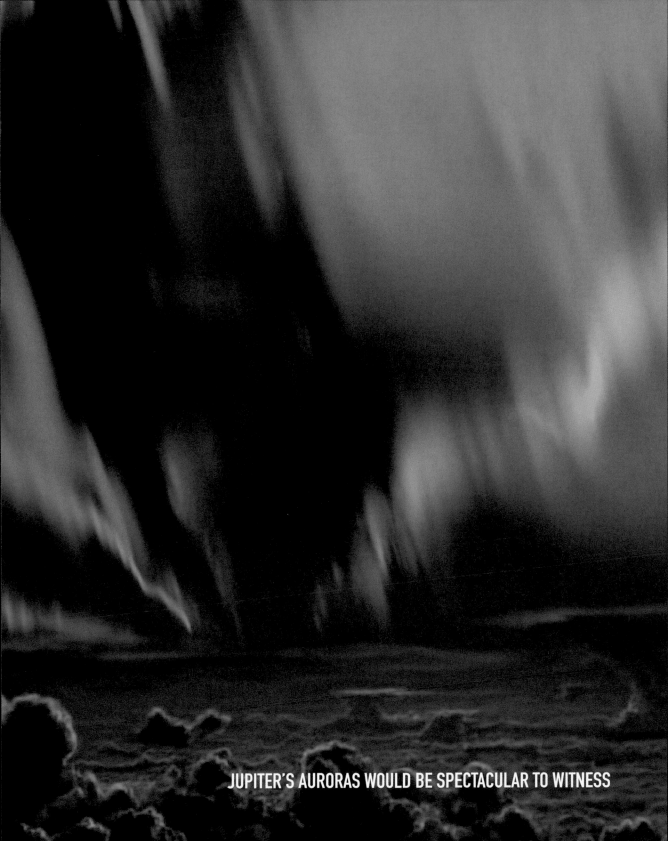
JUPITER'S AURORAS WOULD BE SPECTACULAR TO WITNESS

WHY IS MERCURY'S CORE SO BIG?

Mercury is the smallest planet in our Solar System, but in a surprising twist, its density is much higher than one might expect. In fact, Mercury is almost as dense as the Earth. Earth's high density is a result of gravitational compression, but Mercury – a smaller and lighter planet – has an intrinsically high density due to the presence of a very large core that is rich in iron.

Calculations of the radius of Mercury's core show that it occupies about 57 per cent of the volume of the entire planet. In contrast, the Earth's core accounts for just 17 per cent of its volume. Mercury's core is also the most iron-rich of all the major planets and it's not entirely clear how this came to be the case.

There are two leading hypotheses for why Mercury ended up with such a substantial core, both of which start with the assumption that **it was once a larger planet** with core proportions closer to its terrestrial neighbours – Venus, Earth and Mars. In one scenario, Mercury may have acquired much of the lighter, rocky material in its mantle and crust in a large collision with another protoplanet early in the Solar System's history. A competing idea is that Mercury formed before the Sun's temperature and energy output lowered. If so, a larger Mercury would have been blasted by intense radiation, capable of vaporising its outer layers before the young Sun reached a cooler, calmer state.

the most iron-rich of all the major planets

Curiously, measurements by NASA's *Messenger* spacecraft have presented stumbling blocks for both proposed ideas. Perhaps an old hypothesis, that the solar nebula dragged silicate material away from the proto-Mercury, explains its iron-rich nature. The ESA/Japan Aerospace Exploration Agency (JAXA) *BepiColombo* mission **may provide the clues necessary to answer this puzzle**, after it arrives at Mercury in 2025.

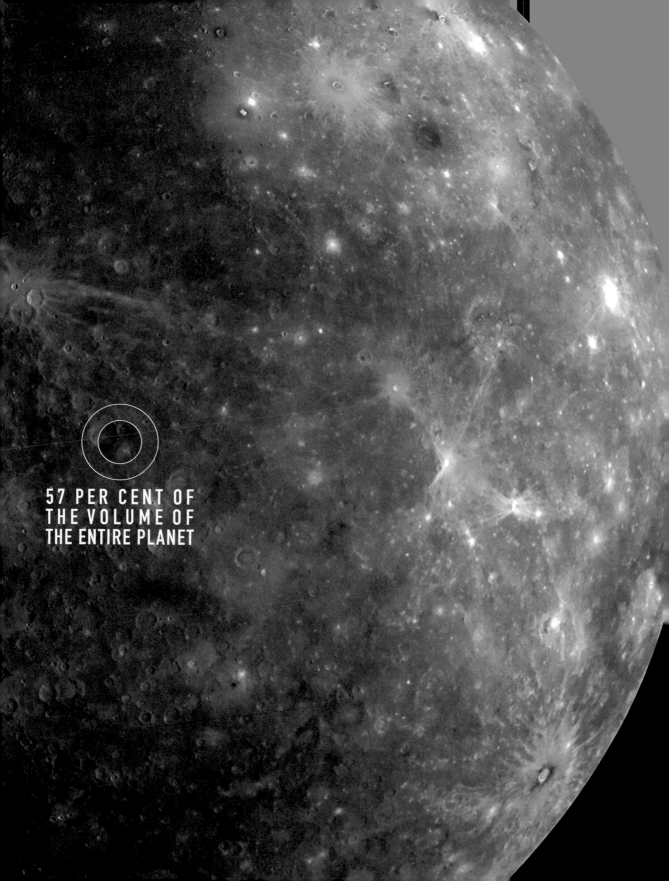

57 PER CENT OF
THE VOLUME OF
THE ENTIRE PLANET

STELLAR CREATION ON A GARGANTUAN SCALE

Starburst is a process that has been seen to occur in galaxies across the Universe, in which large numbers of stars form together in dense clouds of compressed gas. Typically, many massive and luminous stars are born in these regions, making starburst galaxies particularly bright and emissive in high energy radiation such as ultraviolet (UV) light.

hundreds or thousands of times greater than the normal rate

The process of starburst can be triggered in various ways, including **galaxy interactions, collisions, mergers and other gravitational perturbations**. They cause disruption to the interstellar medium (ISM), which increases the rate at which large gas clouds collapse, creating favourable conditions for the formation of luminous stars.

Powerful stellar winds and shock waves, released from tumultuous young stars, further disrupt the surrounding medium, **triggering even more star formation**. The rate of star formation during a starburst event can be hundreds or thousands of times greater than the normal rate in an unperturbed region.

Although the process that triggers starburst (such as a galaxy merger or the cannibalisation of satellites galaxies) can appear destructive, the starburst event itself is highly creative. The surge of new, powerful stars will turn out chemically enriched gasses when they die, **seeding more material for the formation of planets** – perhaps habitable ones – in the distant future.

MESSIER 94

Today a wide variety of exoworlds, including exomoons, has been found, leading to more possibilities of identifying a potentially habitable planet with similar conditions to the Earth. This is very exciting, but we shouldn't forget the first known exoplanets. After all, many of them belong to a whole new category unlike anything we see in the Solar System.

Large, gas-giant exoplanets orbiting very close to their parent stars are labelled 'Hot Jupiters'. Most of them have orbits ranging from 20 hours to a few days, which means they are much closer to their stars than Mercury is to the Sun. As a result, they are searing at outrageously high temperatures, which results in some exotic properties. In our Solar System, Venus is the hottest planet, with surface temperatures that exceed 450 °C, but this pales in comparison to the hottest Hot Jupiters.

KELT-9b, located about 650 light-years away from us in the constellation Cygnus, is the hottest yet discovered. It completes one orbit about its powerful parent star every 1.5 days and is tidally locked, meaning one side is always facing the star. The result is a blistering surface temperature almost ten times hotter than Venus at 4,300 °C! KELT-9b's atmosphere is so hot that hydrogen molecules break apart and stream away in a tail of ions, which trails behind the planet. Some of these ions reform into hydrogen atoms and molecules on the planet's night-side, which is permanently in shadow but still very warm.

KELT-9b is one of many superheated exoplanets. Other examples include WASP-121b, 900 light-years away from us in the constellation Puppis, and HD 209458b, 150 light-years away in the constellation Pegasus. WASP-121b orbits its star every 1.3 days and has a surface temperature of around 2,600 °C. Observations of this planet have revealed the presence of a stratosphere, or an upper layer of the atmosphere that is warmer than the lower layers, possibly due to the absorption of ultraviolet radiation from the star. HD 209458b orbits its parent star in 3.5 days and has a surface temperature of around 1,000 °C. Observations of this planet have revealed the presence of an extended atmosphere, or exosphere, that extends out to several times the size of the planet itself.

It seems that such environments should be utterly unsuitable for planets in the first place, but most of these gas giants are larger and heavier than Jupiter. They generate strong gravitational fields that hold them together, resisting tidal forces and stellar winds that would otherwise act to break them apart.

gas-giant exoplanets orbiting very close to their parent stars

HELLISH
'HOT JUPITERS'
MAKE VENUS
LOOK PLEASANT

4,300 °C

WHAT DO X-RAY TELESCOPES SEE?

It's not uncommon to have an X-ray at least a few times in your life. Whether it's a routine check-up with your dentist, or the result of an unfortunate accident, it's a reliable way to peer inside the body and has become fundamental to modern healthcare. X-rays also occur naturally from sources in space, but due to the atmosphere they are absorbed before they reach the ground. Thus, astronomers deploy X-ray space telescopes above the atmosphere to capture this high-frequency radiation.

X-ray astronomy has its roots in the 1960s, when sounding rockets made the first detections of extrasolar X-rays, now known to originate from compact, massive objects like black holes and neutron stars. Today we live in the age of orbiting X-ray telescopes such as the ESA's XMM-Newton and NASA's Chandra X-ray Observatory. They're specially designed to perform imaging and spectrographic observations in the X-ray part of the spectrum, which **provide information about some of the most energetic objects and events** in the Universe.

Black holes are obvious targets for X-ray telescopes. They frequently emit X-rays as they devour matter from their surroundings and so X-ray telescopes can watch them as they feed, studying the most violent parts of the process. Similarly, neutron stars can produce X-ray bursts when they accrete enough material from a neighbouring star to undergo a thermonuclear eruption.

X-ray telescopes can watch them as they feed, studying the most violent part of the process

X-rays are often associated with these extreme objects, but they're also emitted from unlikely places such as low mass stars (including the Sun), auroras on other planets and even from Pluto. They may form as a result of interactions between planets and the solar wind, but **they require high levels of energy to be produced**. The X-ray Universe has received less attention than other parts of the electromagnetic spectrum, but it is a growing area of focus for astronomers who seek open questions to answer.

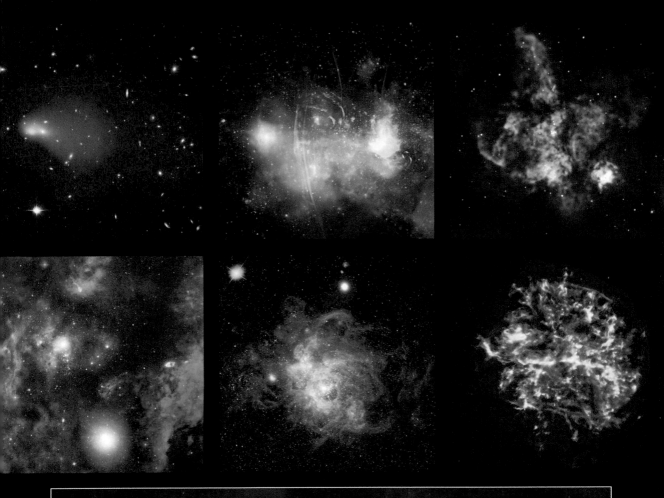

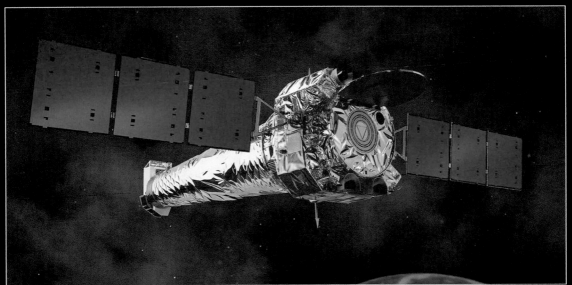

CHANDRA

Launched in 2013, the ESA's *Gaia* mission is one of the most ambitious astronomical endeavours in history. The spacecraft's primary goal is to map our galaxy in unprecedented detail, by recording the properties of more than one billion stars.

The *Gaia* spacecraft is equipped with two carefully aligned telescopes that capture light from celestial objects and a monstrous, 937.8-megapixel camera composed of 106 individual CCD (charged-couple device) sensors. The spacecraft's instruments are so sensitive that they can detect stars up to 400,000 times fainter than those visible to the naked eye. **To date, *Gaia* has observed over 1.8 billion sources**.

The data collected by *Gaia* is being used to create a highly detailed map of the Milky Way, which goes well beyond the apparent positions of stars. It records coordinates, distance, 3-dimensional proper motion, parallax, brightness and colour information with pinpoint accuracy, producing an extraordinary treasure trove of data that requires more than one petabyte (one million gigabytes) of storage.

The *Gaia* catalogue is so extensive that it probably contains many astrophysical sources and phenomena that have never been observed before. Yet **it will take generations of astronomers many years to analyse it**. The map can be used to search for multiple star systems and exoplanets, or watch elements being created by exploding stars. It allows astronomers to measure precisely the dynamics of the Milky Way's dwarf satellite galaxies and calibrate the population distribution of stars across the Universe.

they can detect stars up to 400,000 times fainter than those visible to the naked eye

Gaia is expected to operate until 2025 and its final data release will be its most comprehensive and precise. It's likely that this data will be among the most widely cited in modern astronomy and you're sure to see the name of this mission many times as future press releases are written to announce surprising new discoveries.

MAPPING THE STARS LIKE NEVER BEFORE

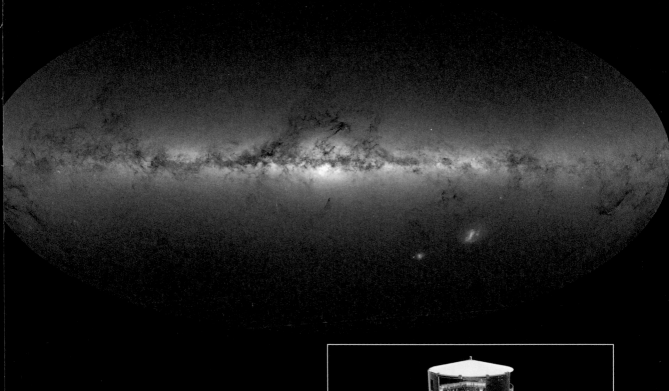

GAIA

EUROPA

ENCELADUS

ENCELADUS PLUMES

PLUTO

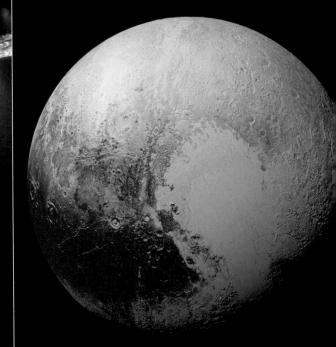

THESE ARE THE SOLAR SYSTEM'S WATER WORLDS

When we think of oceans, we often picture vast bodies of water on Earth, but there is more than one water world in the Solar System. Recent discoveries have revealed that many icy worlds, including moons and dwarf planets, harbour liquid water in significant quantities. While the Earth is unique in having oceans above the ground, subsurface oceans can exist in unlikely places well beyond the reaches of the Sun's habitable zone.

The most well-known example of a subsurface ocean is at Jupiter's moon Europa. In the 1990s, the *Galileo* spacecraft discovered evidence of a global ocean beneath Europa's fractured, icy shell. Subsequent observations from the Hubble Space Telescope (HST) have captured plumes of water vapor that erupt through fissures in the moon's surface. Two of Europa's siblings, Callisto and Ganymede, are also strongly suspected to have subsurface oceans, meaning three out of four Galilean moons (the largest moons of Jupiter) are **up for consideration as potential habitats for extra-terrestrial life**. Tidal forces from Jupiter's powerful gravitational environment may supply the energy required to keep these watery interiors warm enough for chemistry to occur. Future missions, including NASA's *Europa Clipper* and ESA's *Jupiter Icy Moons Explorer* (JUICE) are designed to investigate this intriguing possibility.

Another moon with a confirmed subsurface ocean is Enceladus, which orbits around Saturn. In 2005, the *Cassini* spacecraft discovered **geysers of water vapor and ice erupting from the moon's south pole**. Follow-up observations revealed that these geysers were emanating from a subsurface ocean and Enceladus is known to contain some of the elements necessary for life, including nitrogen, carbon, oxygen and hydrogen.

Further out still from the Sun is Neptune. Its large moon Triton has been suggested to be a candidate water world. Triton is thought to have been captured by Neptune billions of years ago and its orbit has since stabilised and circularised, which may indicate the presence of subsurface tides under its frigid crust.

Moons aren't the only place to look for significant water bodies. Two dwarf planets – Ceres and Pluto – are also likely to be hiding oceans. On Ceres, water seems to be transporting salt to the surface, evaporating and leaving deposits that form bright spots called faculae. Meanwhile, Pluto's complex geology, as revealed by the flyby of the *New Horizons* spacecraft in 2015, hints at a sustained subsurface ocean that is surprisingly warm. If true, **it could indicate that many other worlds in the Kuiper Belt are harbouring liquid water**. Even though very little energy is available so far from the Sun, liquid water can be sustained under the right conditions and the possibility that one of the Solar System's many water worlds beyond the Earth is hosting aquatic lifeforms can't be ruled out.

Albert Einstein's general theory of relativity – our current theory of gravity – makes many strange predictions about what can happen in space-time. Among the most counter-intuitive is the notion that time runs more slowly in a gravitational field. This effect, called gravitational time dilation, has been confirmed by numerous experiments and is a fundamental principle of modern physics.

According to the theory of relativity, space and time are intimately linked, forming a four-dimensional fabric known as space-time. Gravity, according to general relativity, is not a force that pulls objects towards each other, but rather a geometric property of space-time, which is treated as curvature. A massive body, such as a star or planet, curves the paths taken by photons through space in a measurable way. When the curvature is greater, light must propagate along it, taking a longer path. As a result, **clocks close to strong sources of gravity seem to run slower** than those further away. In fact, they really do run slower!

Clocks on board GPS satellites, for example, run slightly faster than their counterparts on the ground. These satellites orbit at an altitude of approximately 20,200 km. Their clocks run faster than ground-based clocks by a few tens of a millionth of a second every day. The effect is tiny, but if it went uncorrected, the satellite signals would lose their positional accuracy by as much as 10 metres per day! GPS signals have

timing corrects which account for the effects of gravitational time dilation.

In a strong gravitational field, such as that near a black hole, curvature can become extreme. Here, gravitational time dilation can have drastic effects. Time runs much more slowly in the environment close to a black hole. If you were to visit one and go into orbit, you'd age at a much slower rate. From your perspective, events everywhere else in the Universe would be happening much more quickly!

Unfortunately, **you can't buy yourself any more time here on Earth**. You are already ageing as slowly as possible on the surface of the planet. Airline pilots and stewards who spend much of their working lives at high altitude actually do age a little faster, but the differences are imperceptible – just a tiny fraction of a second over a whole career.

time runs much more slowly in the environment close to a black hole

A full understanding of the large-scale effects of gravitational time dilation has great value for scientists seeking to understand the nature of dark energy and, a century after he first introduced it, Einstein's mathematics is still puzzling cosmologists. It's a weird way to look at the Universe but, for now, it's the best one we have.

NEED MORE TIME?
USE A GRAVITATIONAL FIELD

TENS OF A MILLIONTH OF A SECOND

THIS IS WHAT WINNING THE EXOPLANET LOTTERY LOOKS LIKE

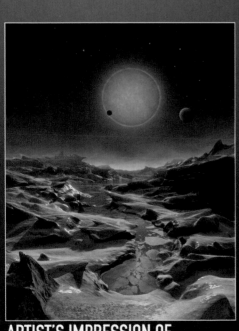

ARTIST'S IMPRESSION OF TRAPPIST-1

In 2017, astronomers announced the discovery of not one, two or even three, but *seven* Earth-sized exoplanets orbiting an ultra-cool, dim red dwarf star called TRAPPIST-1. This discovery, made using observations from a relatively small telescope system, was hailed as a major breakthrough in exoplanet hunting.

TRAPPIST-1 is located about 40.7 light-years away from us in the constellation Aquarius and is only slightly larger than Jupiter. The star is so cool and dim that its habitable zone, or the region around the star where temperatures are just right for liquid water to exist, is much closer to this star than we are to the Sun. However, **its planets are also much closer to it than Mercury is to the Sun**, with at least three orbiting within its habitable zone.

All seven exoplanets in the TRAPPIST-1 system were detected using the transit method, whereby astronomers measure the tiny dips in the star's brightness as the exoplanets pass in front of the star. By analysing and unpicking the patterns of these dips, astronomers can determine the size and orbital properties of each exoplanet separately, and infer their masses collectively.

They are named TRAPPIST-1b through to TRAPPIST-1h, in order of increasing distance from the star. TRAPPIST-1b, the closest exoplanet to the star, completes one orbit in just 1.5 days, while TRAPPIST-1h takes 18.8 days. All seven planets are much closer to each other than any of the planets in our Solar System and their proximity means that they feel each other's gravitational influence. They are in orbital resonance, which is not uncommon for systems of this nature and probably helps to keep their orbits stable over long periods.

a major breakthrough in exoplanet hunting

Of course, the most exciting aspect of the TRAPPIST-1 planetary system is that it offers many potential habitats for life. Of the seven planets, five – b, d, f, g and h – are capable of having atmospheres, oceans and significant quantities of ice, enabling a range of biomes and climate conditions. It's very possible that one or more of these worlds satisfies all the conditions necessary to be a habitable planet, so the system is a priority target for further study.

Cutting-edge observatories such as the James Webb Space Telescope (JWST) are capable of determining the contents of their atmospheres and astronomers are cautiously optimistic that **rich planetary systems may be common around red dwarf stars** – the most abundant stars in the Milky Way. Every researcher working in this field hopes to make a similarly exciting discovery and win the exoplanet lottery.

THE JAMES WEBB SPACE TELESCOPE: A NEXT-GENERATION INFRARED POWERHOUSE

JAMES WEBB
SPACE TELESCOPE

On Christmas Day 2021, the James Webb Space Telescope (JWST) launched into space on board an *Ariane 5* rocket, sailing out towards its orbital station at the L2 Lagrange point. Over a period of several months, the telescope was deployed bit-by-bit and then powered up to produce its first images. As the world waited, astronomers carefully prepared a series of astonishing images that exceeded everyone's expectations. Now the telescope is working at full capacity, conducting science operations for a wide range of research projects.

First proposed in 1996, the JWST has been one of the most ambitious and eagerly anticipated observatories of the early twenty-first century. Unlike its forerunner the Hubble Space Telescope (HST), which mostly observes visible wavelengths, the JWST is designed to detect infrared radiation, which can penetrate through gas and dust clouds that would otherwise block visible light. This allows the telescope to see through cosmic 'fog' and observe the earliest stages of star and planet formation, which would ordinarily be hidden from view.

The JWST was designed from the ground up to be an infrared beast, since **infrared astronomy has become increasingly fruitful**, yielding new insights about everything from stars and galaxies, to alien worlds and even the Big Bang. Key to the JWST's performance is its suite of advanced instruments, including the Near Infrared Camera (NIRCam) and the Near Infrared Spectrograph (NIRSpec). These instruments are capable of detecting faint objects in the infrared spectrum and mapping the chemical compositions of stars and galaxies with unprecedented precision. The Mid-Infrared Instrument (MIRI) is a joint camera-spectrograph that is able to probe very faint objects in our Solar System, such as distant comets and icy worlds in the mysterious Kuiper Belt.

the JWST is designed to detect infrared radiation, which can penetrate through gas and dust clouds that would otherwise block light

Since infrared radiation has a long wavelength relative to visible light, the JWST requires a large mirror to achieve good resolution. Therefore, it's equipped with a giant segmented mirror that measures 6.5 metres in diameter. This mirror is made up of 18 hexagonal segments that can be individually adjusted to achieve near-perfect optical alignment. The mirror is of unprecedented size for a space telescope and had to survive the violence of rocket launch, followed by a very careful deployment.

To keep its instruments cool, the JWST uses a novel, 21-metre-long sunshield comprising five, ultra-fine sheets of specially coated Kapton. The shield masks the Sun from view, and dissipates its heat so that JWST's cameras operate at just 50 Kelvin (-223 °C.) The resulting high sensitivity is crucial for the JWST to meet its science objectives, particularly when studying faint, high redshift galaxies, **whose light reaches us from the early history of the Universe**.

The JWST results most likely to capture public attention will be related to its observations of exoplanets. Using a coronagraph, JWST is able to block out the intense light of a star in order to study its planets in detail. Its giant mirror is capable of directly imaging these exoplanets, while its fine spectrographic capabilities will reveal what gasses are present in their atmospheres.

Along the way, we can expect a constant stream of extraordinary and beautiful images to be released by astronomers using the JWST. They are stunning portraits of the Universe, filled with colour, but it's worth noting that the colours we see in these images are all captured in infrared. These wavelengths are invisible to our eyes, so visible colours have been assigned to them in order to produce meaningful images. It isn't the way we would see the Universe, but the JWST was built to **far exceed the capabilities of the human eye and deliver cutting-edge scientific observations**. The images are just icing on the cake!

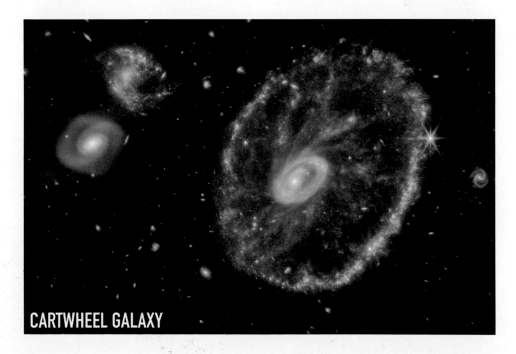

CARTWHEEL GALAXY

GALAXIES GALORE: WEBB'S VIEW
OF PANDORA'S CLUSTER

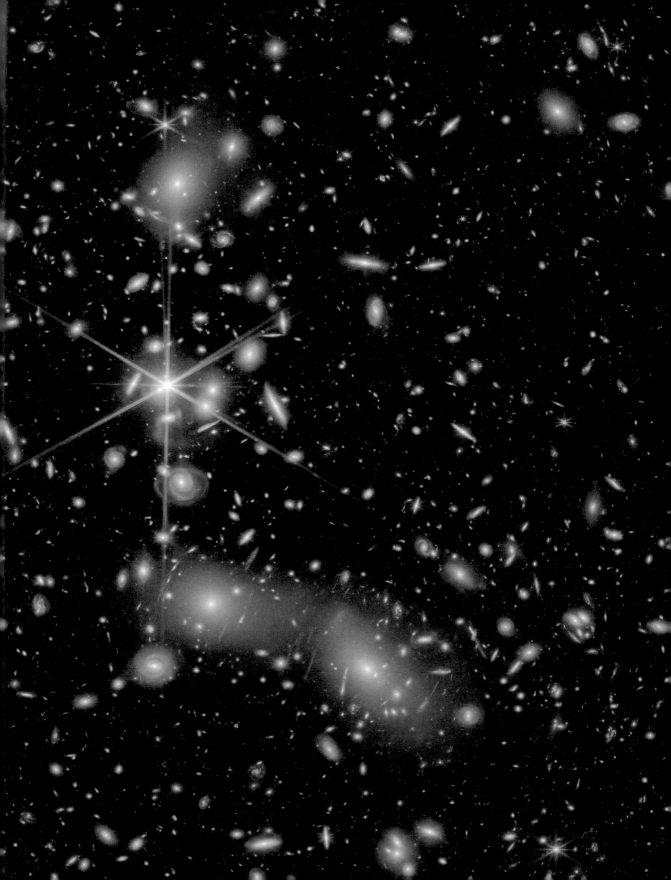

GLOSSARY OF TERMS

Accretion
Accumulation of mass by a gravitationally significant object drawing in material from the surrounding region. Accretion discs form around young stars and black holes.

Angular momentum
Angular momentum is a physical quantity of a rotating object, analogous to linear momentum of a moving object. Crucially, it is conserved in a closed system, such that it cannot be created or destroyed, but may be exchanged between two or more interacting objects.

Asteroid
A small, typically irregular body composed primarily of rock and metal, which orbits the Sun. Most asteroids in the Solar System occupy the Main Asteroid Belt, largely contained between the orbits of Mars and Jupiter.

Astronomical Unit (AU)
The average distance between the Earth and the Sun, equal to 92.3 million miles (149.6 million kilometres).

Auroral oval
A ring of auroral emission surrounding a magnetic pole, which changes size, shape and position according to the influence of the space weather environment. Auroral ovals appear on the Earth, and every planet in the Solar System except Mercury, as well as several moons.

Blueshift / redshift
A change in the properties of light received from a source due to various environmental factors. This can be perceived as a change in the colour of light, either towards the blue end of the spectrum or towards the red, though this effect also occurs in light outside of visible light. The most common source of this effect is the relative motion of the source and observer, where an object approaching will have its light blueshifted while an object receding will show redshift, though strong gravitational effects and the expansion of the Universe can also produce these shifts.

Comet
A small body composed primarily of ice and frozen gas, which orbits the Sun. Most comets originate from far beyond the orbits of the planets. Comets which approach the Sun undergo outgassing, growing long tails of debris in space.

Curvature
In Einstein's general theory of relativity, curvature is a property of space-time, directly related to the energy and momentum of radiation and matter. It describes these properties in geometric terms, as their influence on a space-time manifold. The presence of curvature alters the paths of objects in space, and even photons, which results in many strange effects observed directly in nature.

Day-side	The Sun-facing side of an object in the Solar System, such as a planet or moon, or the side of an extrasolar object that is facing its parent star. For a near-spherical object, such as the Earth, the day-side corresponds to one half of the surface.
Doppler effect	The change in the frequency of sound or light waves received from a moving source. When a source of sound or light waves moves towards you, the frequency of incoming waves is increased, causing the audible pitch of sound to be raised, or the colour of light to become bluer. Conversely, when it is travelling away from you, the frequency is decreased, resulting in a lower audible sound pitch or redder visible light.
Dwarf planet	An object in hydrostatic equilibrium (approximately spherical in shape) which orbits the Sun but has not cleared, or cannot clear, its orbit of significant debris. Ceres and Pluto are examples of dwarf planets. Both have the characteristics of small planets, but both share their orbital neighbourhoods with substantial amounts of material.
Eclipse, lunar	An event during which the Moon passes partially or entirely into the shadow of the Earth in space.
Eclipse, solar	An event during which the Moon passes partially or entirely across the face of the Sun as seen from a portion of the Earth's surface.
Ecliptic	An imaginary line tracing the apparent path of the Sun through the celestial sphere over one year. The ecliptic passes through the constellations of the zodiac. The Moon, planets and asteroids always appear close to the ecliptic.
ESA	The European Space Agency, representing 22 member states.
Exoplanet	A contraction of the term 'extra-solar planet', an exoplanet is a planetary body that is not within the Solar System. It may be in orbit around another star or floating freely between the stars. Thousands of exoplanets have been identified, and astronomers believe there are many more exoplanets than stars.
Exposure time	Measured in seconds – the length of time a camera's shutter is left open. Longer exposure times are used to collect more light for a brighter photograph.

HII region
An emission nebula, composed primarily of hydrogen, which glows due to the ionisation of gas by intense radiation from young stars. HII regions have temperatures in excess of 10,000 Kelvin.

Heliospheric
Of or relating to the Sun's outermost atmosphere and/or magnetosphere, collectively known as the heliosphere. In a wider definition, the heliosphere includes a vast region around the Sun that ends at the heliopause. This is sometimes termed the astrosphere.

Kapton
A material engineered and patented by DuPont Corporation in the 1960s, which exhibits very high thermal stability. Kapton is used in the construction of thin, stable and mechanically critical components, such as printed circuits and spacecraft thermal control systems. It was employed in the design of the cutting-edge heat shield that allows the James Webb Space Telescope to maintain ultracool operating temperatures.

Kelvin scale
A temperature scale named after Lord Kelvin (William Thompson). It is an absolute scale used in thermodynamic calculations, rather than the Celsius scale. In the Kelvin scale, 0 Kelvin is called absolute zero – the temperature at which all thermodynamic interactions cease. This is equal to -273.15 degrees Celsius.

K-type star
A class of star with a surface temperature ranging between 3,900–5,300 Kelvin. K-type stars are cooler than the Sun, and are generally orange in colour.

Kuiper belt
A region of the Solar System beyond the orbit of Neptune, extending from about 30 AU to 50 AU. Pluto is the most famous member of the Kuiper Belt, which is also home to many other small worlds.

Lagrange point
Named after Joseph-Louis Lagrange, a Lagrange point is a region of space where the mutual gravity of two co-orbiting objects is balanced with the centrifugal force of the orbit. These can be considered to be gravitational dead zones. They are ideal locations for spacecraft undergoing long missions, allowing the spacecraft to be positioned in stable orbits requiring only small, fuel-efficient corrections.

Magnification
A measure of the scale factor for images formed by a telescope and eyepiece in combination.

Meteor
The flash of light emitted by a small object, such as a fragment of rock or ice, burning up in the Earth's atmosphere, commonly known as a shooting star. Meteors occur sporadically throughout the day and night.

Meteorite Any naturally occurring object from space that survives its journey through the Earth's atmosphere and reaches the surface. Most meteorites originate from fragments of asteroids, but others have been determined to have come from the Moon or Mars. Meteorites can be valuable for both collectors and scientists, as they provide samples from elsewhere in the Solar System that can be studied comprehensively.

Meteor shower A period of elevated meteor activity which occurs when the Earth passes through a debris stream in orbit around the Sun.

M-type star A class of star with a surface temperature ranging between 2,300–3,900 Kelvin. M-type stars are substantially cooler than the Sun, and are generally red in colour. Red dwarf stars are very common M-type stars, the most abundant type of star in the Galaxy. The nearest star to the Sun, Proxima Centauri, is an M-type star.

Natural satellite Also known as a moon, a natural object in orbit around a planet, dwarf planet or other significant body excluding the Sun.

Nebula From the Latin word meaning 'cloud', a nebula is a gaseous structure in space. Some nebulae emit light as gases are ionised by the radiation of nearby stars. Others are seen in silhouette, appearing dark in the sky. Stars may form from large nebulae, but nebulae are also created when stars die and release their atmospheric material into the Galaxy.

Neutron star An ultra-compact stellar remnant that is typically the product of a supernova. Neutron stars are incredibly dense, with surfaces composed of degenerate neutrons. They are unusual, extreme objects that produce the strongest magnetic fields in nature.

Night-side The side of a celestial body not illuminated by the Sun, or its parent star.

Occultation An event in which one celestial object passes in front of another, covering it. The occulting object must have a larger apparent size in order to fully occult the background object.

Orbital period The time taken for an object to complete its orbit. For planets, asteroids and comets, this value is usually expressed in years. For moons, it is usually expressed in days.

Parallax The apparent differences in the positions and displacements of objects along different lines of sight. We observe parallax when looking out of a train window. Nearby objects seem to whiz by, whereas distant objects seem to move slowly. In astronomy, this principle is used to measure distances to stars near the Sun.

Photodissociation A process in which photons cause molecules to break down. In the near-vacuum conditions of space, it is the primary cause of the breakdown of molecules. Photodissociation occurs when an inbound photon delivers enough energy to break a chemical bond.

Photosphere The dense 'surface' of the Sun, beneath its atmosphere. Details in the Sun's photosphere can be viewed with the use of a white light filter.

Planet An object in hydrostatic equilibrium, which orbits the Sun and which has cleared its orbit of significant debris. There are eight planets in the Solar System: Mercury, Venus, Earth, Mars, Jupiter, Saturn, Uranus and Neptune.

Protoplanetary disk A disc of material around a young star in which planets are forming. The Earth and other planets were once protoplanets in a protoplanetary disk surrounding the Sun.

Ram pressure Air pressure that is created by objects moving at high speed through the atmosphere. Ram pressure builds in front of a rapidly travelling object, where air cannot be displaced quickly enough to move around it. This in turn increases the compressed air's temperature. Meteors become superheated due to ram pressure, as they typically travel at tens of miles per second.

Selenology (Selenologic/ Selenological) The scientific study of the properties, composition and history of the Moon's surface. Selenology, from the Greek name for the Moon – Selene – is, to the study of the Moon, as geology is to the study of the Earth.

Spin-orbit resonance Tidal forces can cause some orbiting bodies to reach a situation where their period of spin and period of orbit are left in integer ratios of each other. The simplest ratio, 1:1, is known as tidal locking. If an object is in an eccentric orbit and experiencing relatively weak tidal forces, the ratio of its rotation rate and orbital period may be described by integers other than 1:1. For example, Mercury experiences a 3:2 spin-orbit resonance, meaning it rotates on its own axis three times for every two orbits of the Sun.

Subluminal Denoting a speed that is slower than the speed of light. Some forms of radiation, such as the solar wind, travel at subluminal speeds.

Substellar object A significant astronomical object that is smaller and cooler than a normal star. Brown dwarfs, many of which do not shine despite undergoing fusion in their cores, are substellar objects.

Superluminal Denoting a speed that is faster than the speed of light. Objects with mass cannot travel at, or exceed, the speed of light, but superluminal speeds are relevant to the mathematics of cosmology, as the expansion of the Universe is not limited by the speed of light.

Terrestrial planet A planet primarily made of rock and metal, without an extended atmosphere. In the Solar System, the terrestrial planets are Mercury, Venus, Earth and Mars.

Tidal forces Tidal forces are felt by objects in orbit, where there is a significant difference in the magnitude (and sometimes direction) of a gravitational force across the object. For example, an object can experience a stronger gravitational force on one side than the other, resulting in phenomena similar to the tides of the Earth's oceans. Tidal forces can also apply stress to a solid crust, where opposing sides of the surface are pulled in different directions by gravitational force.

Tidal locking Due to tidal forces, some orbiting bodies are subject to tidal locking, in which the rotation rate matches the orbital period. The Moon is tidally locked in its orbit, such that it shows one side to the Earth at all times. Tidal locking is a special case of spin-orbit resonance with a ratio of 1:1.

Wavefront When modelling radiation as a series of propagating waves, a wavefront is one of any of a set of points that share the same phase and are separated by one wavelength. For example, the wavefront may be chosen as the peak of each wave.

Wavelength The distance between two wavefronts in a wave. In the case of light, this determines its colour. Measured in nanometres, visible light has a wavelength between about 400 nm (violet) and 700 nm (red).

Wolf-Rayet star An intensely bright and hot star that disturbs the interstellar medium around it. Wolf-Rayet stars are characterised by their high rate of mass loss, as they eject their atmospheres into space through powerful stellar winds and frequent eruptions. They have surface temperatures that typically range between 20,000–200,000 Kelvin.

Zodiac A collection of 12 ancient constellations intersected by the ecliptic. The zodiac has long been admired for its connection to the Sun, Moon and planets, and was established as a calendar over 2,000 years ago.

ACKNOWLEDGEMENTS

4	Croisy / Shutterstock
5	Arthur Balitskii / Shutterstock
6	galacticus / Shutterstock
7	Agor2012 / Shutterstock
8	Tom Kerss
10	Zdeněk Bardon (bardon.cz)/ ESO
12	ESA & NASA/Solar Orbiter/ EUI team; Data processing: E. Kraaikamp (ROB)
14	Tom Kerss
16	Tom Kerss
17	Tom Kerss
18 main image	NASA/JPL
18 bottom left	ESA/AOES
18 bottom right	NASA/JPL
20	ESO/VISTA. Acknowledgment: Cambridge Astronomical Survey Unit
22	NASA/JPL/Texas A&M/Cornell
23	Jurik Peter / Shutterstock
24	Tshooter / Shutterstock
25	NASA
26	NASA/JPL-Caltech/R. Hurt (SSC/Caltech)
27	galacticus / Shutterstock
28	shooarts / Shutterstock
29	chaoss / Shutterstock
30	Arthur Balitskii / Shutterstock
31 main image	NASA/Dan Burbank/Tom Kerss
31 inset	ESO/E. Slawik
32	Panimoni / Shutterstock
33	NASA/JPL-Caltech
35	NASA/JHUAPL/SwRI
37	Hubble Image: NASA, ESA, N. Smith (University of California, Berkeley), and The Hubble Heritage Team (STScI/AURA); CTIO Image: N. Smith (University of California, Berkeley) and NOAO/AURA/NSF
38	ESA/Hubble & NASA
39	galacticus / Shutterstock
40–41	NASA, ESA, and the Hubble Heritage Team (STScI/AURA)
43	© N. Bartmann (ESA/ Webb), ESO/M. Kornmesser and S. Brunier, N. Risinger (skysurvey.org)
44	University of Warwick/Mark Garlick
45	NASA's Goddard Space Flight Center/CI Lab
46	NASA
48	NASA
49	Morphart Creation / Shutterstock
50	Johan Swanepoel / Shutterstock
51 bottom left	Arthur Balitskii / Shutterstock
51 bottom right	NASA
52	NASA, ESA, CSA, STScI, Webb ERO Production Team
53	Sahara Prince / Shutterstock
55 main image	NASA
55 inset	sakkmesterke / Shutterstock
57	ESO/M. Kornmesser
59	NASA, ESA, CSA, Leah Hustak (STScI)
60 main image	NASA, ESA, Z. Levay and R. van der Marel (STScI), T. Hallas, and A. Mellinger

174	Morphart Creation / Shutterstock
175	Tom Kerss
176	ESA/Hubble, M. Kornmesser
178	Bodor Tivadar / Shutterstock
179	DSS/STScI/Tom Kerss
180	NASA
181	u3d / Shutterstock
182	ESO/M. Kornmesser
185	ESO/L.Calçada.
186	ESO
187	NASA, ESA, N. Smith (University of Arizona, Tucson), and J. Morse (BoldlyGo Institute, New York)
188	NASA, ESA, CSA, STScI
189	Arthur Balitskii / Shutterstock
190	ESO/L. Calçada/P. Delorme/R. Saito/VVV Consortium
193	M. Garlick/University of Warwick/ESO
194	X-ray: NASA/CXC/CfA/M. Markevitch, Optical and lensing map: NASA/STScI, Magellan/U.Arizona/D.Clowe, Lensing map: ESO WFI
197	NSF/LIGO/Sonoma State University/A. Simonnet
198	NASA/JPL–Caltech/T. Pyle
199	Nazarii_Neshcherenskyi / Shutterstock
200	artwork © Don Dixon
201	Bodor Tivadar / Shutterstock
203 main image	© ESA/Planck Collaboration
203 inset	Suzanne Tucker / Shutterstock
205	NASA, ESA, CSA, Jupiter ERS Team; image processing by Judy Schmidt
206–207	© RON MILLER/ BLACK CAT STUDIOS

208	Arthur Balitskii / Shutterstock
209	NASA
210	ESA/Hubble & NASA
211	ESA/Hubble & NASA
213	ESO/L. Calçada
215 all images	NASA
216	Morphart Creation / Shutterstock
217 main image	© ESA/Gaia/DPAC, CC BY-SA 3.0 IGO. Acknowledgement: Gaia Data Processing and Analysis Consortium (DPAC); A. Moitinho / A. F. Silva / M. Barros / C. Barata, University of Lisbon, Portugal; H. Savietto, Fork Research, Portugal.
217 inset	ESA/ATG medialab
218 top left	NASA, ESA, and L. Roth (Southwest Research Institute and University of Cologne, Germany)
218 top right	NASA/JPL/Space Science Institute
218 bottom left	NASA/JPL/Space Science Institute
218 bottom right	NASA/JHUAPL/SwRI
221	Rost9 / Shutterstock
222 main image	NASA
222 inset	ESO/M. Kornmesser
224–225 main image	NASA, ESA, CSA, STScI
225 bottom right	NASA/GSFC
227	NASA, ESA, CSA, STScI, Webb ERO Production Team
228–229	NASA, ESA, CSA, Ivo Labbe (Swinburne), Rachel Bezanson (University of Pittsburgh)
240	Tom Kerss

Specialist editorial support was provided by Dr Greg Brown, Senior Public Astronomy Officer at Royal Observatory Greenwich.

AUTHOR BIOGRAPHY

Tom Kerss F.R.A.S. is an astronomer and the author of numerous best-selling books about the night sky for both adults and children. Having worked at the Royal Observatory, Greenwich, for more than six years, he now shares his passion for the stars with people all over the world, delivering courses, podcasts and media interviews. Tom loves nothing more than to seek out the darkest and most beautiful skies on Earth, but he does most of his stargazing from his home in London. Find out more about Tom's projects at **tomkerss.co.uk**